COLORADO 24/7

CONNECTICUT 24/7

DELAWARE 24/7

FLORIDA 24/7

GEORGIA 24/7

KANSAS 24/7

KENTUCKY 24/7

LOUISIANA 24/7

MAINE 24/7

MARYLAND 24/7

MONTANA 24/7

NEBRASKA 24/7

NEVADA 24/7

NEW JERSEY 24/7

NEW HAMPSHIRE 24/7

OKLAHOMA 24/7

OREGON 24/7

PENNSYLVANIA 24/7

RHODE ISLAND 24/7

SOUTH CAROLINA 24/7

VIRGINIA 24/7

WASHINGTON 24/7

WEST VIRGINIA 24/7

WISCONSIN 24/7

WYOMING 24/7

...t any picture you want on any state book cover. Makes a great gift. Go to www.america24-7.com/customcover

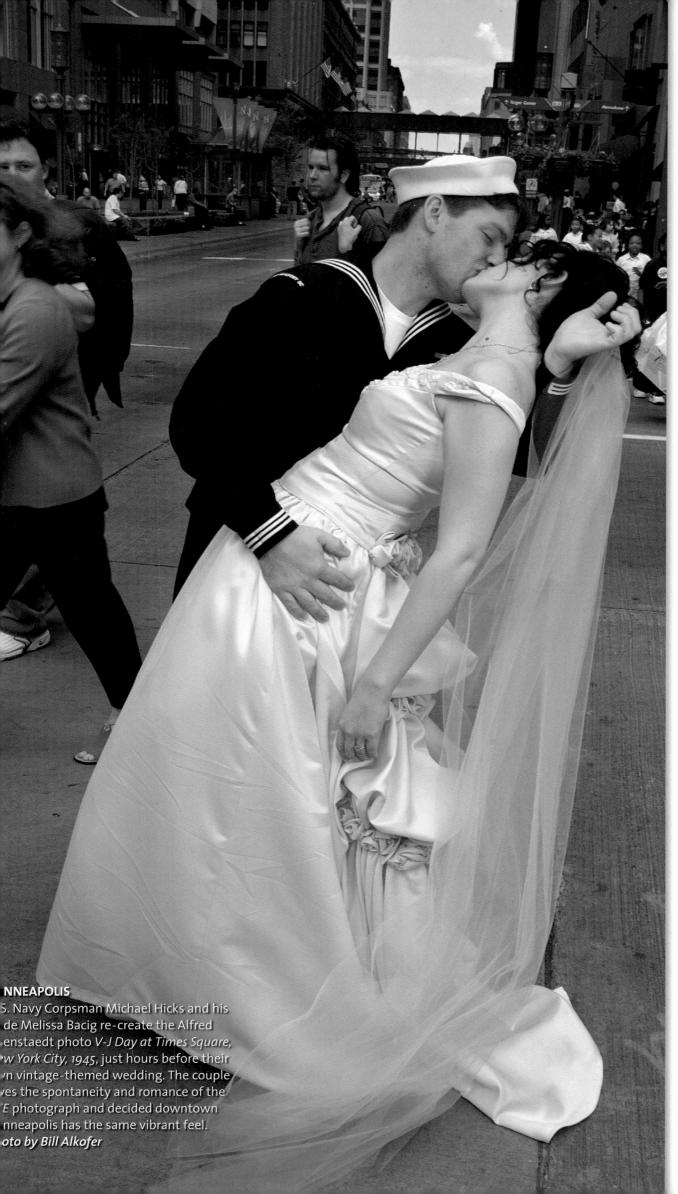

NNEAPOLIS
S. Navy Corpsman Michael Hicks and his
de Melissa Bacig re-create the Alfred
enstaedt photo *V-J Day at Times Square,*
w York City, 1945, just hours before their
n vintage-themed wedding. The couple
es the spontaneity and romance of the
E photograph and decided downtown
nneapolis has the same vibrant feel.
oto by Bill Alkofer

Minnesota 24/7 is the sequel to
The New York Times bestseller
America 24/7 shot by tens of thou-
sands of digital photographers
across America over the course of
a single week. We would like to
thank the following sponsors, the
wonderful people of Minnesota,
and the talented photojournalists
who made this book possible.

LONDON, NEW YORK, MUNICH, MELBOURNE, and DELHI

Created by Rick Smolan and David Elliot Cohen

24/7 Media, LLC
PO Box 1189
Sausalito, CA 94966-1189
www.america24-7.com

First Edition, 2004
04 05 06 07 08 10 9 8 7 6 5 4 3 2 1

Published in the United States by
DK Publishing, Inc.
375 Hudson Street
New York, NY 10014

DK Publishing, Inc. offers special discounts for bulk purchases for sales promo-
tions or premiums. Specific, large-quantity needs can be met with special
editions, personalized covers, excerpts of existing guides, and corporate
imprints. For more information, contact:

Special Markets Department
DK Publishing, Inc.
375 Hudson Street
New York, NY 10014
Fax: 212-689-5254

Cataloging-in-Publication data is available
from the Library of Congress
ISBN 0-7566-0063-4

Printed in the UK by Butler & Tanner Limited

First printing, October 2004

PAYNESVILLE
Morning fog retreats from a Sauk River
Valley farm.
Photo by Kimm Anderson

MINNESOTA 24/7

24 Hours. 7 Days.
Extraordinary Images of
One Week in Minnesota.

Created by Rick Smolan and David Elliot Cohen

About the America 24/7 Project

A hundred years hence, historians may pose questions such as: What was America like at the beginning of the third millennium? How did life change after 9/11 and the ensuing war on terrorism? How was America affected by its corporate scandals and the high-tech boom and bust? Could Americans still express themselves freely?

To address these questions, we created *America 24/7*, the largest collaborative photography event in history. We invited Americans to tell their stories with digital pictures. We asked them to shoot a visual memoir of their lives, families, and communities.

During one week in May 2003, more than 25,000 professionals and amateurs shot more than a million pictures. These images, sent to us via the Internet, compose a panoramic yet highly intimate view of Americans in celebration and sadness; in action and contemplation; at work, home, and school. The best of these photographs, more than 6,000, are collected in 51 volumes that make up the *America 24/7* series: the landmark national volume *America 24/7*, published to critical acclaim in 2003, and the 50 state books published in 2004.

Our decision to make *America 24/7* an all-digital project was prompted by the fact that in 2003 digital camera sales overtook film camera sales. This techno-logical evolution allowed us to extend the project to a huge pool of photographers. We were thrilled by the response to our challenge and moved by the insight offered into American life. Sometimes, the amateurs outshot the pros—even the Pulitzer Prize winners.

The exuberant democracy of images visible throughout these books is a revela-tion. The message that emerges is that now, more than ever, America is a supersized idea. A dreamspace, where individuals and families from around the world are free to govern themselves, worship, read, and speak as they wish. Within its wide margins, the polyglot American nation manages to encompass an inexplicably complex yet workable whole. The pictures in this book are dedicated to that idea.

—*Rick Smolan and David Elliot Cohen*

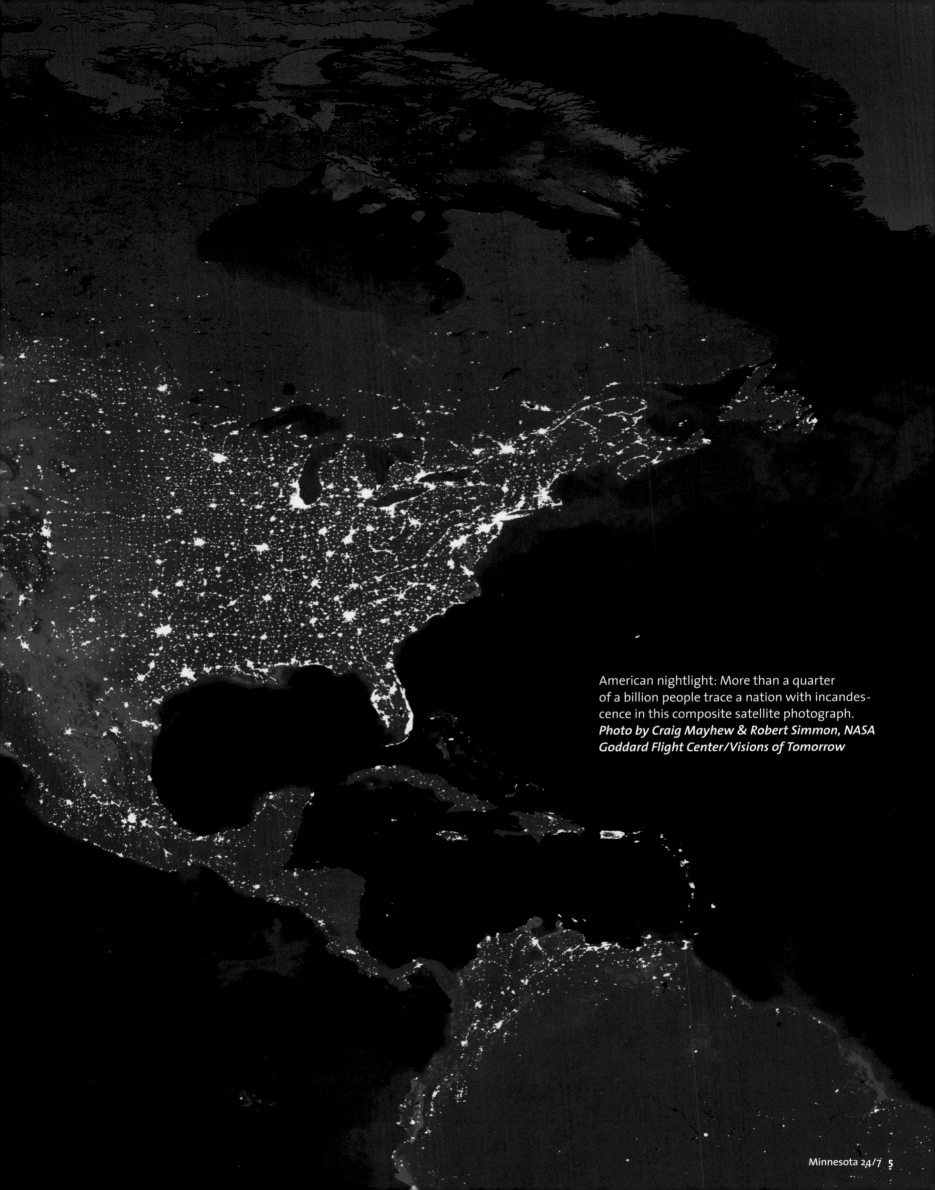

American nightlight: More than a quarter
of a billion people trace a nation with incandes-
cence in this composite satellite photograph.
*Photo by Craig Mayhew & Robert Simmon, NASA
Goddard Flight Center/Visions of Tomorrow*

Sterner Stuff

By Nick Coleman

Lieutenant Zebulon Pike was sent by the United States of America to find out what the nation had bought into up at the top end of the Louisiana Purchase. After Lewis and Clark traveled up the Missouri River in search of a northwest passage, Pike went north, up the Mississippi River, where he bought a chunk of land from the Dakota Indians at the confluence of the Mississippi and a river the Indians knew as "the river that is the color of the clouds."

"Minnesota" is the name that eventually settled on the river and the place. There have been claims over the years that it means Land of Sky Blue Waters (you may remember the beer commercials). But any true Minnesotan knows there is more than a little Paul Bunyan tall-tale telling and a lot of wishful thinking in that blue-sky stuff. If there is one thing that defines Minnesota, it is a perverse pride in the vigor it takes to live in a northern place where beauty and harshness have equal weight.

We are 400,000 deer hunters, one million anglers, five million Vikings fans, and 15,000 lakes (10,000 sounds better on a license plate). We are the state of 3M and of 3S, too: Schools, Science, and Spirituality. A place where public colleges and private institutions, from the University of Minnesota to the Mayo Clinic, have worked in a progressive political tradition to make a state that isn't just at the top of the Mississippi but at the top of the country.

A state of hockey, of Herb Brooks and 12 gold-medal winners on the 1980 Olympic hockey team still enshrined in our hearts. A state of turkeys and soybeans and sugar beets and corn. Of the rugged Lake Superior shore,

ISABELLA LAKE
Tuesday, May 13, 5:02 a.m.; latitude 47 north, longitude 91 west. Of Minnesota's 40,000 lakes, 25 percent are larger than 10 acres.
Photo by Richard Hamilton Smith

the pristine headwaters of the Mississippi, and the sprawling energy of the Twin Cities. Of Hubert Humphrey, Walter Mondale, and Jesse Ventura. Sinclair Lewis, F. Scott Fitzgerald, and Al Franken. Charles Lindbergh, Judy Garland, and the World's Largest Twine Ball.

Whether we can keep it going sometimes worries us. We've had our share of budget woes, spending cuts, and political squabbling. We've had our resilience and our resources tested by newcomers fleeing wars in Africa and Asia, or fleeing the misery of failed urban areas elsewhere, each of them attracted to a quality of life we like a lot but sometimes don't feel like sharing.

But we will share. It's in our nature. We are good hosts.

Maybe we're still embarrassed that old Zebulon Pike didn't stay long. He came in September of 1805, shot down a Union Jack he found flying over a British fort, and by February had had his fill of the Minnesota winter. Pike skedaddled back down to St. Louis.

Today's Minnesotans are made of sterner stuff.

As you will see in the pages of this book, the people of the North Star State are its most precious resource. From the Indian tribes whose languages shaped the Minnesota map to the Scandinavian, German, and Yankee stock that made Minnesota into a remarkably welcoming place that has opened its arms to Hmong, Somalian, and Latino newcomers, Minnesota is renewing its potential and rediscovering its riches: Its people.

Did I mention our fabulous blue skies?

Born and raised in St. Paul, Nick Coleman *is a news columnist for the* Star Tribune *of Minneapolis.*

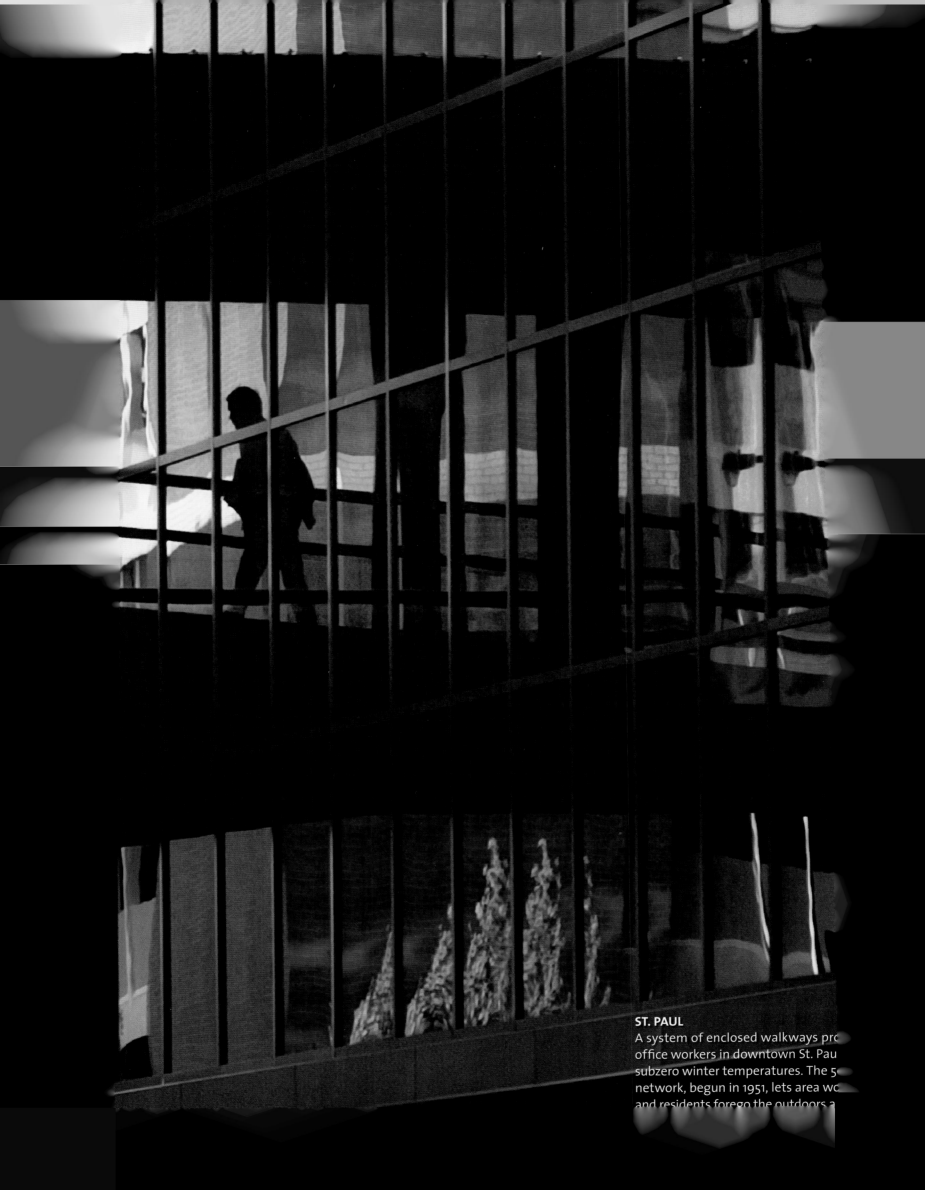

ST. PAUL

A system of enclosed walkways pro[vides] office workers in downtown St. Pau[l] subzero winter temperatures. The 5[?] network, begun in 1951, lets area wo[rkers] and residents forego the outdoors a[?]

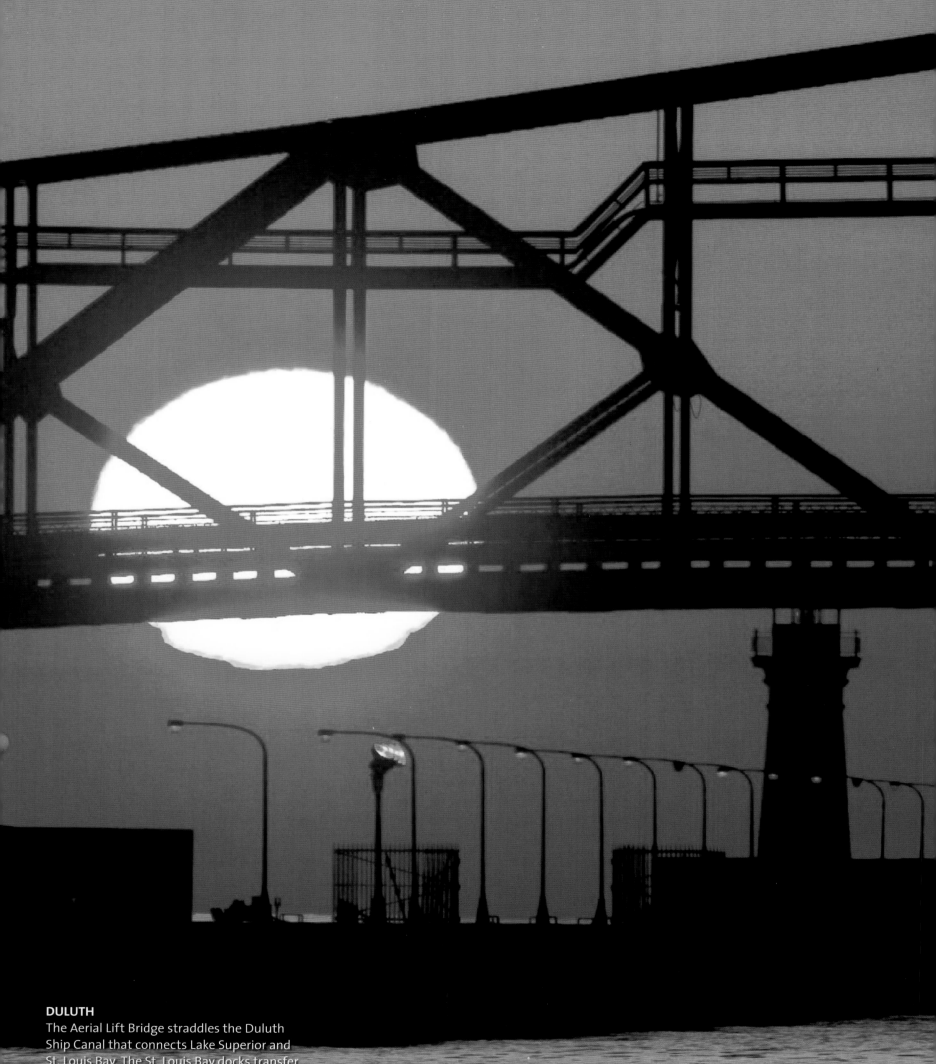

DULUTH

The Aerial Lift Bridge straddles the Duluth Ship Canal that connects Lake Superior and St. Louis Bay. The St. Louis Bay docks transfer enough iron ore, coal, grain, and crude oil to make Duluth the largest-tonnage port on the Great Lakes.

Photo by Richard Hamilton Smith

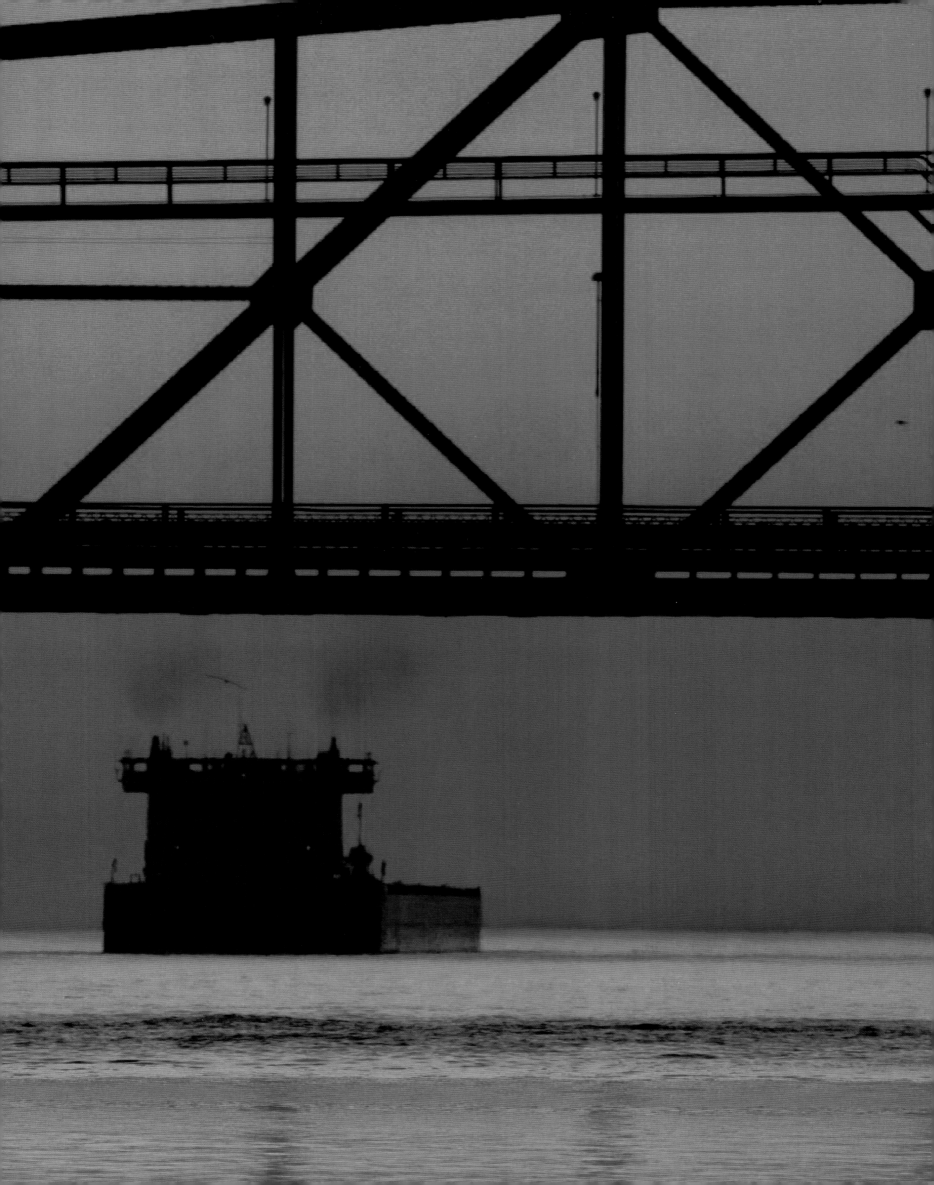

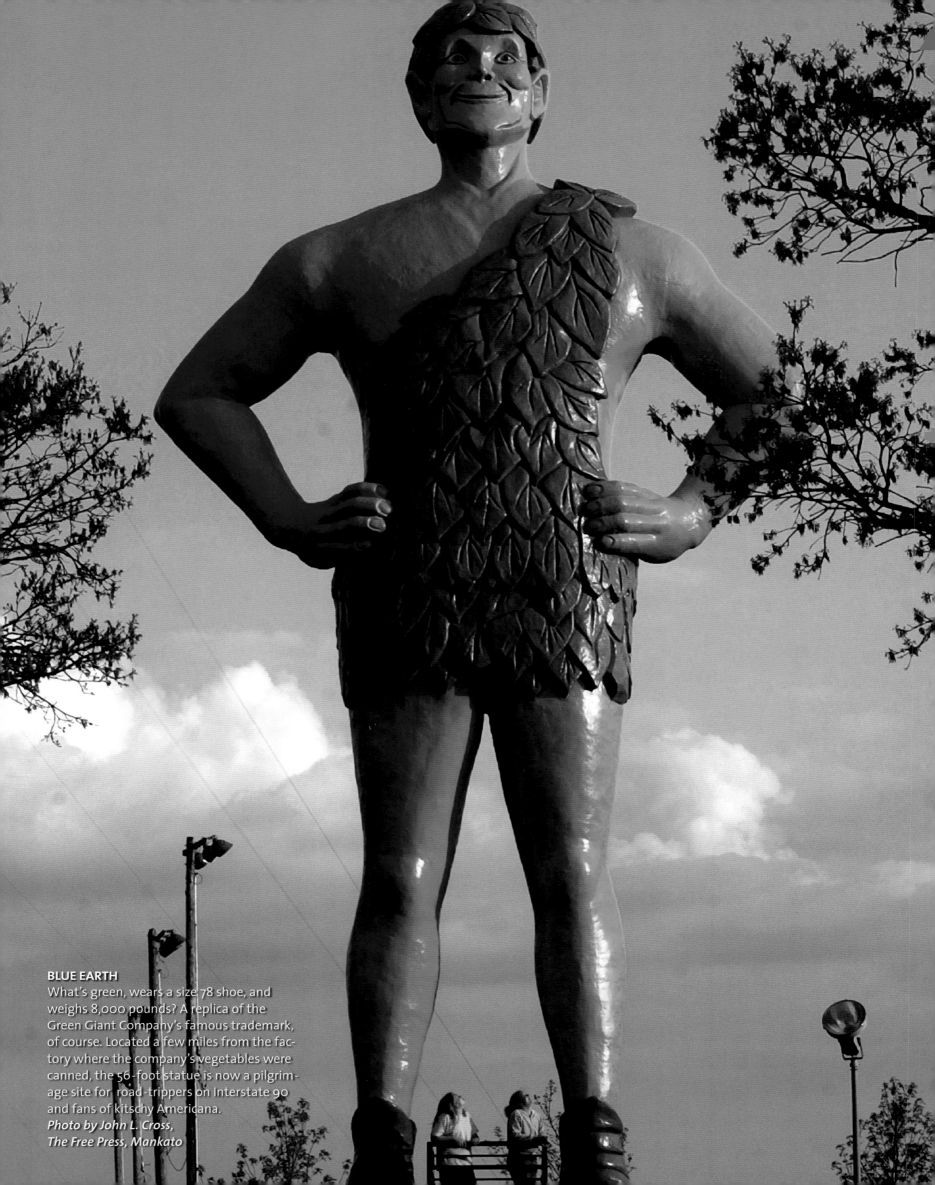

BLUE EARTH

What's green, wears a size 78 shoe, and weighs 8,000 pounds? A replica of the Green Giant Company's famous trademark, of course. Located a few miles from the factory where the company's vegetables were canned, the 56-foot statue is now a pilgrimage site for road-trippers on Interstate 90 and fans of kitschy Americana.

Photo by John L. Cross,
The Free Press, Mankato

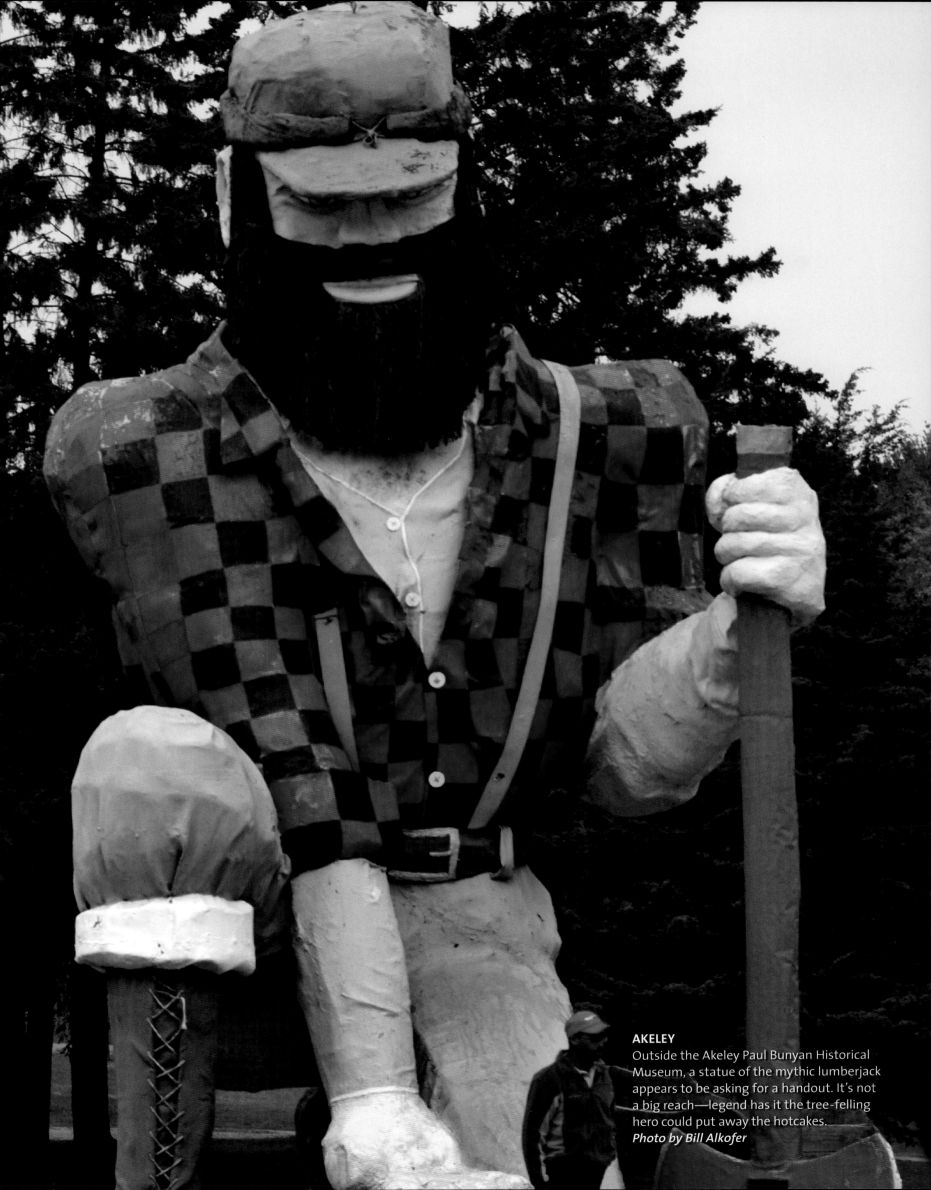

AKELEY
Outside the Akeley Paul Bunyan Historical Museum, a statue of the mythic lumberjack appears to be asking for a handout. It's not a big reach—legend has it the tree-felling hero could put away the hotcakes.
Photo by Bill Alkofer

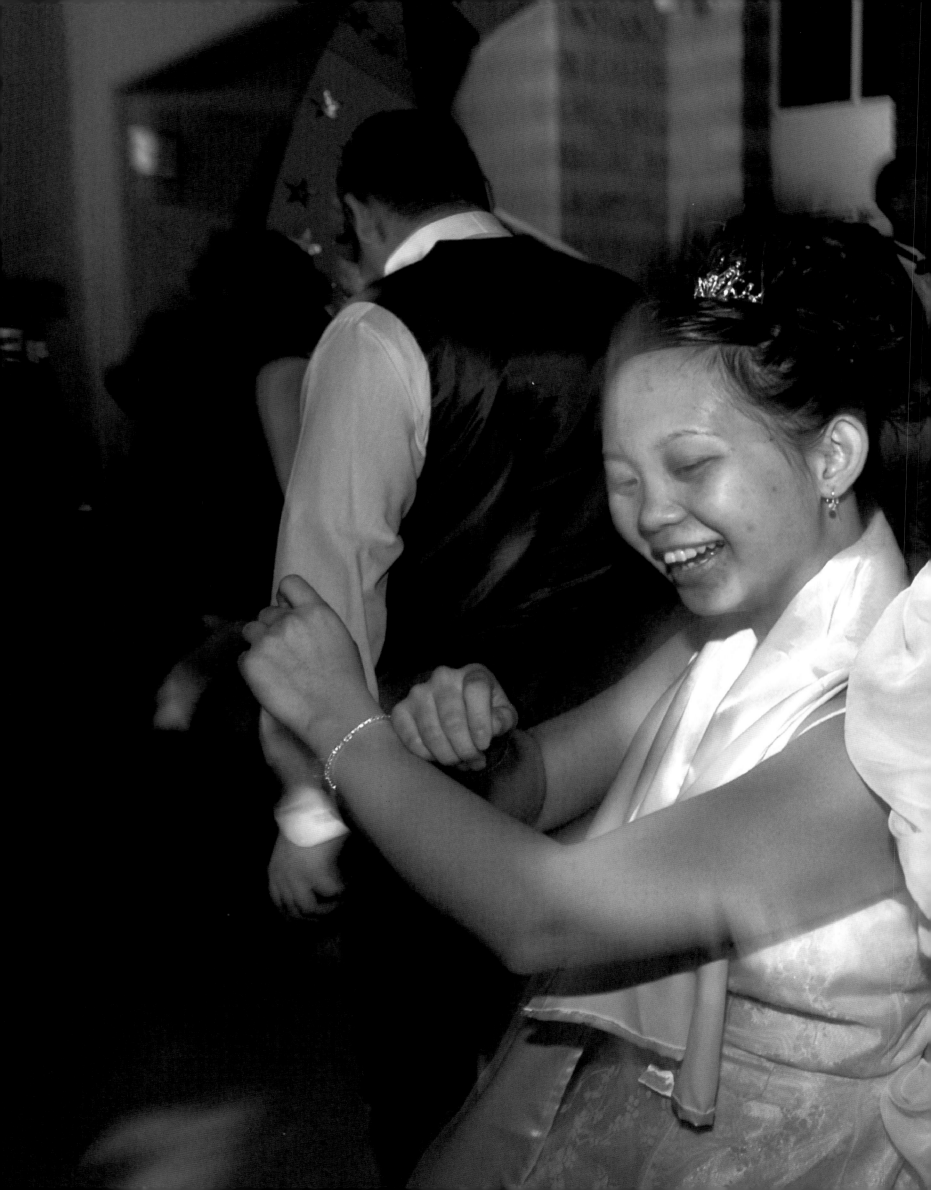

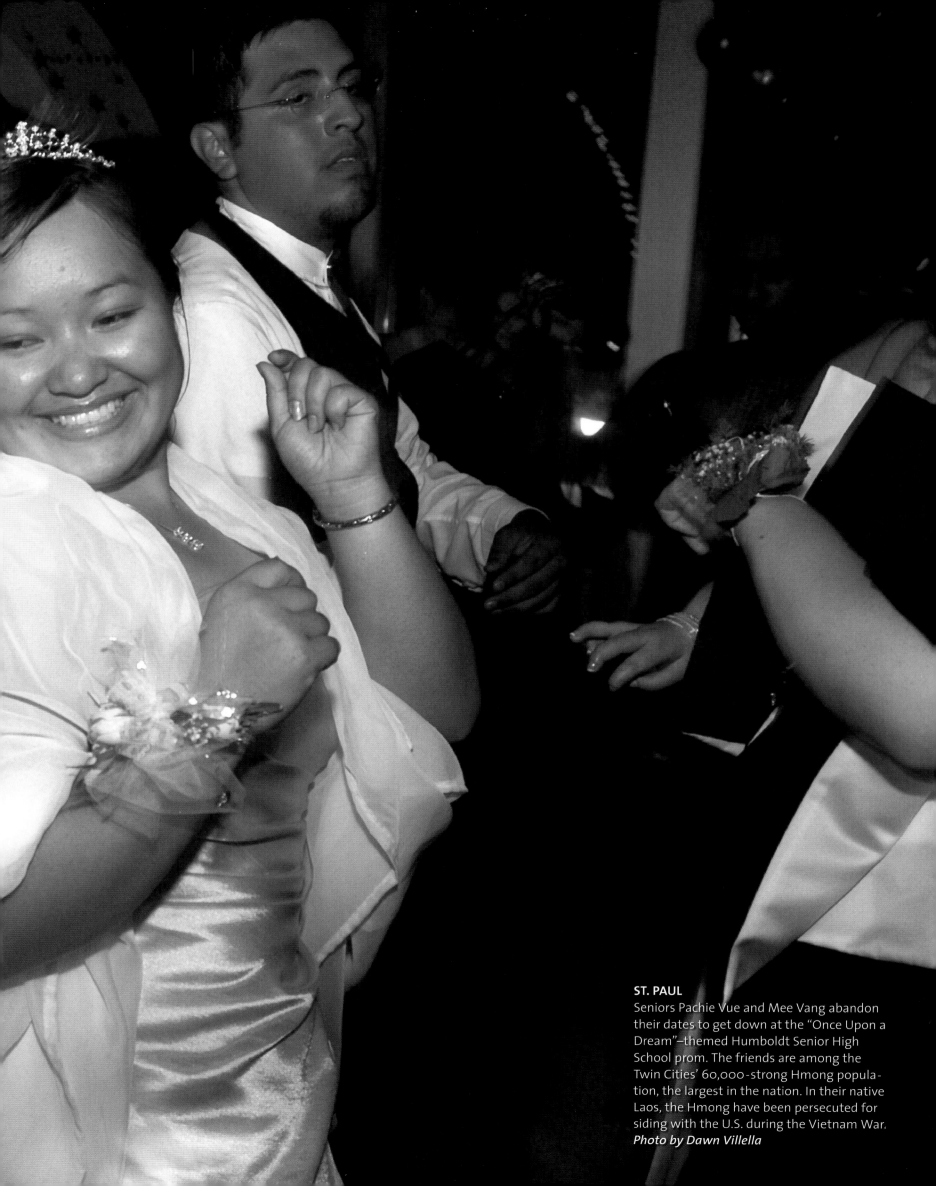

ST. PAUL

Seniors Pachie Vue and Mee Vang abandon their dates to get down at the "Once Upon a Dream"–themed Humboldt Senior High School prom. The friends are among the Twin Cities' 60,000-strong Hmong population, the largest in the nation. In their native Laos, the Hmong have been persecuted for siding with the U.S. during the Vietnam War.
Photo by Dawn Villella

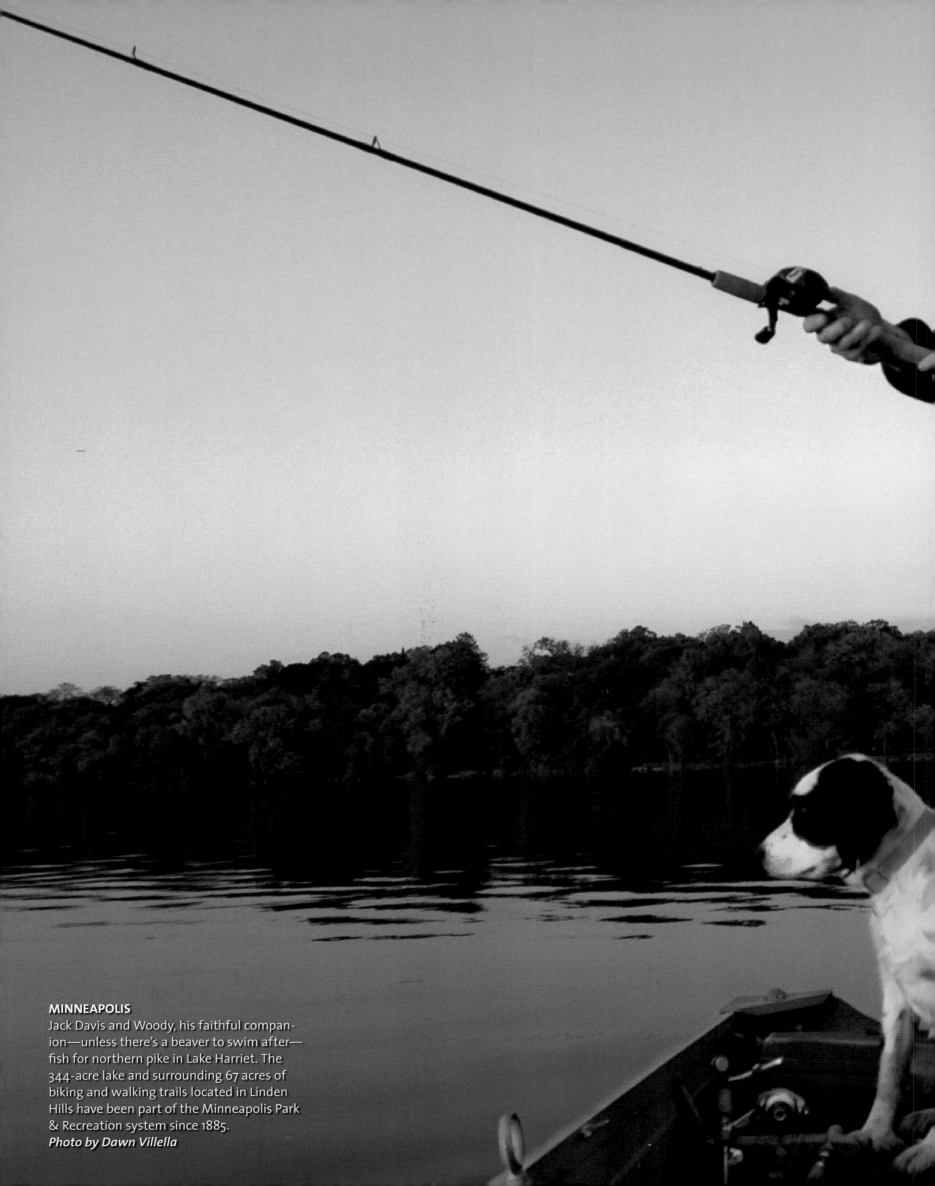

MINNEAPOLIS
Jack Davis and Woody, his faithful companion—unless there's a beaver to swim after—fish for northern pike in Lake Harriet. The 344-acre lake and surrounding 67 acres of biking and walking trails located in Linden Hills have been part of the Minneapolis Park & Recreation system since 1885.
Photo by Dawn Villella

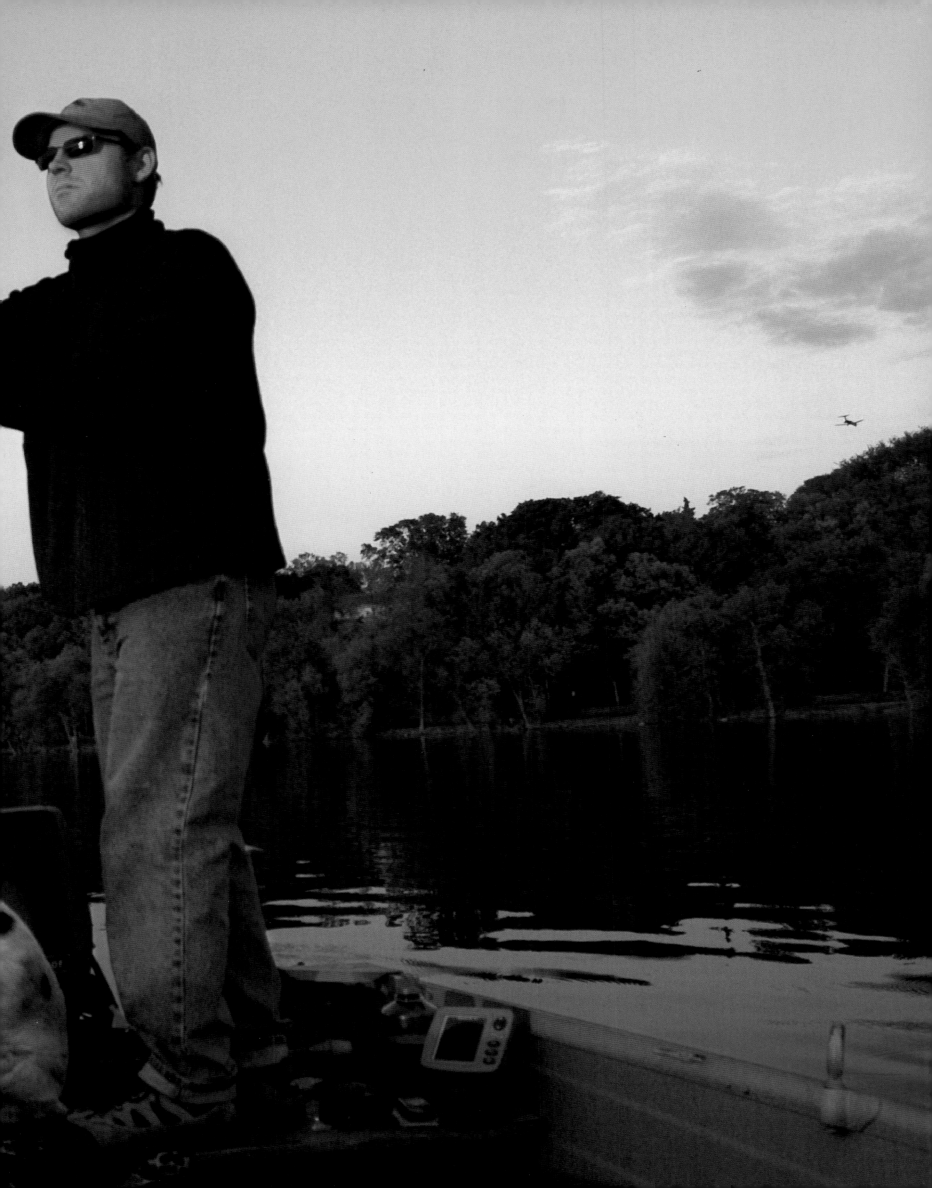

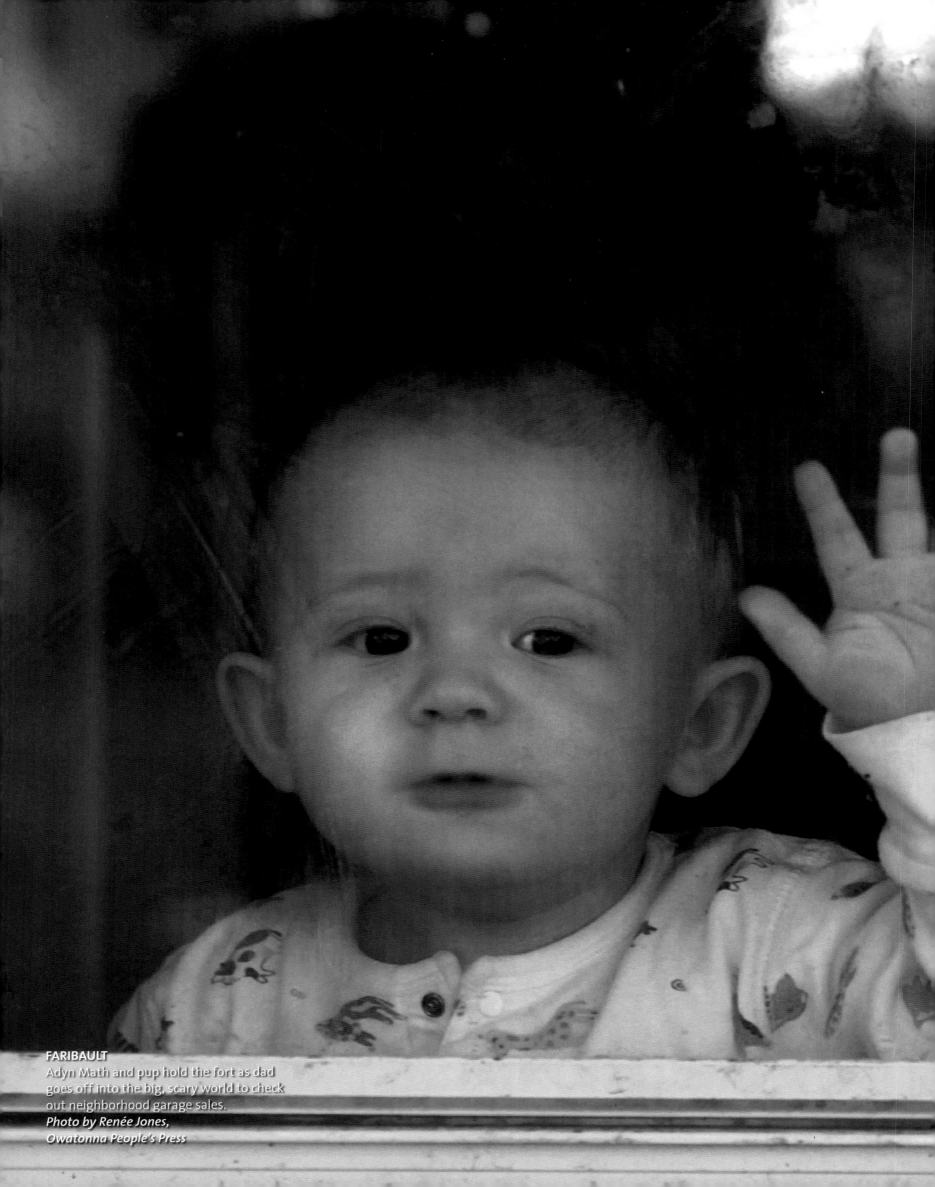

FARIBAULT
Adyn Math and pup hold the fort as dad goes off into the big, scary world to check out neighborhood garage sales.
Photo by Renée Jones,
Owatonna People's Press

Hearth & Home

The big birch tree in the Swanson's front yard has served in many fantasy worlds. Right now, it's the evil Kingdom of Mordor from *Lord of the Rings*. Wyatt (center) and Whitney Swanson (far right) and friends have managed to infiltrate the fortress.
Photo by Jackie Lorentz

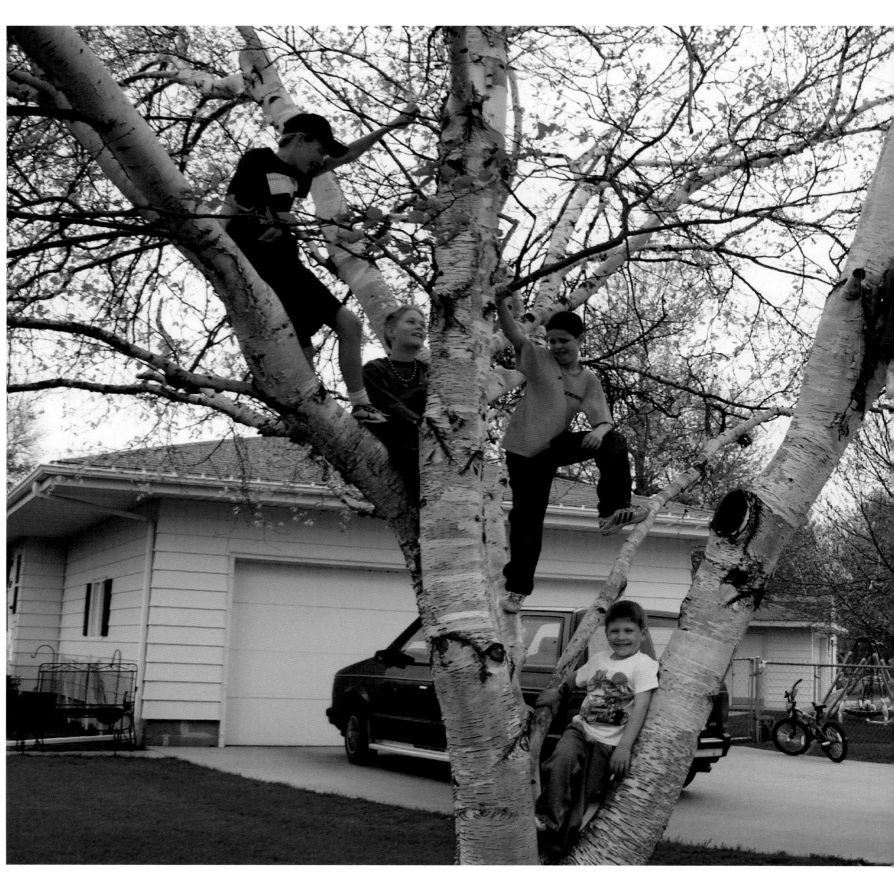

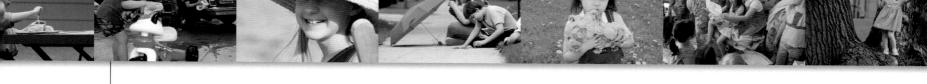

WATERVILLE

It's not unheard of for Waterville to get a load of new snow in May, so 4-year-old Aidan Margo and dad Anthony take advantage of T-shirt weather to wash and buff their hot rods.

Photo by John L. Cross, The Free Press, Mankato

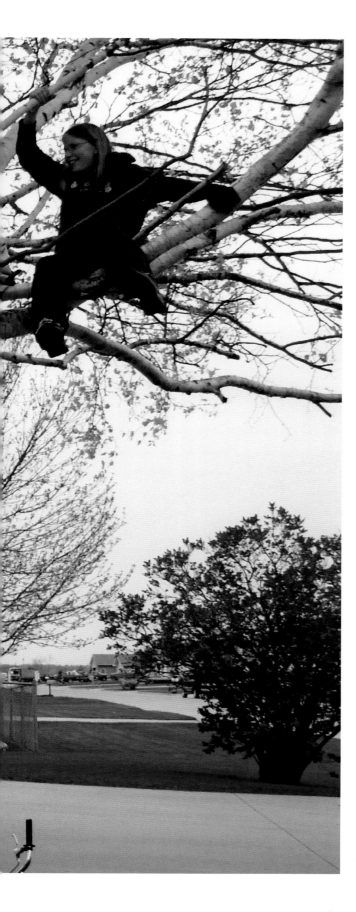

UNDERWOOD

Rub-a-dub-dub! Bathing is a production in the LaFond household, where tub time requires careful scheduling. The little ones wash up first and are ready for bed by the time Joseph, Benjamin, and Martin soap up.
Photos by Stormi Greener

UNDERWOOD

After splashing in the shallows of Pickerel Lake, on her family's waterfront property, one-year-old Elizabeth curls up into a dry towel and a warm hug from sister Marisa, 17. The LaFonds raised seven children of their own before they adopted another six.

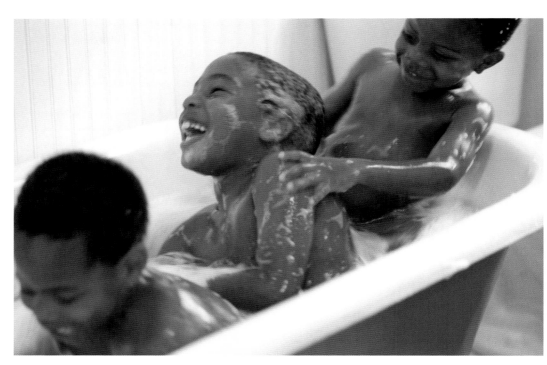

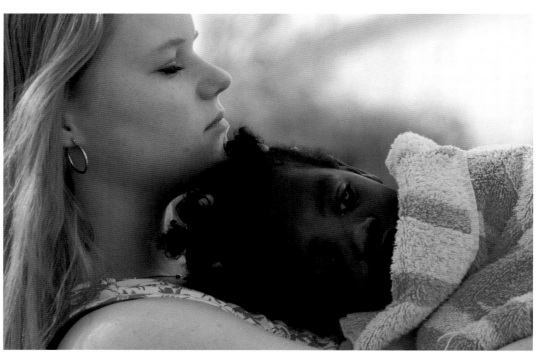

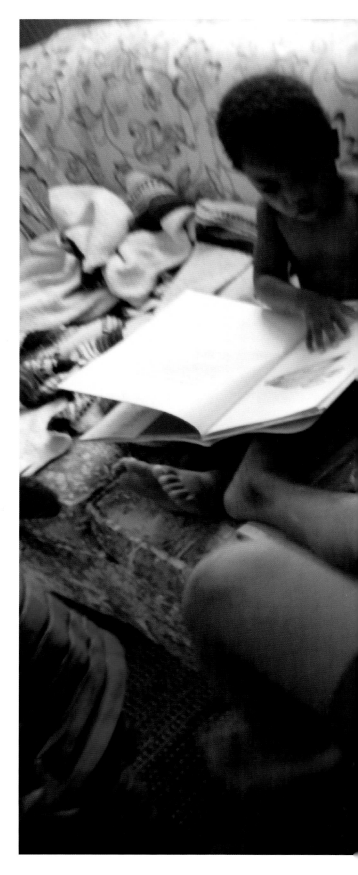

UNDERWOOD

When Marisa returns home after working her two jobs and attending classes at Minnesota State Community College, she gets mobbed by rambunctious duo Joseph and Benjamin. Little Noelle, 2, amuses himself with a storybook.

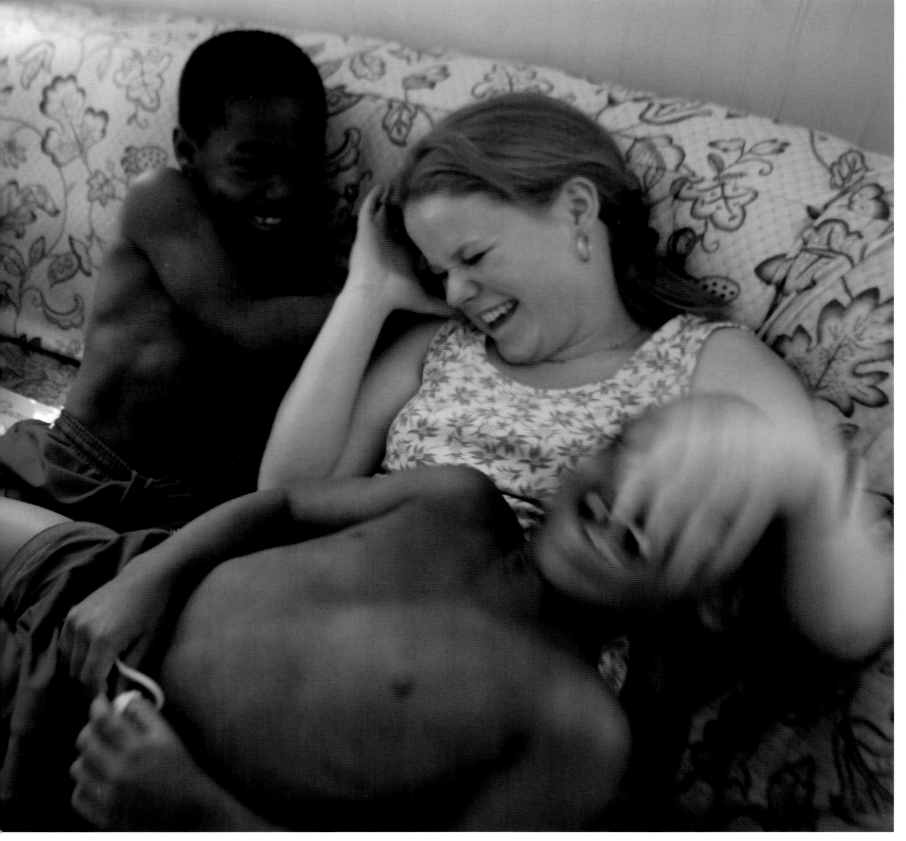

PLYMOUTH

The first thing Sara Anderson requested in the hospital after giving birth was a book. She wanted to read *On the Day You Were Born* to her hours-old daughter Grace Busse. Storytime continues still: Anderson narrates *The Three Little Pigs* while her husband Chris Busse and Grace, now 5, act out scenes with finger puppets.

Photo by Dawn Villella

MINNEAPOLIS

Cousins and best friends Ashley Sarkis, Laura Ingberg, and Elizabeth Houll meet up after school every day for day care, games, and giggles at their grandma Eleanor Horton's home.

Photo by Dawn Villella

ST. PAUL

Strong enough to crush a piece of coal into a diamond, Superman, aka Rory King, has less luck transforming his sprinkler into a drinking fountain.

Photo by Andy King

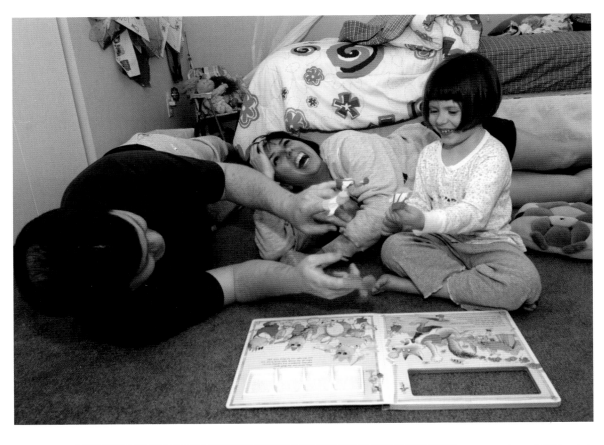

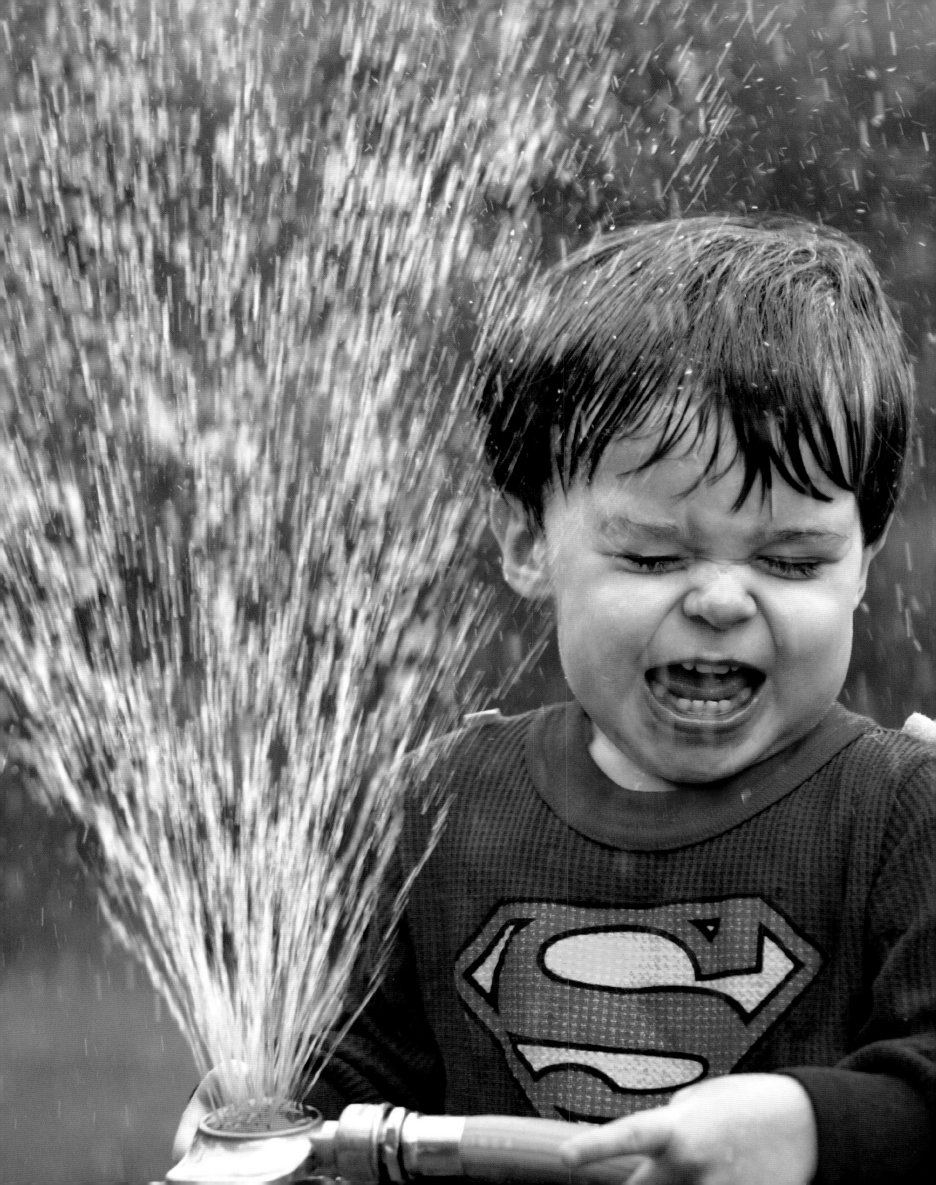

NORTHFIELD

James Bauman, 18, has other things on his mind besides tidiness. It's the end of his senior year in high school, and he has graduation parties and college plans to consider. His mom Janus puts it in perspective: "As far as the room goes, this is a good day."

Photo by Renée Jones, Owatonna People's Press

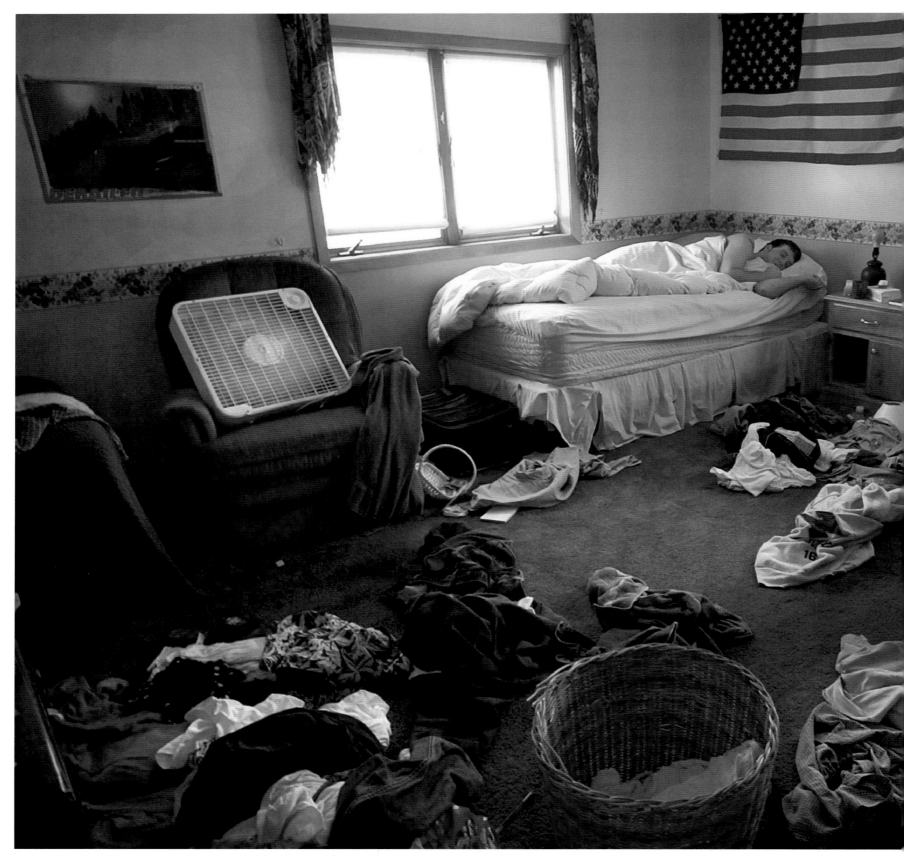

WYKOFF

Every so often 5-year-old Chester Barr runs out of steam and needs a nap. The boy has lately been obsessed with building a castle in Connecticut. "He's a dynamic little guy," says mom Eva. "Every day he has a new plan for what the castle will look like and how he's going to get the land."

Photo by Christina Paolucci

EAST GRAND FORKS

Whenever grandma comes to visit, 6-year-old Erin Hylden snuggles up with her in the guest room for a bedtime story—and then they both drift off to sleep.

Photo by Jackie Lorentz

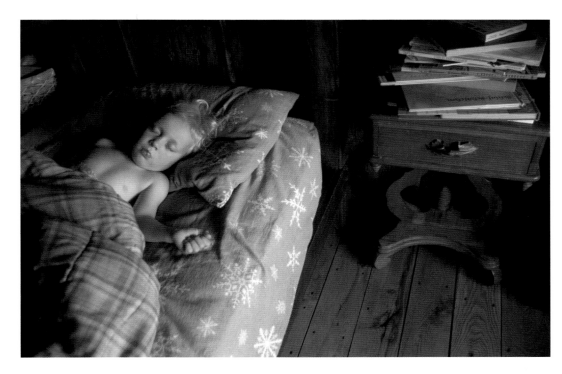

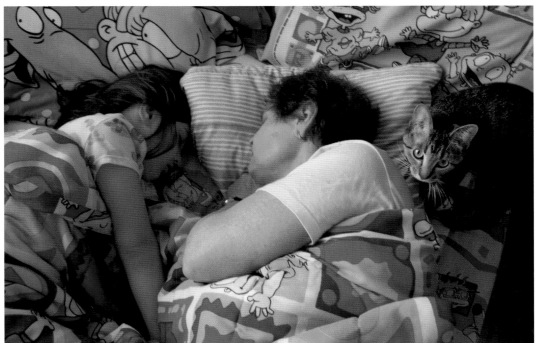

NERSTRAND

During a class visit to Big Woods Dairy, Seth, Emily, and Jeremy of Prairie Creek Community School in Castle Rock play in the barn after learning about environment-friendly farming practices. To protect local water supplies, the dairy does not use pesticides or commercial fertilizers.
Photo by Renée Jones, Owatonna People's Press

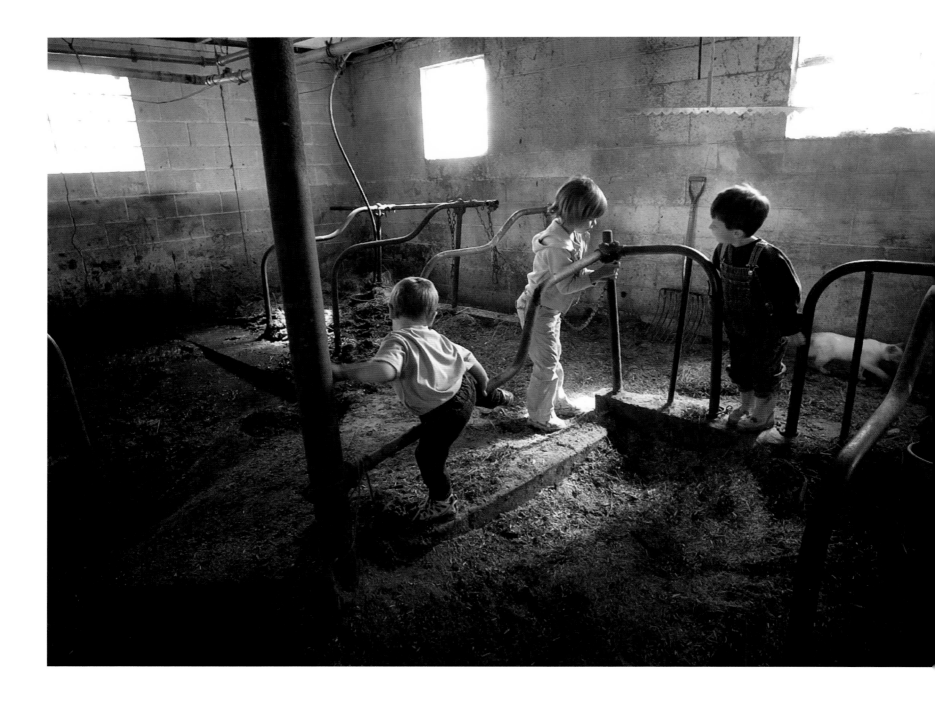

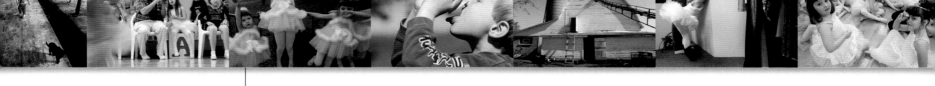

ANOKA

After dancing to "Mr. Sandman" at the sold-out recital for Dance Fever Dance School, preschoolers Stephanie Minnihan, McKayla Towberman, Melea Bruns, and Anne Marie Burke line up for their family shutterbugs. Founded in 1986, the school teaches 350 Twin Cities–area children and teens the fundamentals of jazz, tap, and ballet.
Photo by Darlene Pfister Prois

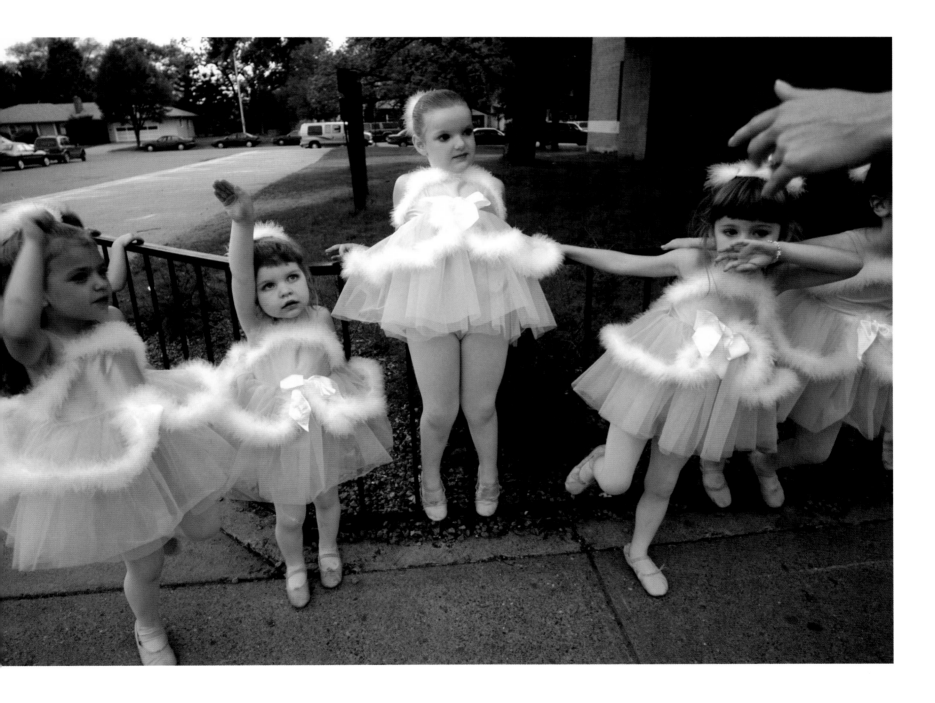

Jacob Nolte steadies Bambi the goat so that her kids Angel (the white one) and Felina can nurse. Jacob's parents raise 400 head of dairy and beef cattle on their farm. As for the handful of goats, they're pets for Jacob and his siblings.
Photos by Bill Alkofer

Eva Nolte, 5, yelps with surprise as a poult gets away from her. Her responsibilities include feeding and watering the turkeys. The Noltes raise a few each year to butcher and eat.

Louise Nolte, 10, sustained a scratch during her after-school chores, but she doesn't mind—she loves handling the fowl. Her family has three coops for their 200 chickens: one for the pets, one for the egg-layers, and one for those that wind up on the dinner table.

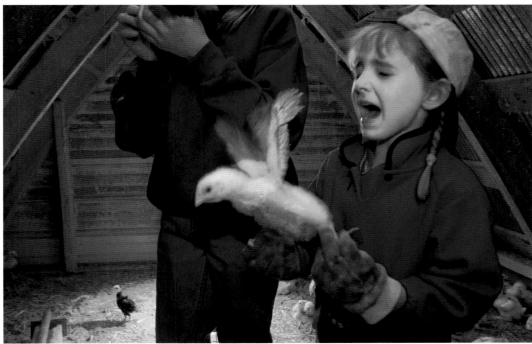

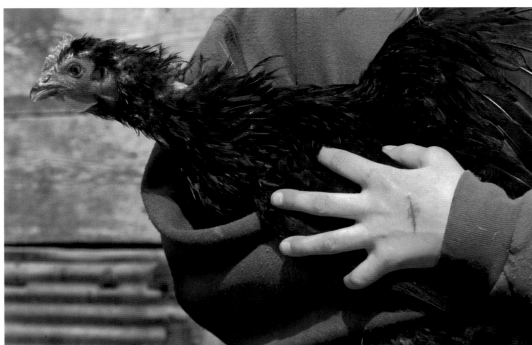

EAGAN
Best pals Devin Henry and Stephanie Jorgensen
apply eyeliner before heading to Dairy Queen,
one of their favorite summertime hangouts.
Photo by Dawn Villella

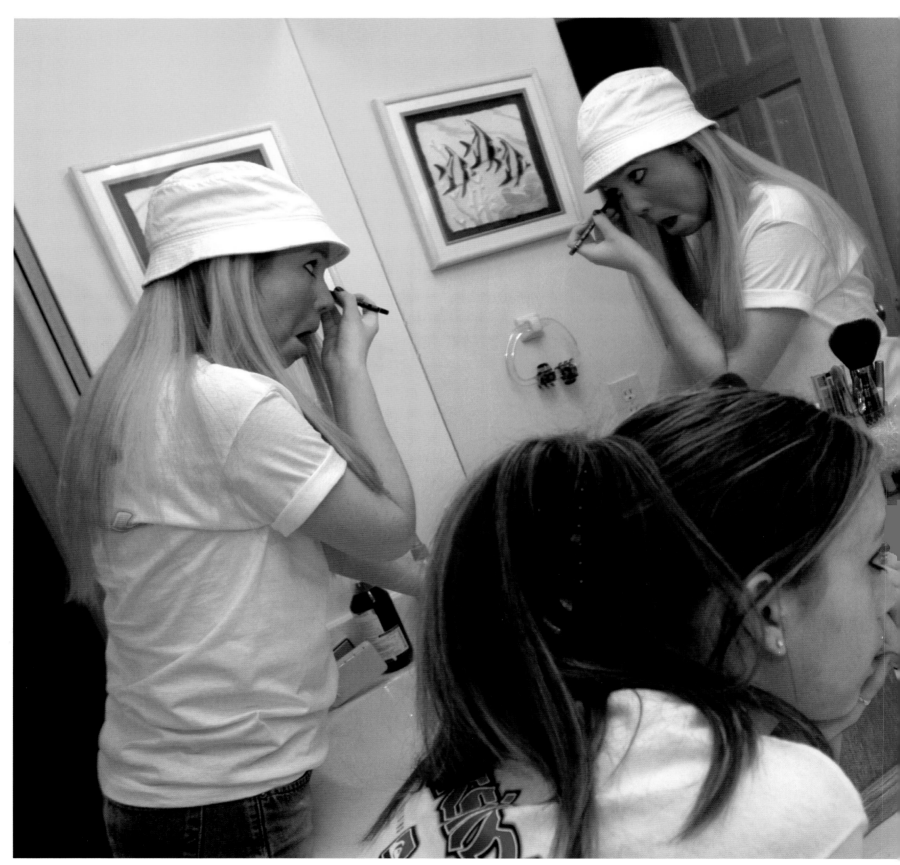

ST. PAUL

In preparation for the Humboldt Senior High School prom, Genny Yang (sitting), primps with her friends Kabao Lor, Sheng Ly, and Mee Vang.
Photo by Dawn Villella

EDINA

Before school, Eli Krieter, 12, puts the finishing touches on his 'do. Eli wanted to grow his hair out and his dad Mike agreed—as long as it looks okay. "And the deal is, his mother and I say what looks good," says Mike.
Photo by Mike Krieter

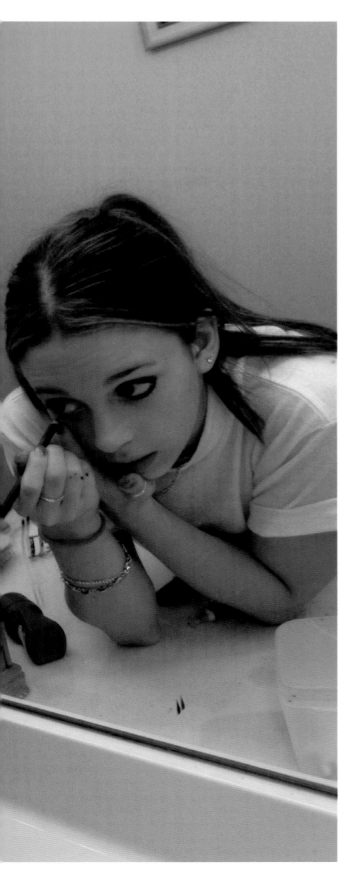

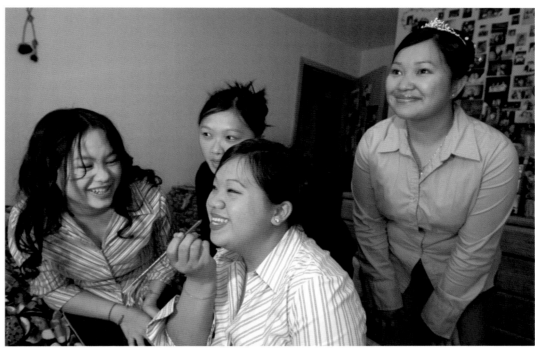

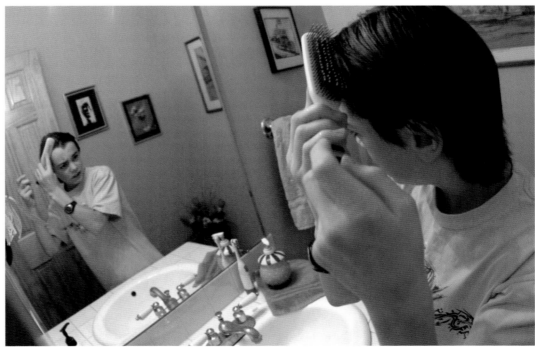

RED LAKE INDIAN RESERVATION
Ninety-three-year-old Fannie Johns is the oldest living full-blooded Ojibwe on the reservation. (Her grandmother lived to the ripe old age of 103.) Johns sits for this portrait at the Jourdain/Perpich Extended Care Facility, in front of a mural depicting the gathering of maple sap.
Photo by Bill Alkofer

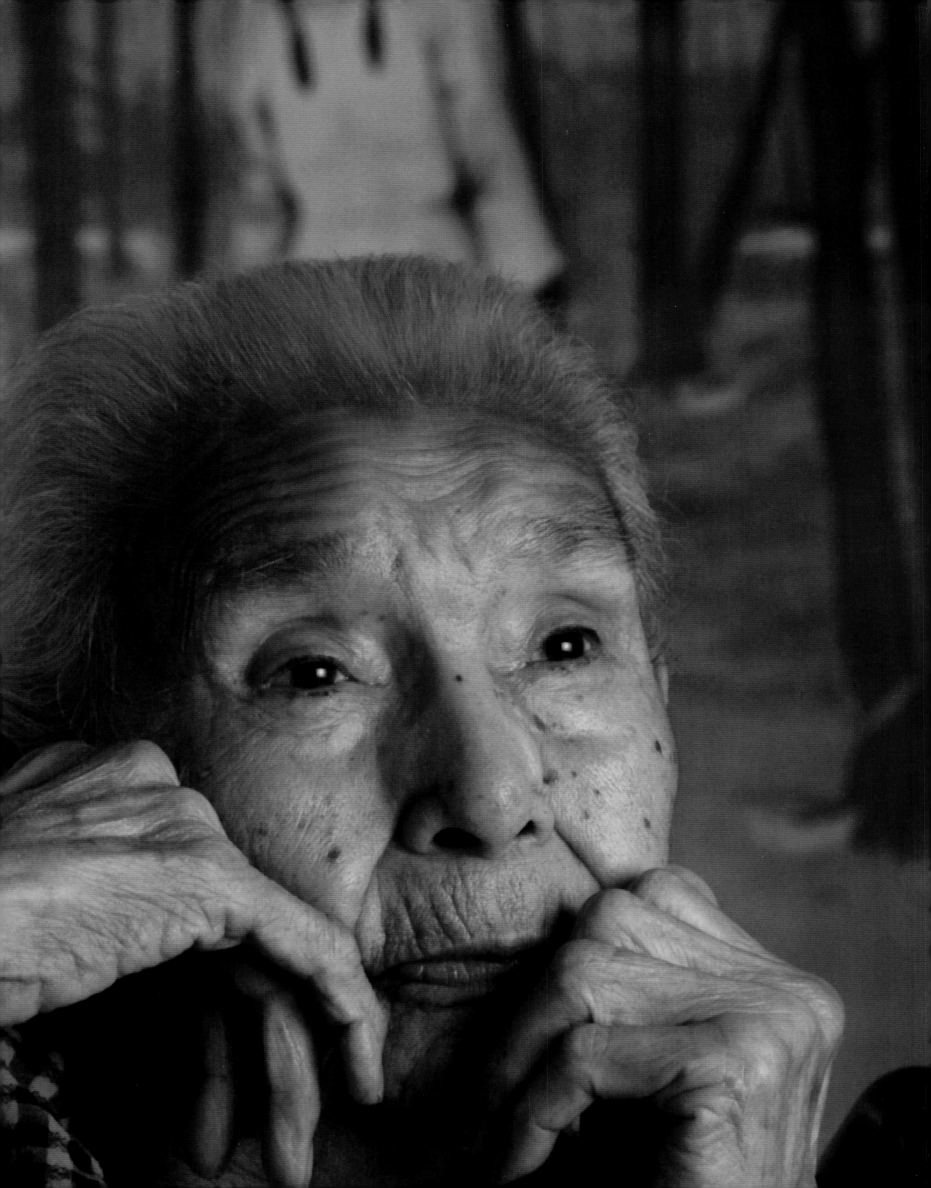

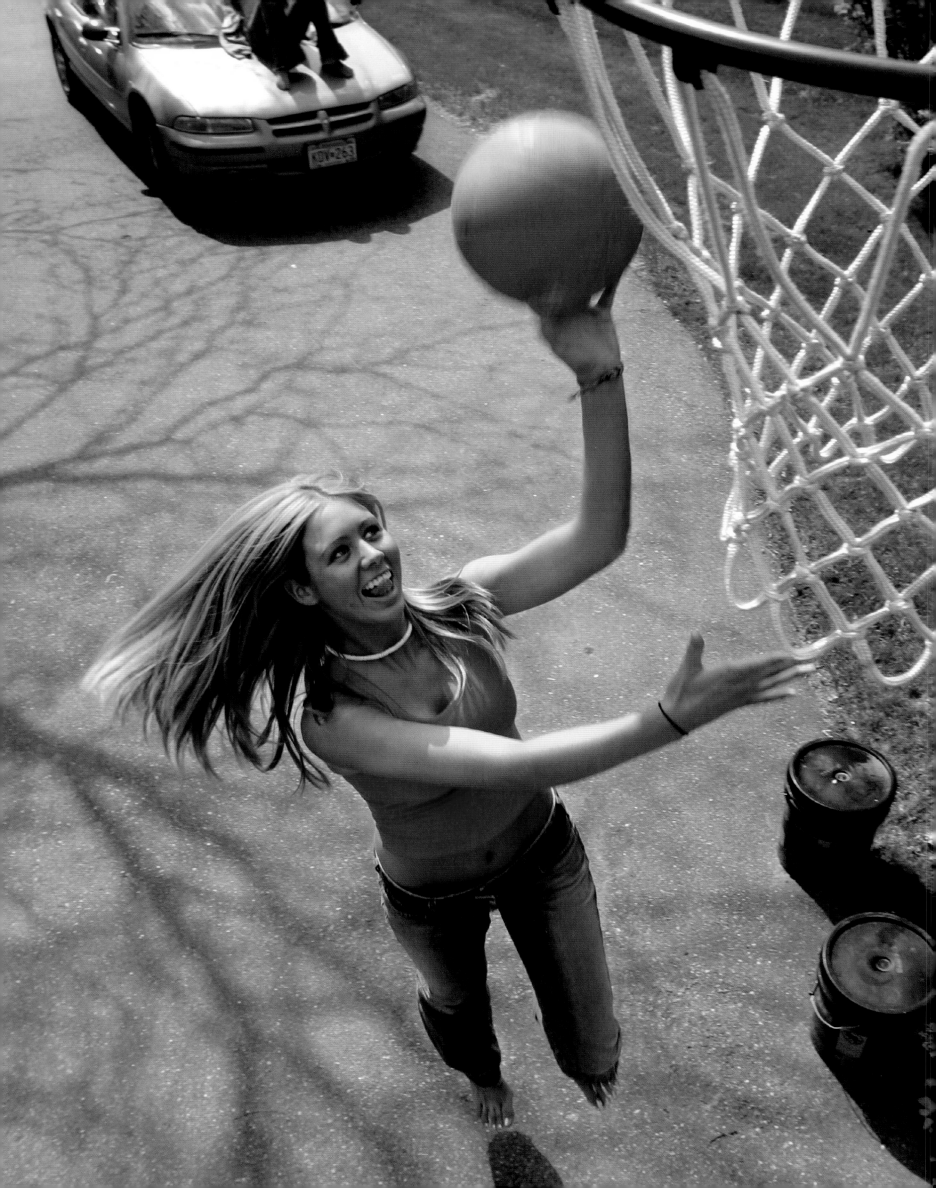

BURNSVILLE

Who says sports can't be glamorous? Not Alyssa Peterson, who practices her layup in designer jeans and with manicured nails. Alyssa, 16, is the co-captain of the Burnsville Blaze High School basketball team and a part-time scooper at her local Baskin-Robbins.

Photos by Brian Peterson,
The Minneapolis Star-Tribune

BURNSVILLE

With summer vacation weeks away and prom just passed, Sarah Peterson, 18, gets ready for another day at Burnsville Senior High School. Archaeologists may someday regard the posters, cards, and paraphernalia covering her walls as the equivalent of ancient cave paintings.

BURNSVILLE

Later that same day, Sarah makes evening plans with her friend Eric: Maybe basketball in the driveway, maybe hanging out at home, maybe a movie.

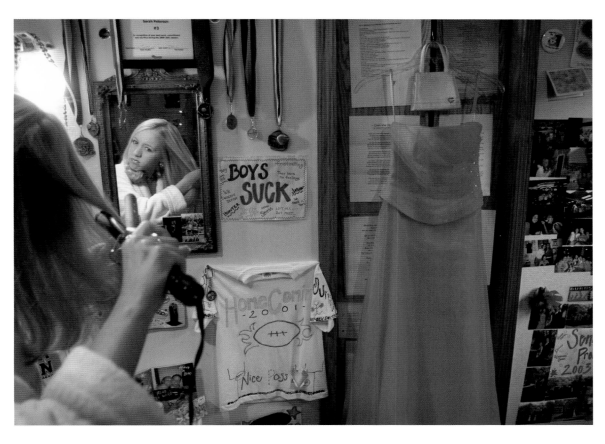

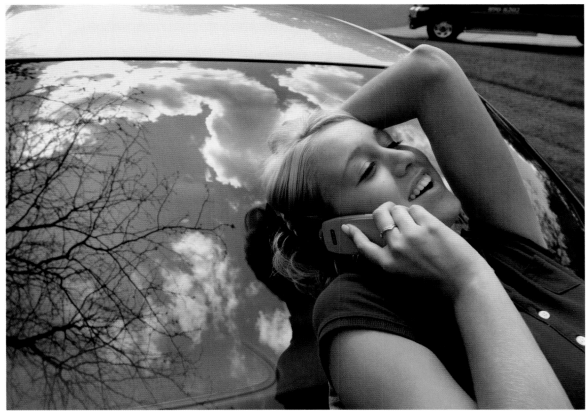

MINNEAPOLIS

On the first warm day in May, Cory Fett, owner of a marketing company, and his girlfriend Emily Lundell, a color tech at a hair salon, donned their summer wear for lounging in Phelps Park. Sharing the mood, Fett's husky Jasper plants a big wet one on Lundell.
Photo by Dawn Villella

MOORHEAD

Artist Sarah Regan Snavely walks her greyhounds Apollo, Kelly, Sterling, and Striker around the campus at Minnesota State University every evening. "The more they walk, the better night's sleep I get," she says.
Photo by Ann Arbor Miller

ROCHESTER

Rielly loves to bat Kati Cooley's glasses off her nose. "It's his favorite thing to do," says the college student. Because the cat is declawed, Kati doesn't worry about getting scratched.
Photo by Dean Riggott, www.riggottphoto.com

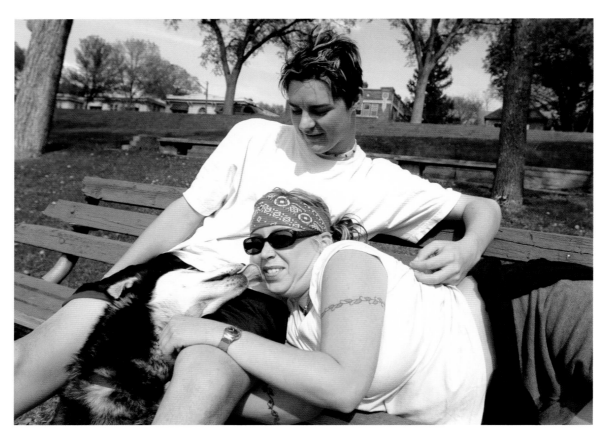

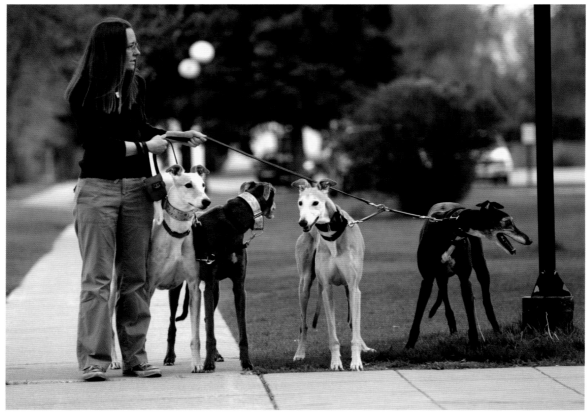

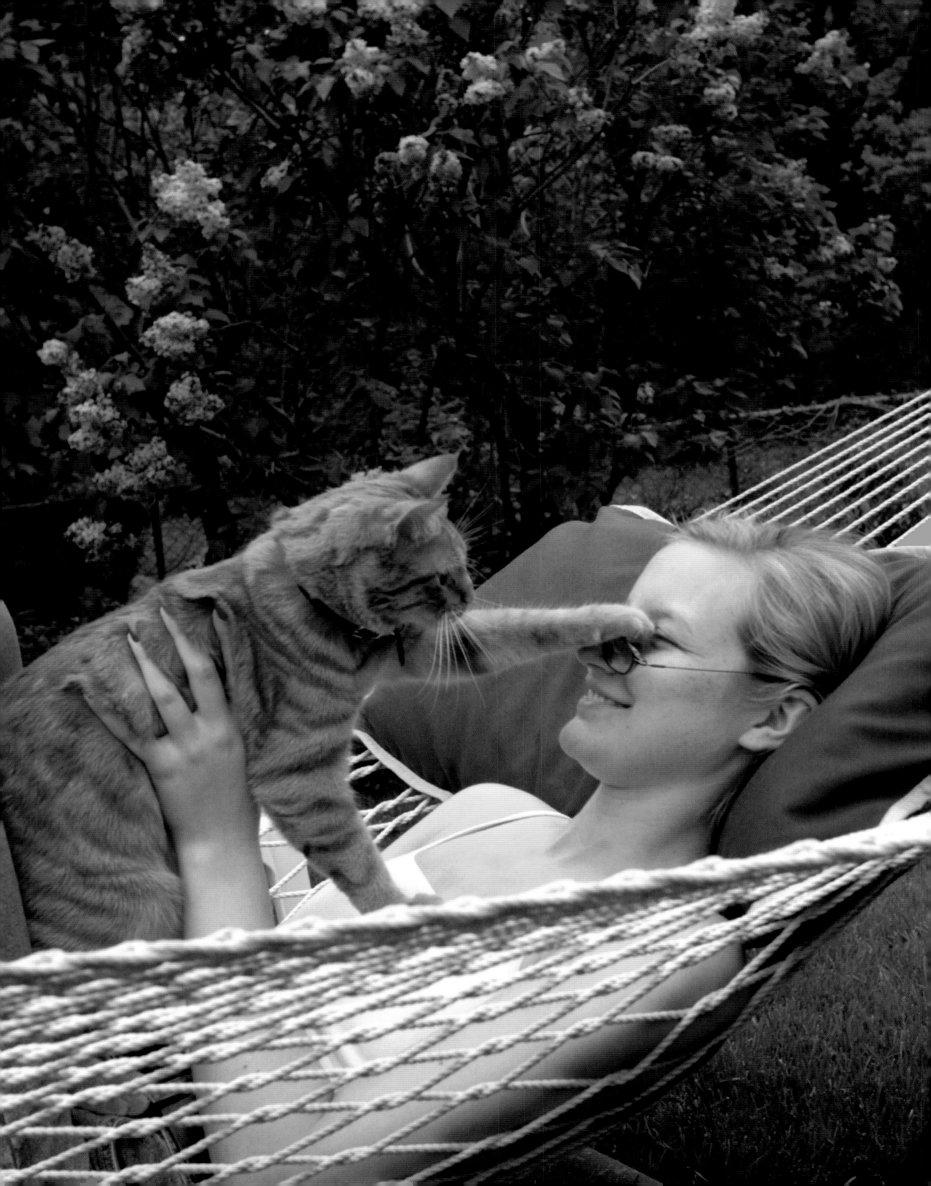

KRAGNES

Flower girl Juliet Tunberg has qualms about walking down the aisle in Charity Neighbour and Paul Treick's wedding. The ceremony, at a venue called the White House, was put together in 10 days, after another bride cancelled her reservation.
Photos by Ann Arbor Miller

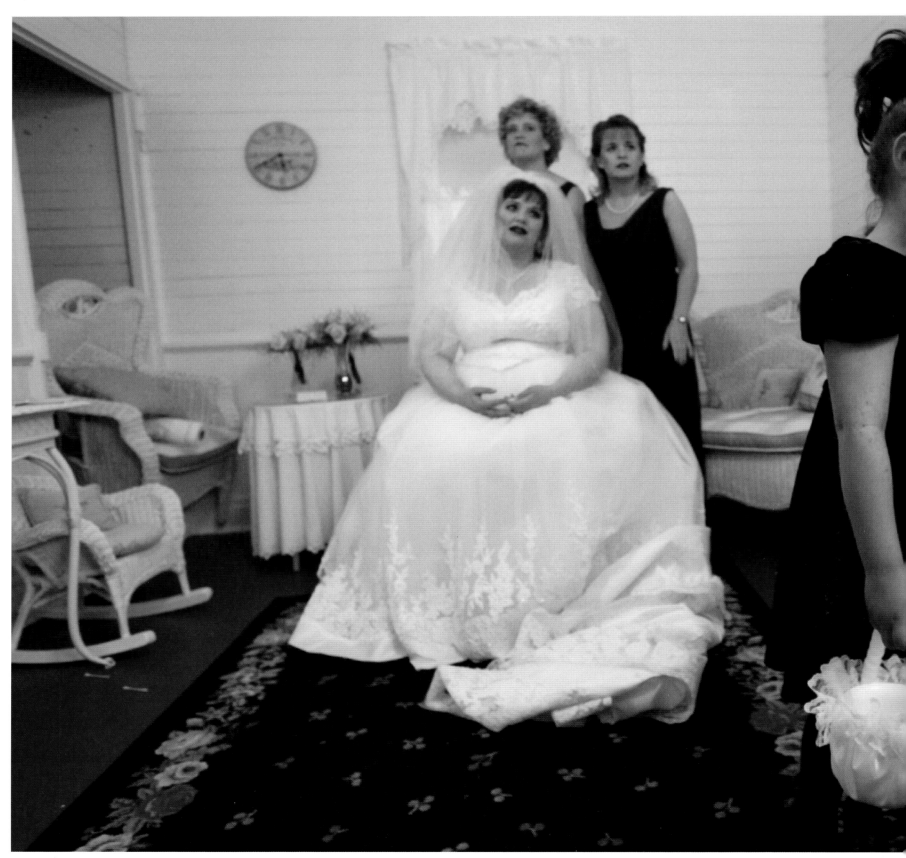

KRAGNES

Charity Neighbour's wedding gown hangs in the Bridal Cottage before the ceremony. Neighbour could not afford the $3,000 dress of her dreams. After praying long and hard, hoping to find a way to purchase it, she learned that the design had been discontinued—and cost only $399.

KRAGNES

Moments before entering the chapel, Neighbour adjusts the blusher of her veil. "I've waited my whole life for my fiancé," says the 38-year-old. "I'm doing this the right way."

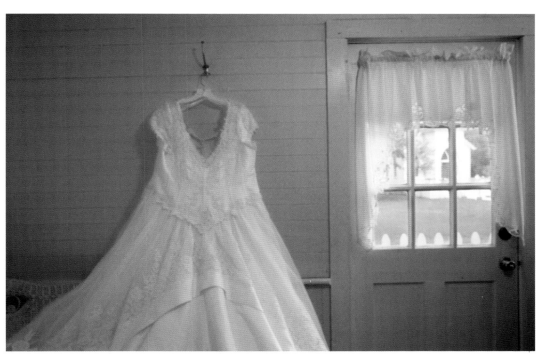

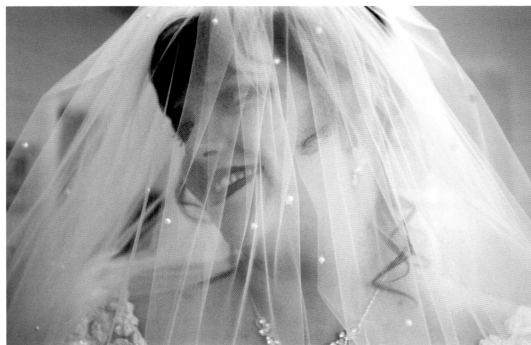

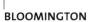

BLOOMINGTON

Separated by 800 miles and multiple marriages, Wisconsin high school sweethearts Barbara Schoepke and Daniel Stevenson had not seen each other for 20 years when Stevenson called to say he was still in love. On May 13, 2003, they married at the Chapel of Love in the Mall of America.

Photos by Richard Marshall

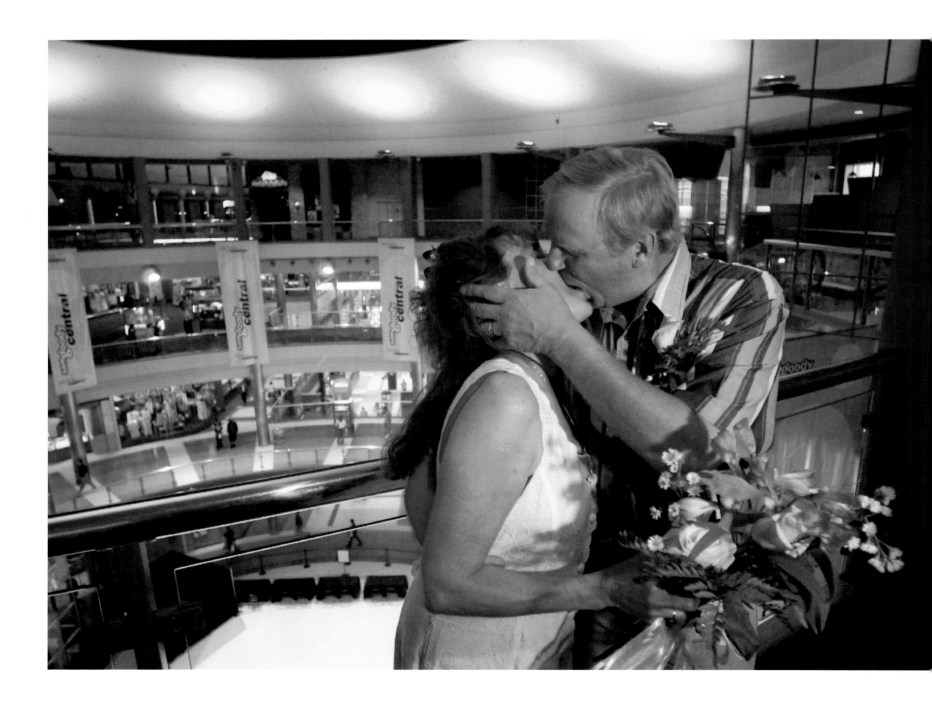

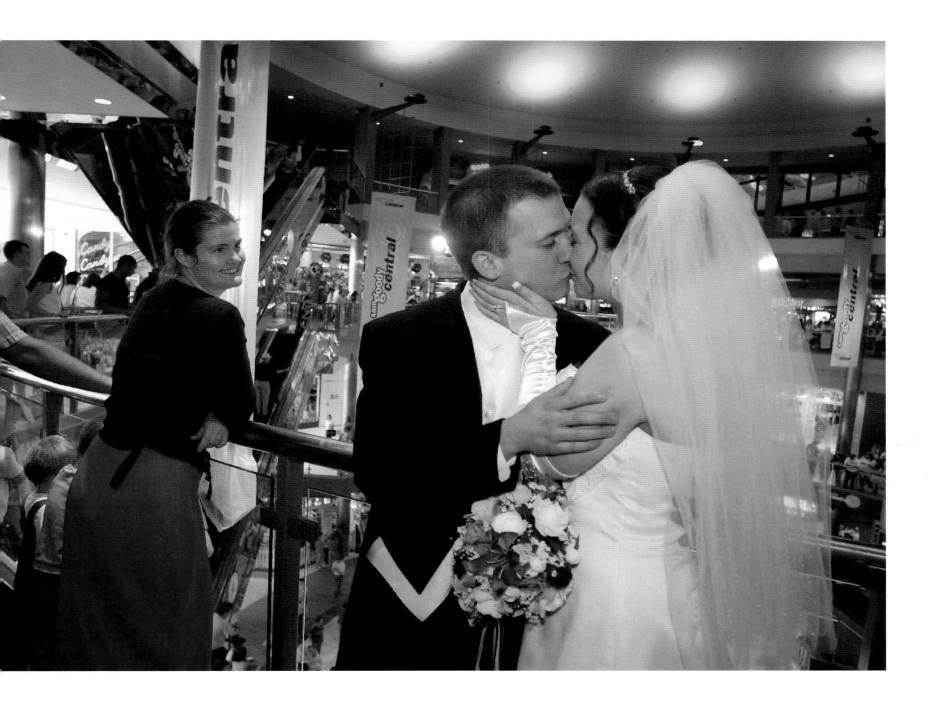

BLOOMINGTON

Newlyweds Jered and Kristin Stowell met four years ago at a party and began their courtship with window shopping at the Mall of America. Since the Chapel of Love opened in 1994 on the third floor of the mall, 4,000 couples have celebrated their nuptials here.

BLAINE

During the warm summer months, it seems like Mike and Kathleen Huey's garage door is always open. "It's nice and cozy," says Mike, who works as a mailman. "Kind of a hangout for the neighbors, who know that when the door's up, they can stop by for a brew."
Photo by Joel W. Sheagren

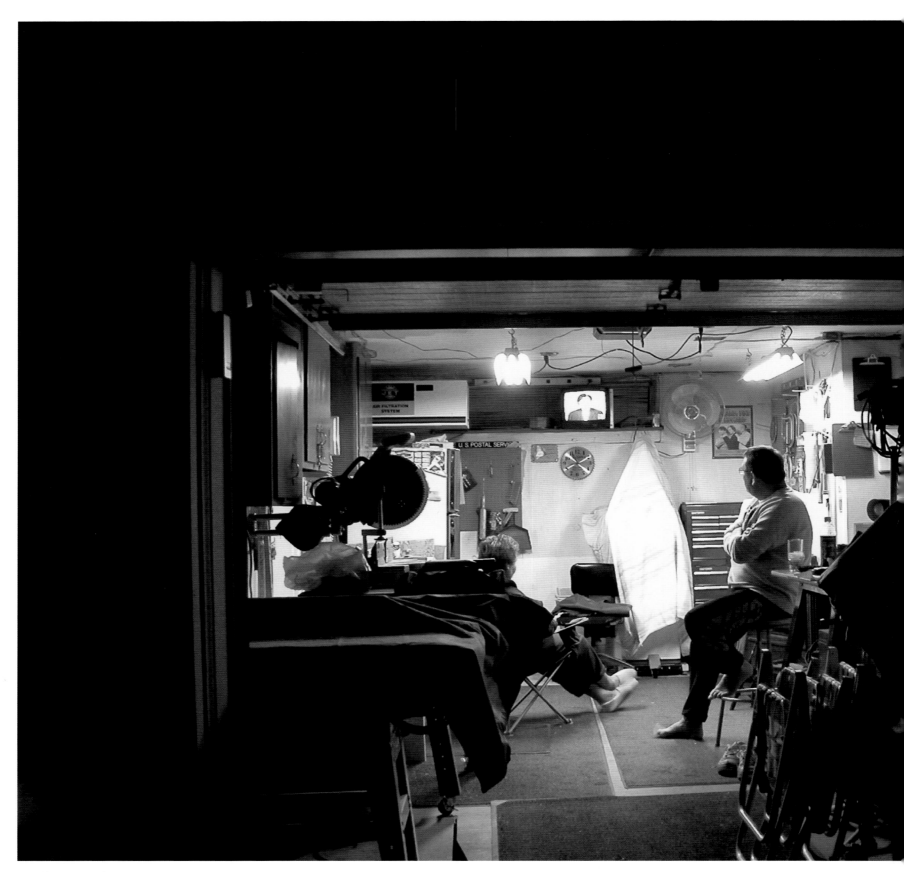

ST. PETER

Three years ago, Dick and Irma Lohrenz (at stove) decided to sell their house and hit the road full-time in a 36-foot Holiday Rambler motor home. They've never looked back—wintering in Texas, summering in Minnesota, and wandering wherever they please the rest of the year.

Photo by Ken Klotzbach

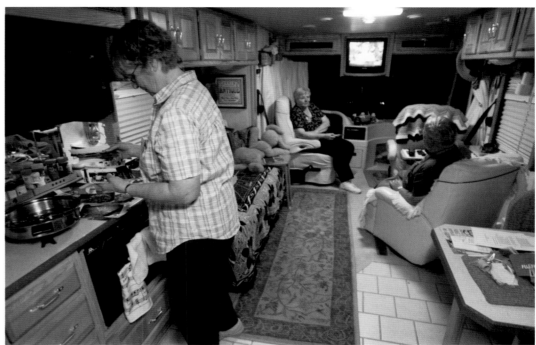

WYKOFF

Todd Juzwiak gets assistance from Atlas and Hercules on DreamAcres, his 60-acre organic farm in Fillmore County. He and his wife Eva Barr run a 35-member Community Supported Agriculture operation. Families in Rochester and Spring Valley pay an annual subscription fee and receive weekly deliveries of produce from late spring through early fall.
Photos by Christina Paolucci

WYKOFF

Stanley and Chester help their dad with the dishes. A small hand pump draws rainwater from an underground cistern, the source of the family's dishwashing and bathing water. Cooking and heating are also low tech: A stove burns wood that the oxen drag from the nearby forest.

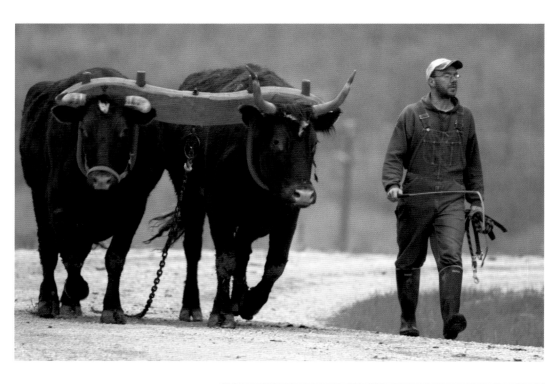

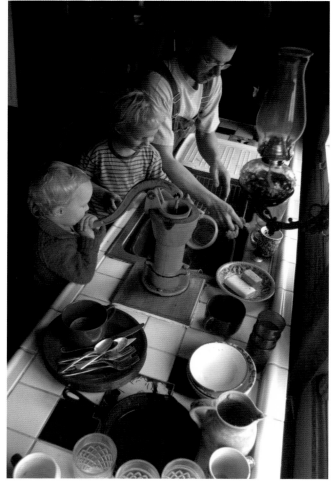

WYKOFF

A bedtime story by kerosene lamp is the norm at off-the-grid DreamAcres. Juzwiak and Barr traveled through Europe working on family farms before buying their own place in 1997.

The year 2003 marked a turning point in the history of photography: It was the first year that digital cameras outsold film cameras. To celebrate this unprecedented sea change, the *America 24/7* project invited amateur photographers—along with students and professionals—to shoot and, via the Internet, submit digital images. Think of it as audience participation. Their visions of community are interspersed with the professional frames throughout this book. On the following four pages, however, we present a gallery produced exclusively by amateur photographers.

WAITE PARK An only child just five months ago, Cody Johnson welcomed the arrival of his brother Jacob and now spends a lot of time admiring him. *Photo by Lisa Johnson*

NORTH MANKATO Chris Weber gets ready to hand off the baton to the next runner at the Garfield Elementary Fun Days race. *Photo by Les Weber*

FARIBAULT Five-year-old Sophia Osborne eyes her newborn brother with mixed emotions. Baby Aaron, it turns out, requires a *lot* of her parents' attention. *Photo by Richard Osborne*

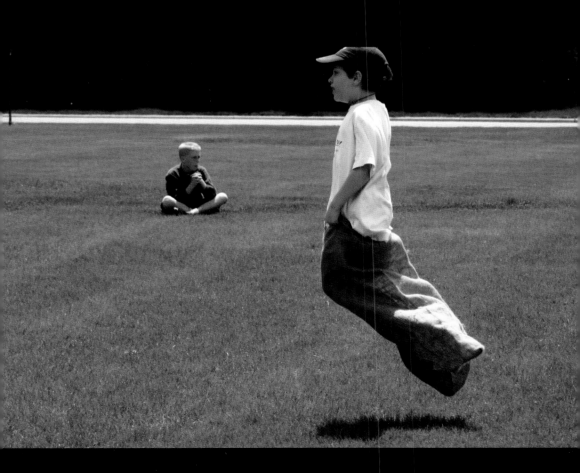

NORTH MANKATO At the Hoover Elementary School Fun Run, third-grader Zach Weber bounds across the grass

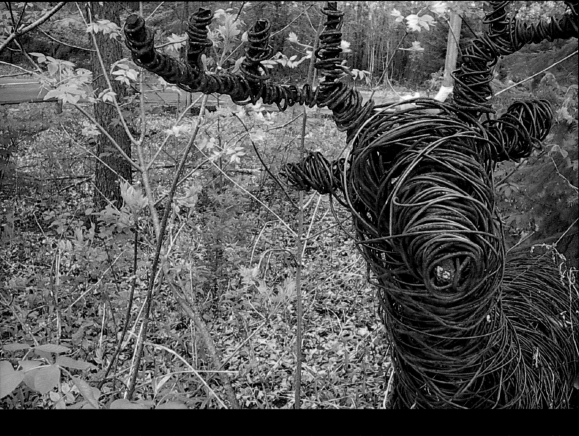

PRINCETON This deer won't eat the garden. *Buck*, a wire sculpture by local artist Russ Vogt, is a welcome addition to Mike and Bonnie Zurek's hobby farm. *Photo by Liz Zurek-Beaudry*

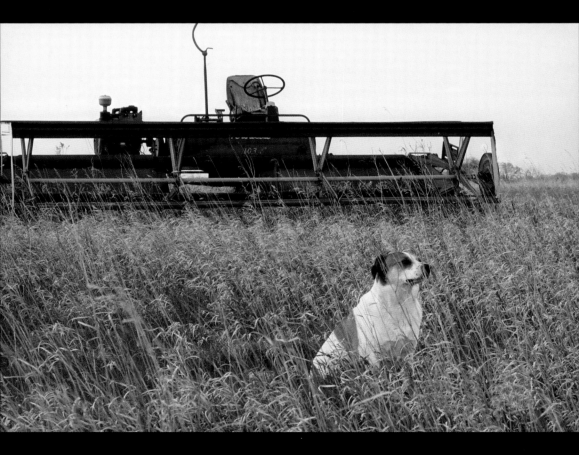

DETROIT LAKES Sadie likes to hang out behind the Kiehl farmhouse. Behind her is an old swatter (a mower) that no longer works. *Photo by Brenda Kiehl*

NEW MARKET TOWNSHIP Urban sprawl encroaches: An old shed is all that remains of a once-productive farm 30 miles south of Minneapolis. *Photo by James Bird*

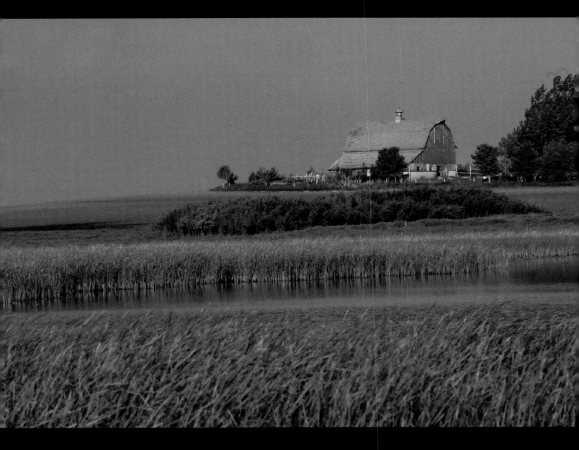

KEISTER Near the Iowa border, the morning sun sets freshly tilled fields on fire. *Photo by Ginger Baker*

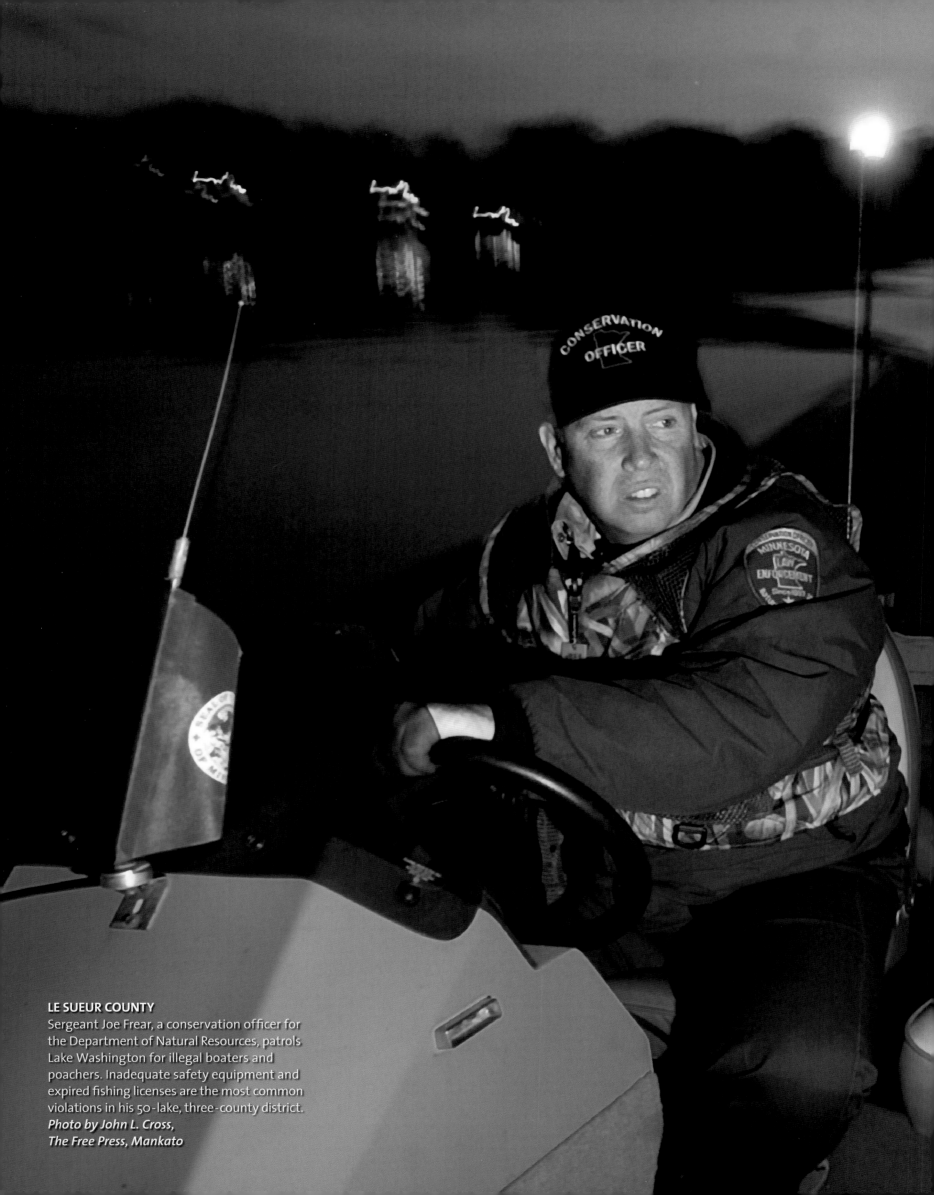

LE SUEUR COUNTY
Sergeant Joe Frear, a conservation officer for the Department of Natural Resources, patrols Lake Washington for illegal boaters and poachers. Inadequate safety equipment and expired fishing licenses are the most common violations in his 50-lake, three-county district.
Photo by John L. Cross,
The Free Press, Mankato

Hard At Work

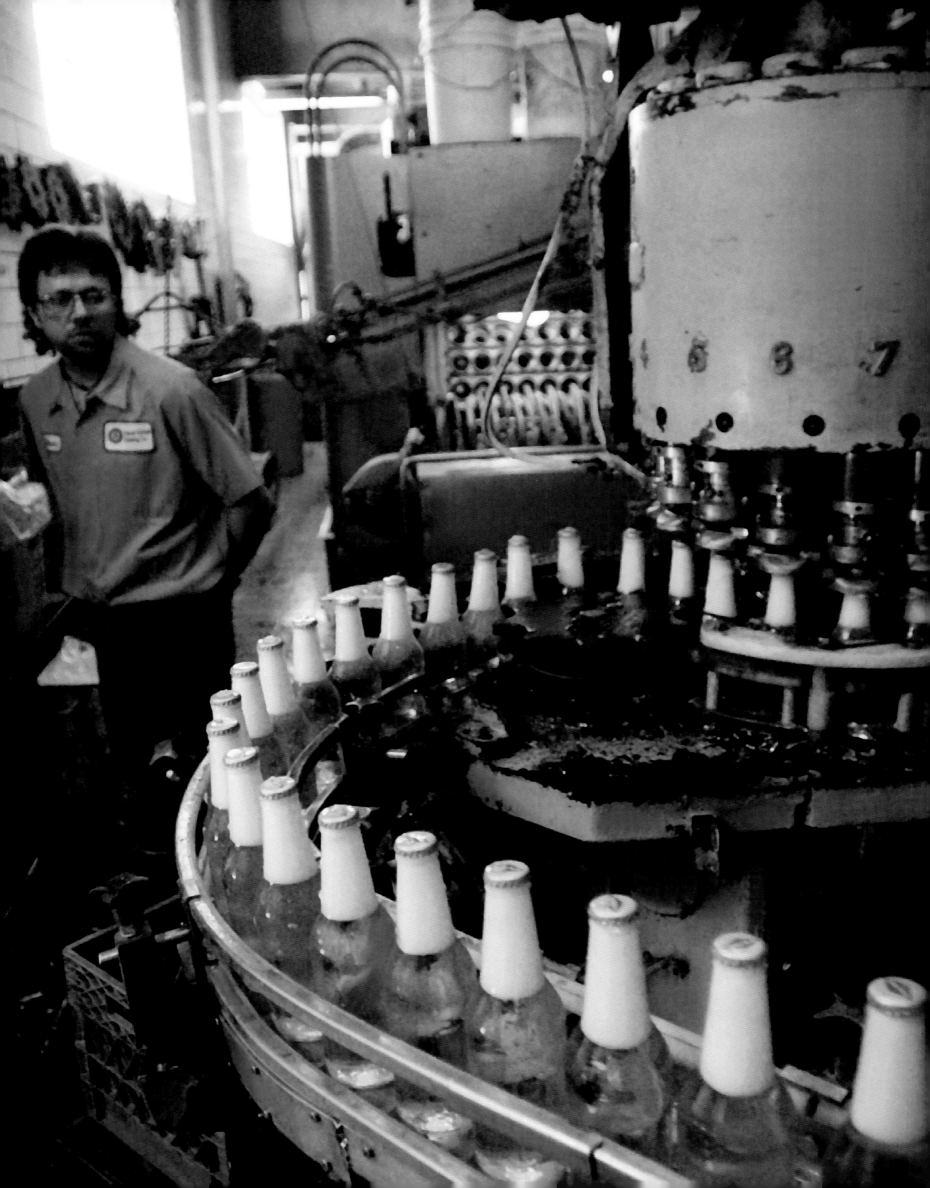

NEW ULM

Dan Gulden inspects bottles emerging from the crowner at the August Schell Brewing Company. Started in 1860 by a German immigrant dissatisfied with the quality of beer in New Ulm, the brewery is still run by the founder's offspring. It's the second-oldest family-owned brewery in the country.

Photos by John L. Cross,
The Free Press, Mankato

NEW ULM

Brewer Jason Miller checks on a batch of wort (a mixture of water, sugar, and malted grain) boiling inside a brew kettle. The sugar will later be converted into alcohol by the active yeast added for fermentation. A week later, a new batch of Grain Belt Premium will be ready for bottling.

NEW ULM

Roll out the barrels: Aluminum beer kegs await refilling and shipping to bars and restaurants throughout the upper Midwest. Schell's signature beer, Deer Brand lager, has been made here since the 1860s.

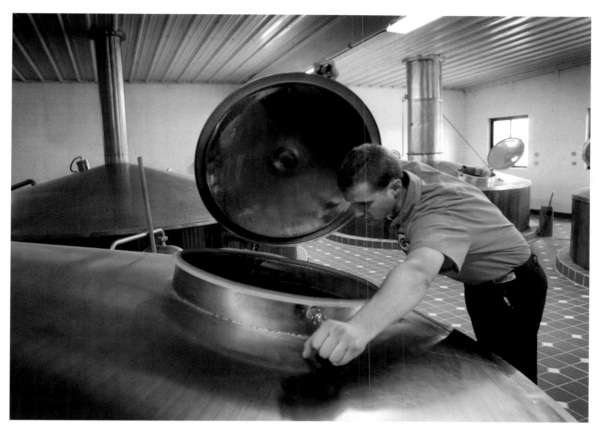

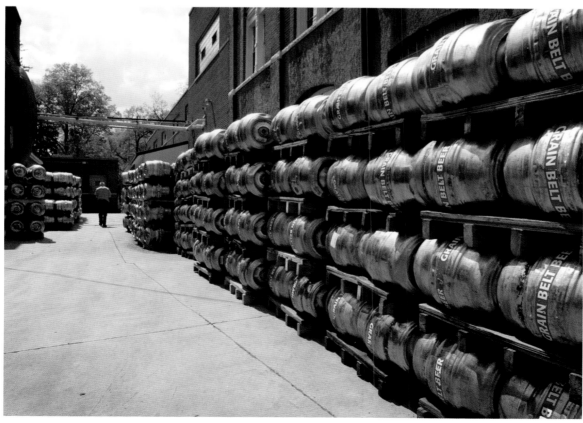

WOODSTOCK
Robert Kuiper guides the top section of a 230-foot wind turbine tower into place. The tower comes in three sections that are bolted together to support 46-foot rotor blades. The tower will join hundreds of others on Buffalo Ridge, a 62-mile swath of elevated land in southwestern Minnesota.
Photo by Ken Klotzbach

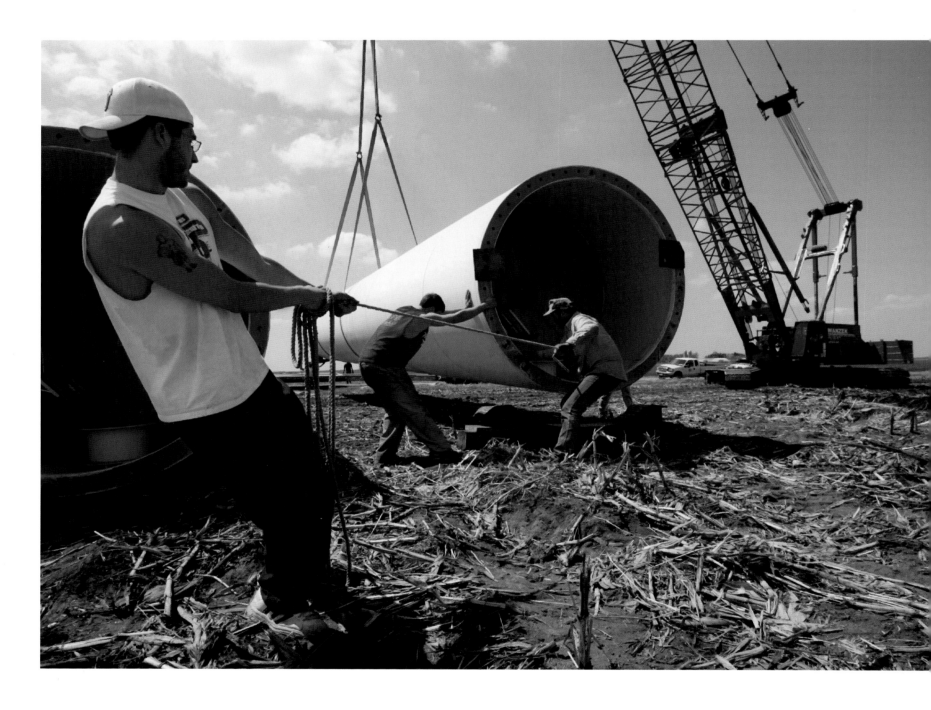

DULUTH

Colonists called them to action with shouts of "Men 'long shore." After this Lake Superior long-shoreman ties off the 21,000-ton bulk carrier *Federal Weser,* he will help load 850,000 bushels of North Plains grain bound for Spain.
Photo by Richard Hamilton Smith

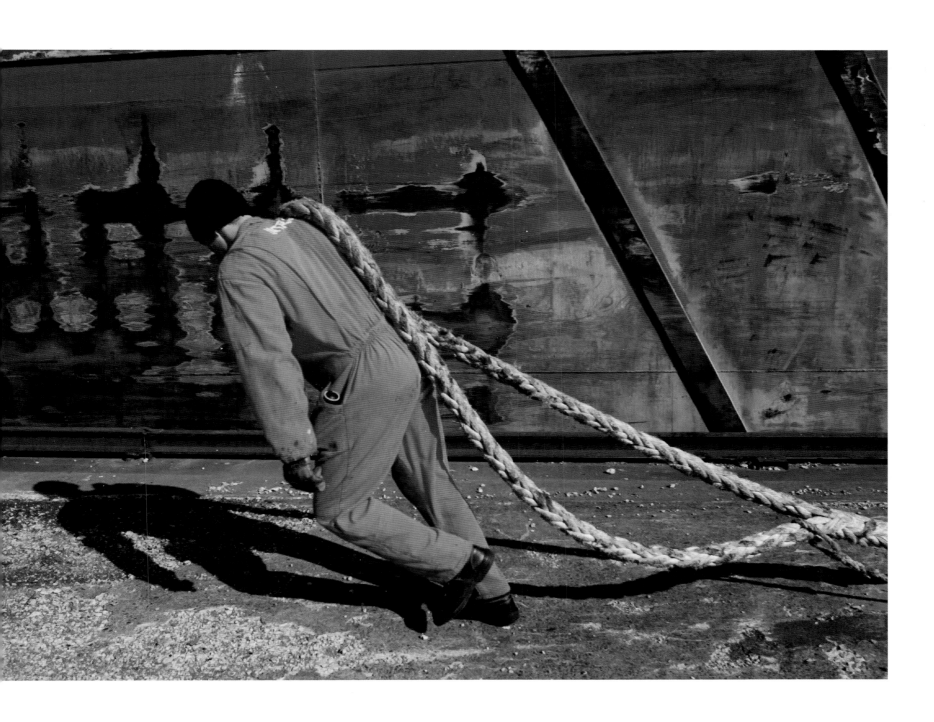

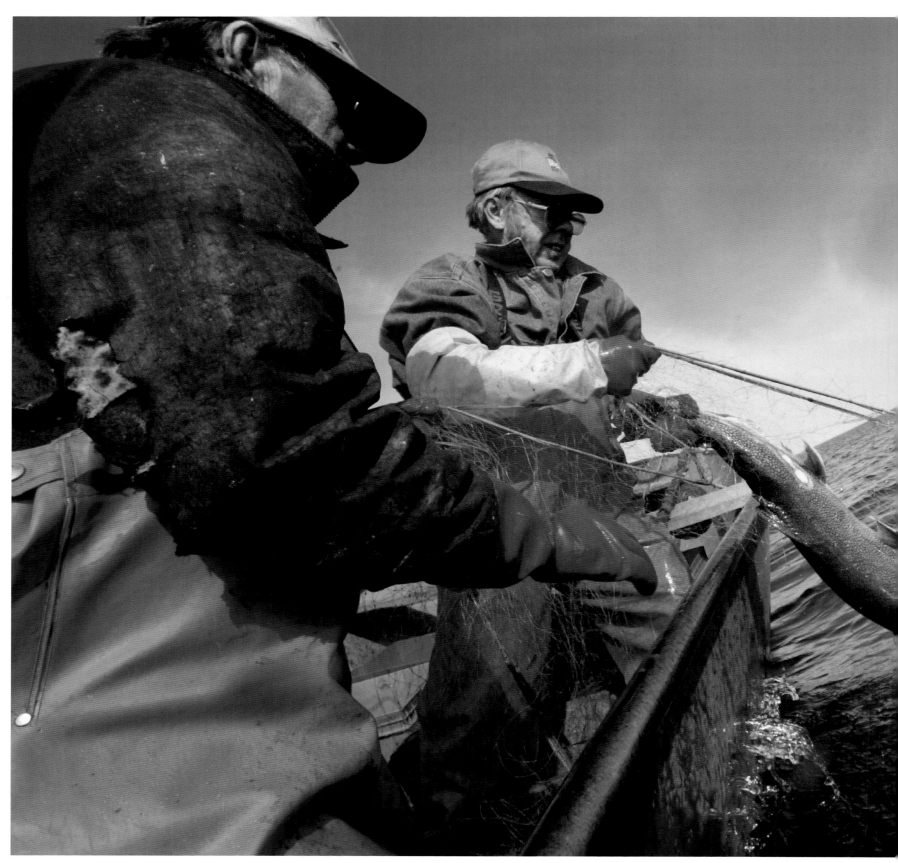

GRAND PORTAGE
Father and son Edward and Lloyd Hendrickson
haul in a Lake Superior trout that they will sell to
a market or restaurant. A crippling bone disease
in childhood prevented Lloyd, 81, from being hired
by one of Grand Portage's commercial fishing
outfits, so he set out on his own as a teenager.
He's been happily self-employed ever since.
Photos by Stormi Greener

GRAND PORTAGE

Earning a living on the lake and raising eight children have kept Fern and Lloyd Hendrickson busy for 64 years. The great-grandparents are beginning to slow down a bit, and they hope that their 61-year-old son Edward will eventually take the reins of the family business.

GRAND PORTAGE

Hendrickson works a second shift after a day of laying and hauling nets—checking for holes and repairing webbing. The long hours and hard labor are taxing, but he says he wouldn't choose any other profession. "I still love it, except, of course, for the overeducated idiots at the Department of Natural Resources who're destroying fishing and farming in this state."

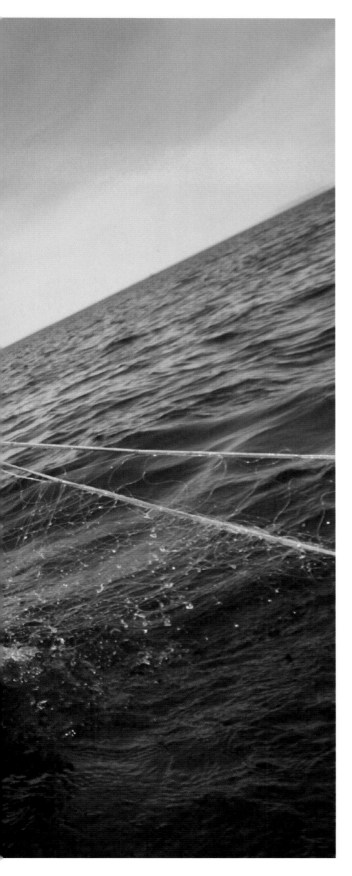

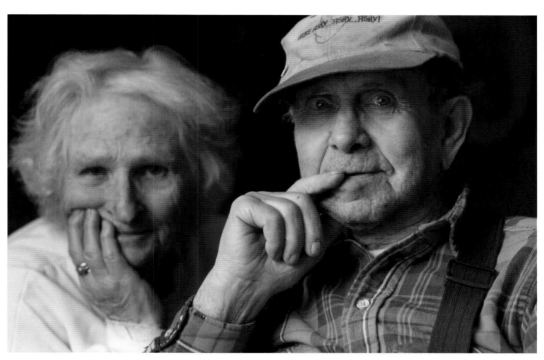

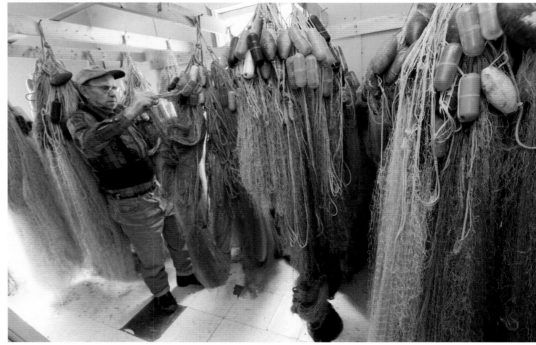

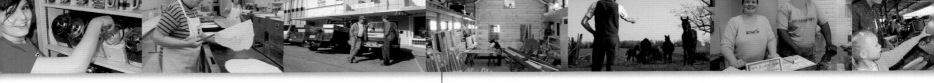

UTICA

Harley Yoder works on a custom-built log cabin at Hillside Log Homes. The Amish craftsman specializes in handmade, fully equipped houses of white cedar.

Photos by Dean Riggott, www.riggottphoto.com

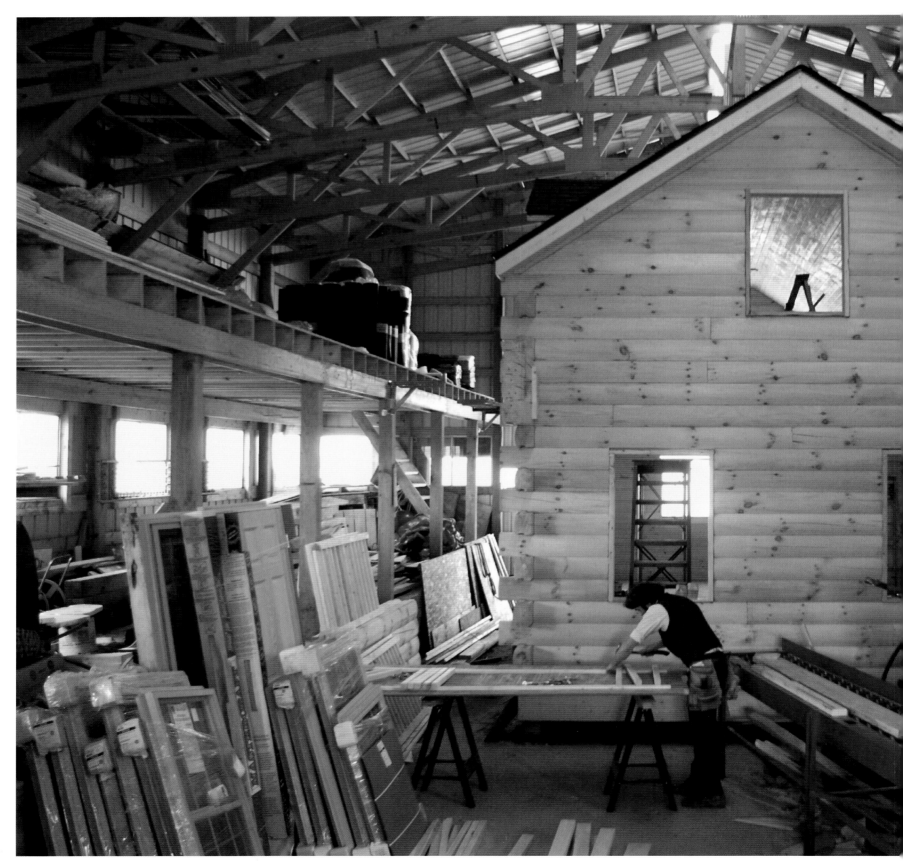

RUSHFORD

Donna James and Lorraine Tweten prepare *lefse*, Norwegian griddlecakes, at the Norsland Lefse factory. The traditional soft bread is made with Idaho russet potatoes, flour, vegetable oil, and salt, and it can keep for up to six months in the freezer.

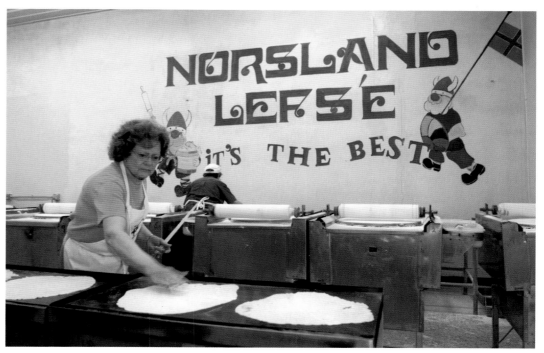

ROCHESTER

Helen Latvala Mitchell and her late husband Ben built the Log Cabin Grill in 1947 with cedar logs that he cut and hauled from the North Woods. Over the years, the couple added 15 motel units, now closed, to this trucker and tourist stop on the outskirts of Rochester. The two smiley faces are painted over 1940s-era Coca-Cola signs.

Photo by Christina Paolucci

ROCHESTER

After Ben passed away in 1996, chief cook and bottle washer Helen, 85, switched to shorter hours: 7 to 9 a.m. for breakfast; 3 to 4 p.m. for coffee. She still serves her famous homemade sourdough pancakes, but gone are the hickory-smoked bacon, pork chops, and chicken that Ben used to cure himself.

Photo by Christina Paolucci

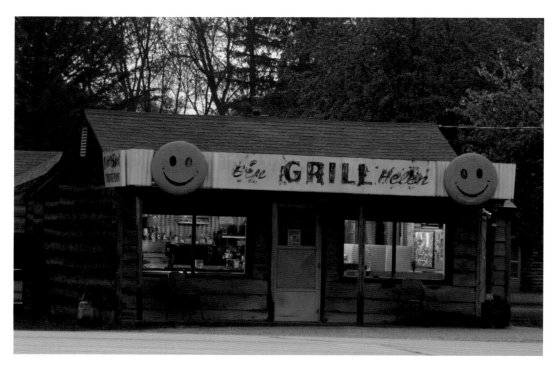

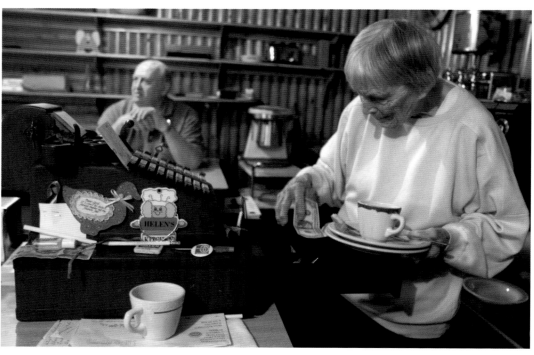

WATERVILLE

If it's 4 p.m. at O'Leary's, then that must be Robert Dusbabek and his moped. The retiree makes his rounds just about every afternoon, whether his vehicle needs gas or not, to shoot the breeze with one of his oldest friends, John O'Leary.

Photo by John L. Cross, The Free Press, Mankato

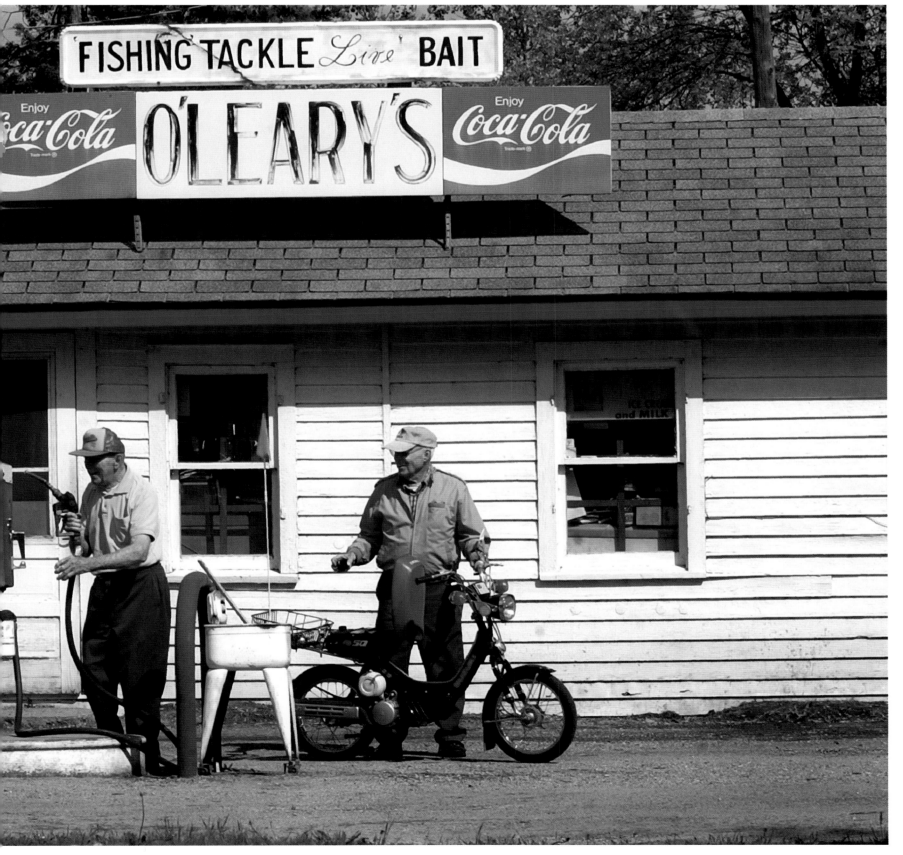

MELROSE

Officer Pedro "Pete" Ortega runs a driver's license check on a speeding motorist using the patrol car's computer. The native of Juarez, Mexico, hopes his position and bicultural background will help him bridge the gap between Melrose's burgeoning immigrant community and the town's more established white residents.
Photos by Kimm Anderson

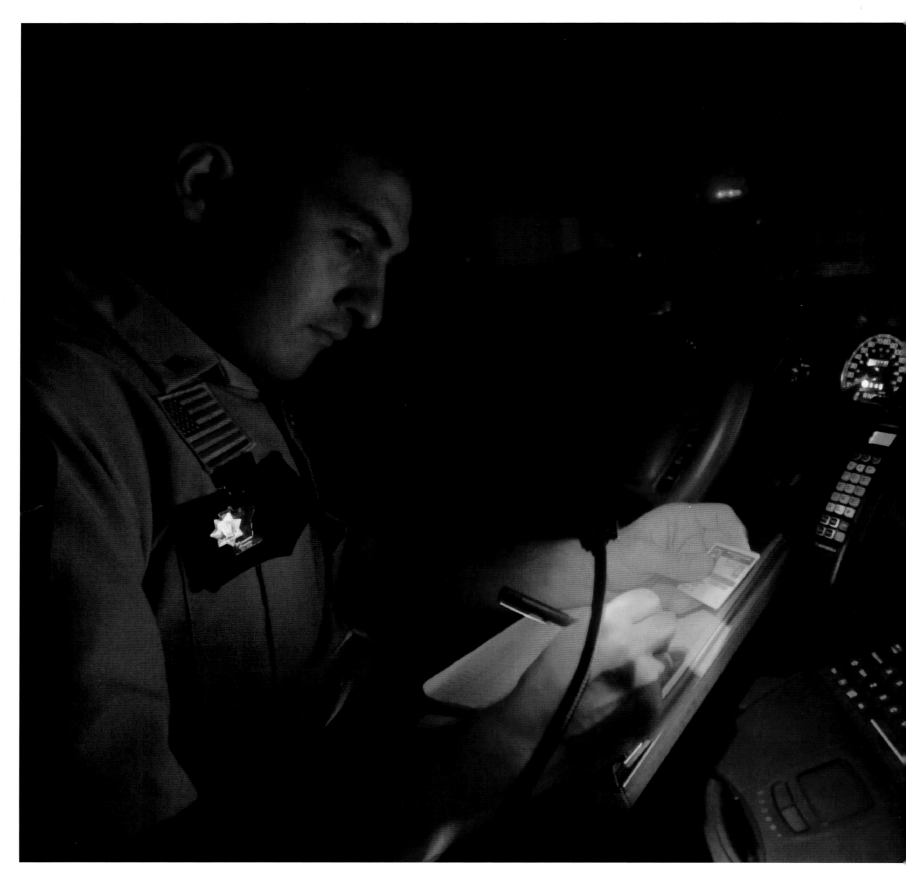

MELROSE

"I like that people look up to me and that I can help out my community," says Ortega of his career. Finding time for his second shift, parenting his three children, is a challenge. "It's hard to juggle it all," he says.

MELROSE

Residents of the Rose Park trailer community, a predominantly Hispanic neighborhood, crowd around Ortega's patrol car during one of his daily visits. Gifts of stickers and baseball cards have helped allay young residents' fears of law enforcement.

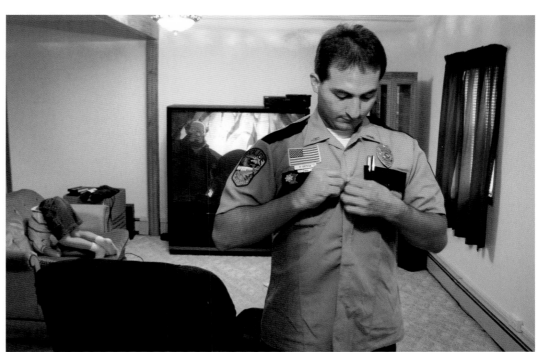

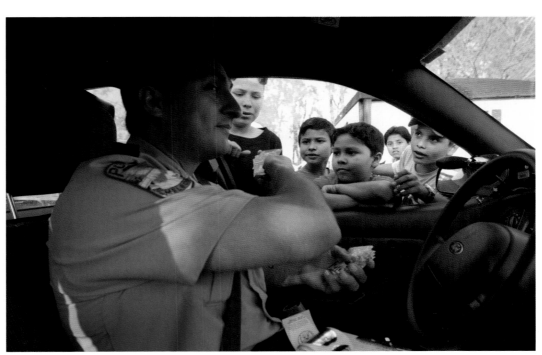

ST. PAUL

Gary Eichten, host of *Midday* on Minnesota Public Radio (MPR), moderates a discussion about early childhood development programs. Eichten is a founder of the innovative station, which went on the air in 1967. His news reporting and commentary are heard across the state and in Idaho, Michigan, and Iowa.
Photos by Thomas Whisenand,
The Minnesota Daily

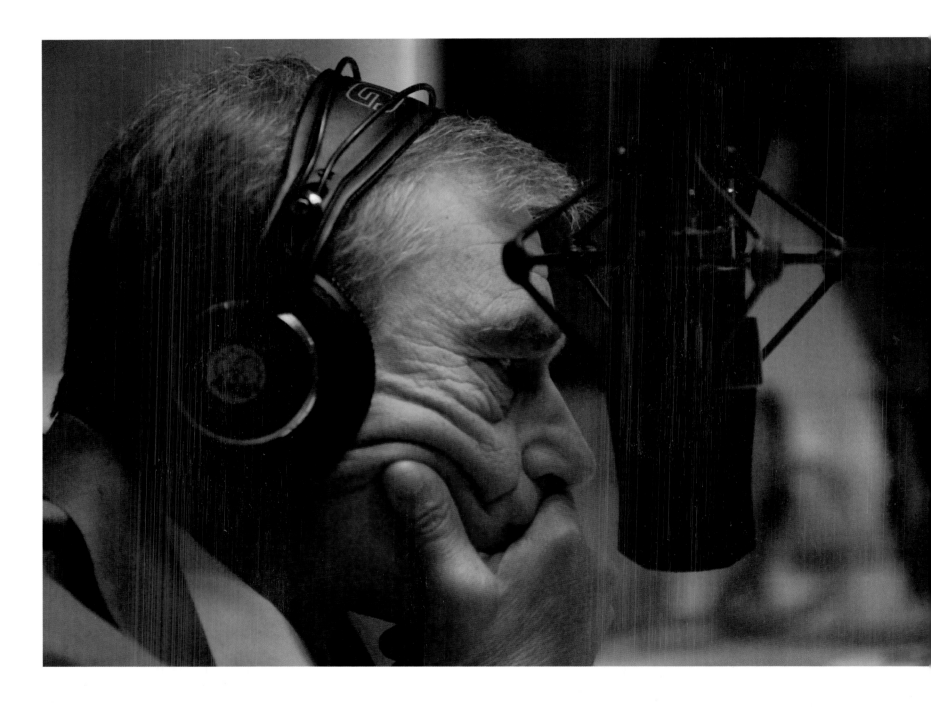

ST. PAUL

MPR Managing Editor Kate Smith listens to her colleagues during a morning editorial meeting. Smith works with the station's reporting staff. "We spend a lot of time staring at our navels, but we actually discuss the news, too," she quips. There's another daily meeting in the afternoon.

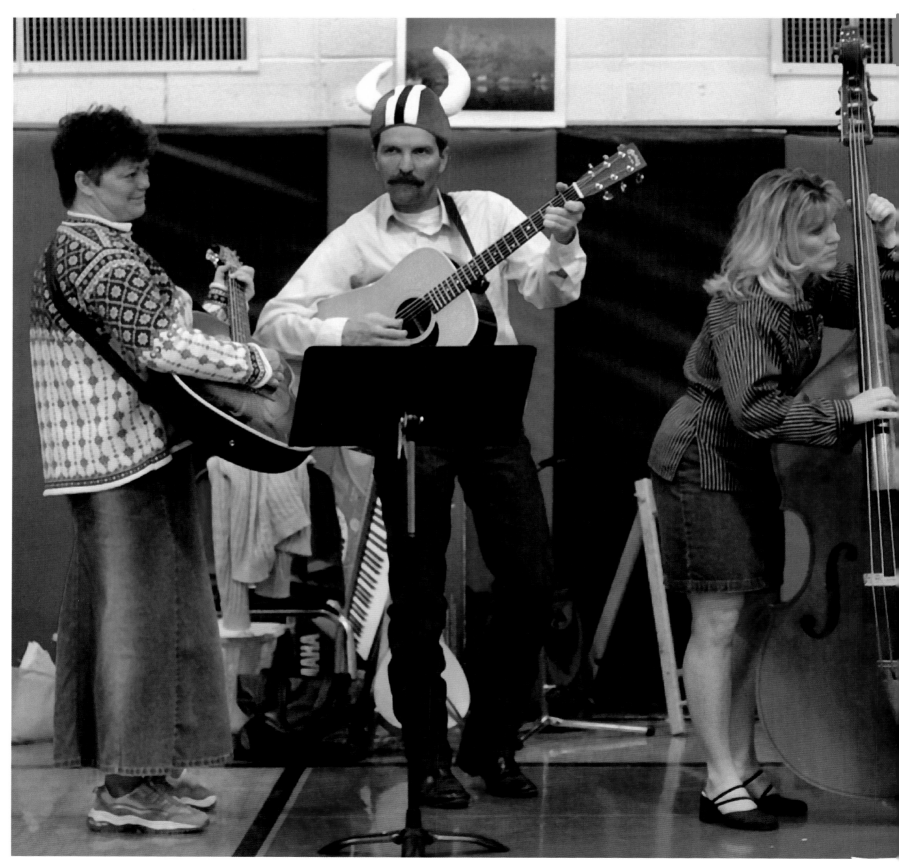

HENDRICKS
Members of the band Genus Poa (from the Latin name for bluegrass) strum and fiddle their way through Norwegian folk classic "Pal Pa Haugen." The group performs regularly at Syttende Mai, the annual Norwegian Independence Day celebration.
Photo by Joe Rossi

LANESBORO

Name that polka: Jan and Arv Fabian, along with Chris Gardner on button accordion, play old-time music at Das Wurst Haus. The Fabians opened the German deli in 1983 using Arv's family recipes for kielbasa, braunschweiger, and root beer. They've since sold the business to Gardner but stay involved in all things culinary and musical.
Photo by Dean Riggott, www.riggottphoto.com

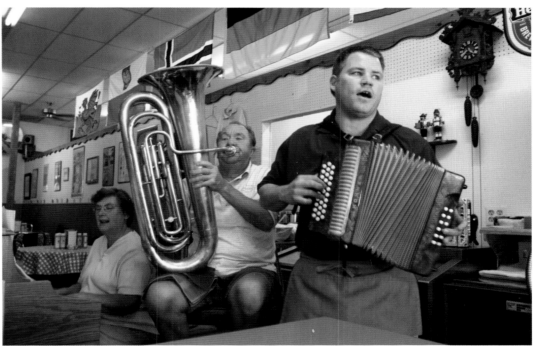

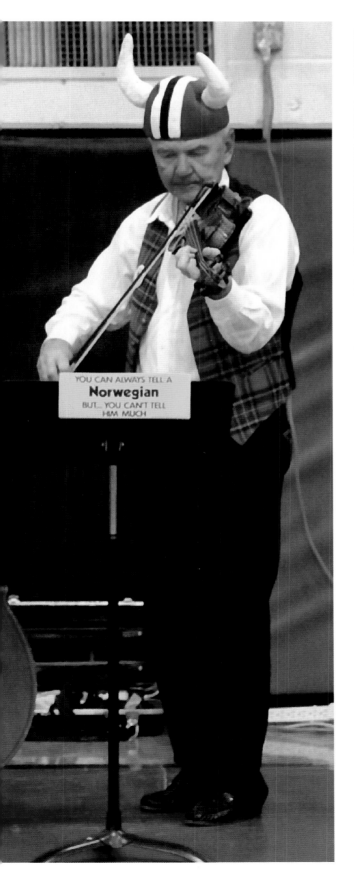

YOU CAN ALWAYS TELL A
Norwegian
BUT... YOU CAN'T TELL
HIM MUCH

MINNEAPOLIS

When he bought the Lyn-Lake Barber Shop in 2000, Jayson Dallman set about modernizing the 1960s salon. He decorated the walls with works by local artists and installed high-tech lighting. In addition to the traditional buzz cut, perfected here on old-timer Dan Morgan, Dallman now offers dreds and dye jobs.

Photo by Dawn Villella

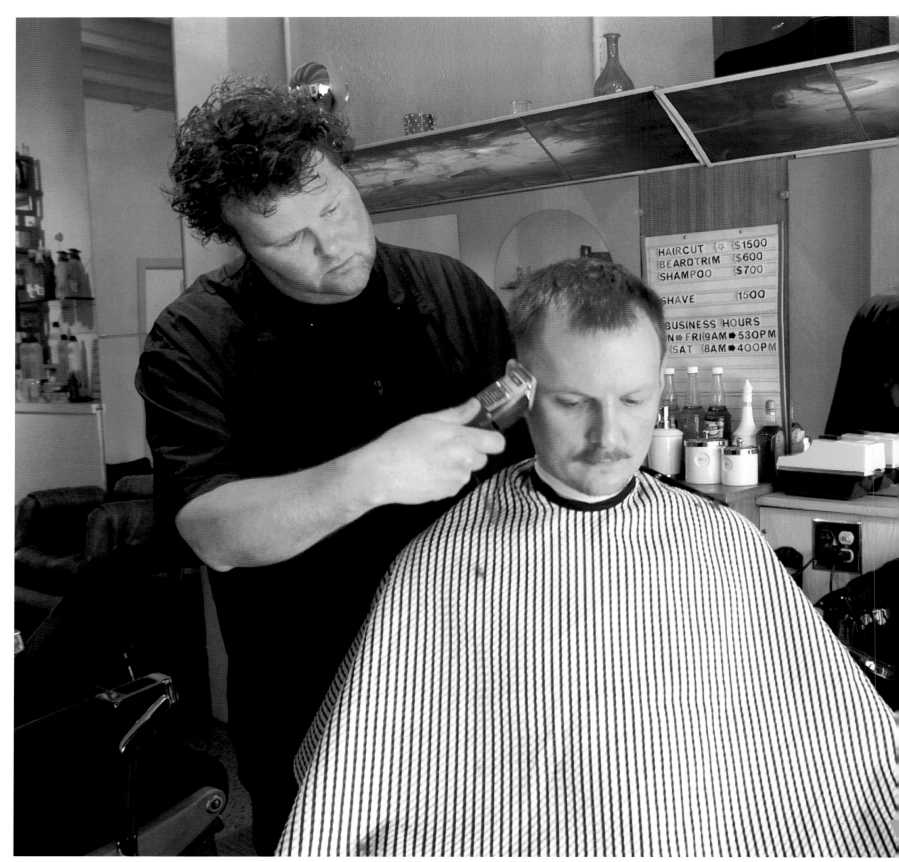

CLIMAX

Loren Wegge, the "yodeling janitor," took the job at Climax-Shelly School after the regular janitor got called up for National Guard active duty. A retired farmer, Wegge makes the seven-mile trip across the Red River each day from his home in Buxton, North Dakota. He first yodeled in his silo, where he liked to sing because of the echo.

Photo by Ann Arbor Miller

AFTON

Don Riggott has been a dealer in religious antiquities since the late 1970s, specializing in Catholic liturgical artifacts. His sources for monstrances, reliquaries, and ciboria, which he stores in his old granary, are churches that merge or are being renovated. "For me," he says, "it's like treasure hunting."

Photo by Dean Riggott, www.riggottphoto.com

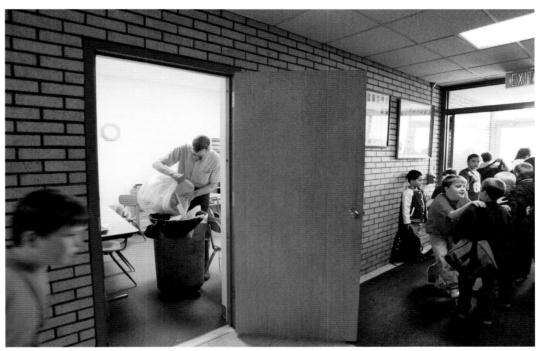

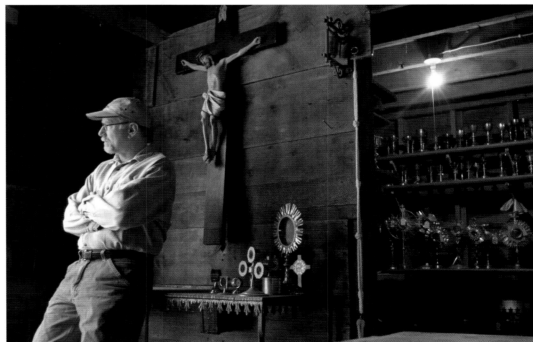

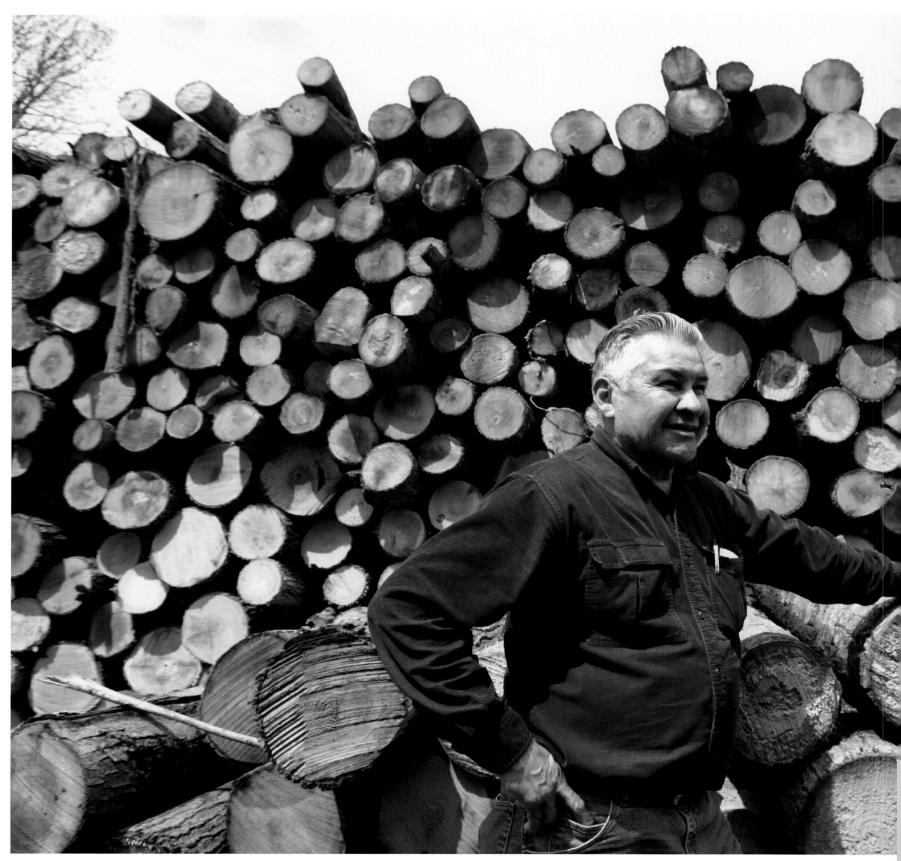

MILLE LACS INDIAN RESERVATION
Leonard Sam, a Department of Natural Resources agent for the Mille Lacs Band of Ojibwe, stands in front of freshly cut timber. The Ojibwe reservation has a casino on it, but the timber harvested from its dense stand of central Minnesota forest offers an extra source of revenue and raw material for housing.
Photo by Andy King

SUPERIOR NATIONAL FOREST

Former logger Ollie Thums takes a break from his duties at the Isabella Lake parking lot. A few years ago, the woods ran out of trees that he could legally cut down, so now he works for the Forest Service clearing the parking lots and trails.

Photo by Richard Hamilton Smith

OWATONNA

From 1886 to 1945, the Minnesota State Public School for Dependent and Neglected Children was home to 10,946 orphans. Of those, 198 are buried in numbered graves in the orphanage's cemetery. An Owatonna city worker places personalized boards inscribed with memorials to the dead on the walkway from the parking lot to the cemetery.

Photo by Renée Jones, Owatonna People's Press

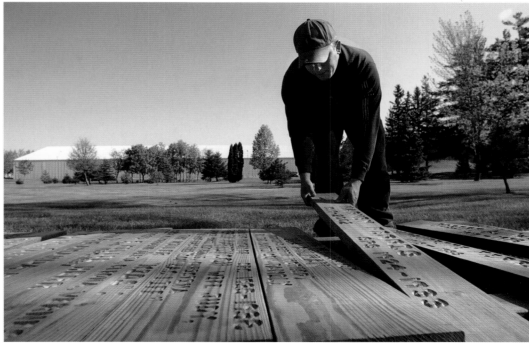

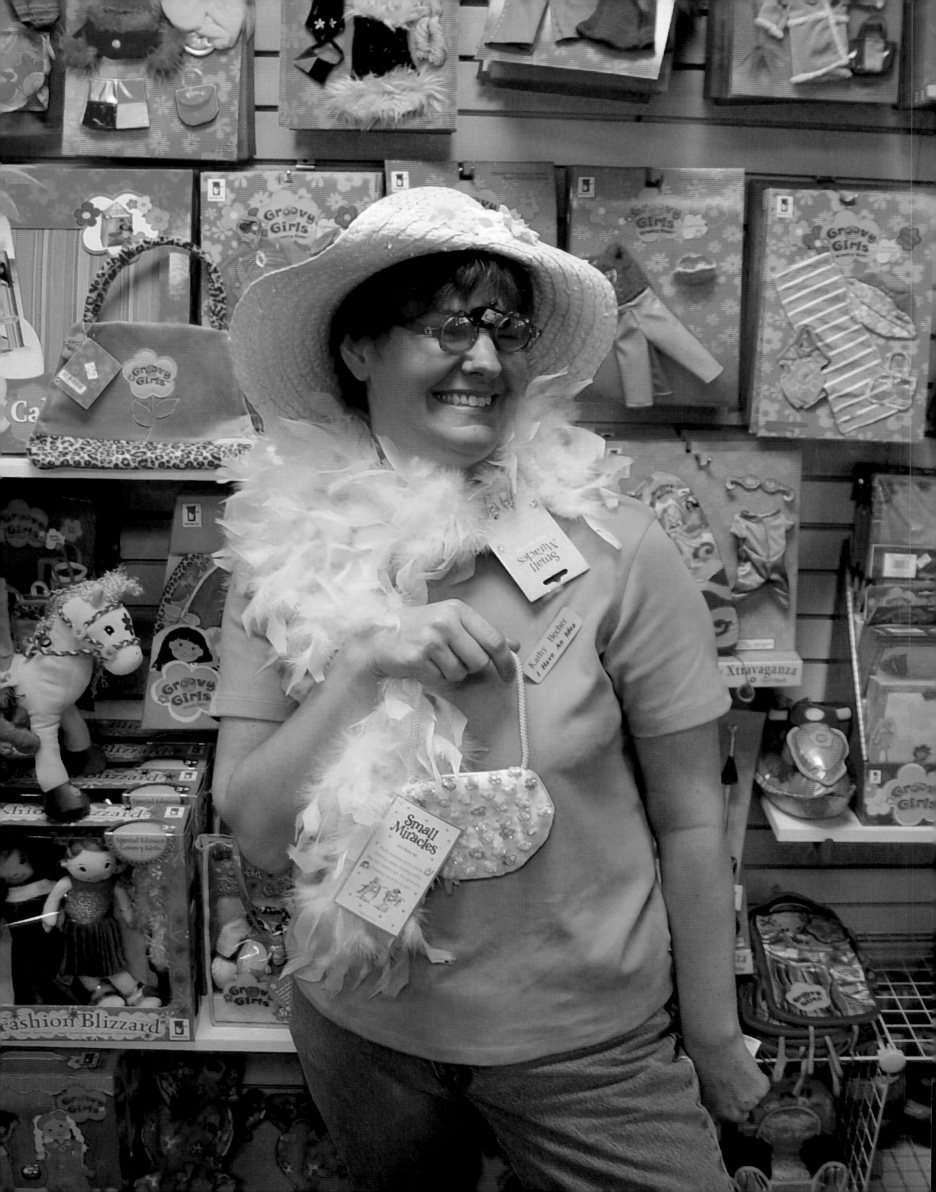

WINONA

Time Out toy store owner Kathy Becher plays dress-up by the Groovy Girl doll display.
Photo by Julie Geiger-Schutz

MINNEAPOLIS

In her showroom, designer Joy Teiken pins an embroidered silk bridesmaid's dress. At 19, Teiken made her first piece of clothing, a hat for her mother, who was dying of cancer. Twelve years later, remembering how beautiful and at peace her mother looked in the hat, Teiken launched her Joynoelle clothing line, which includes hats, handbags, and dresses made out of new and vintage fabrics.
Photo by Dawn Villella

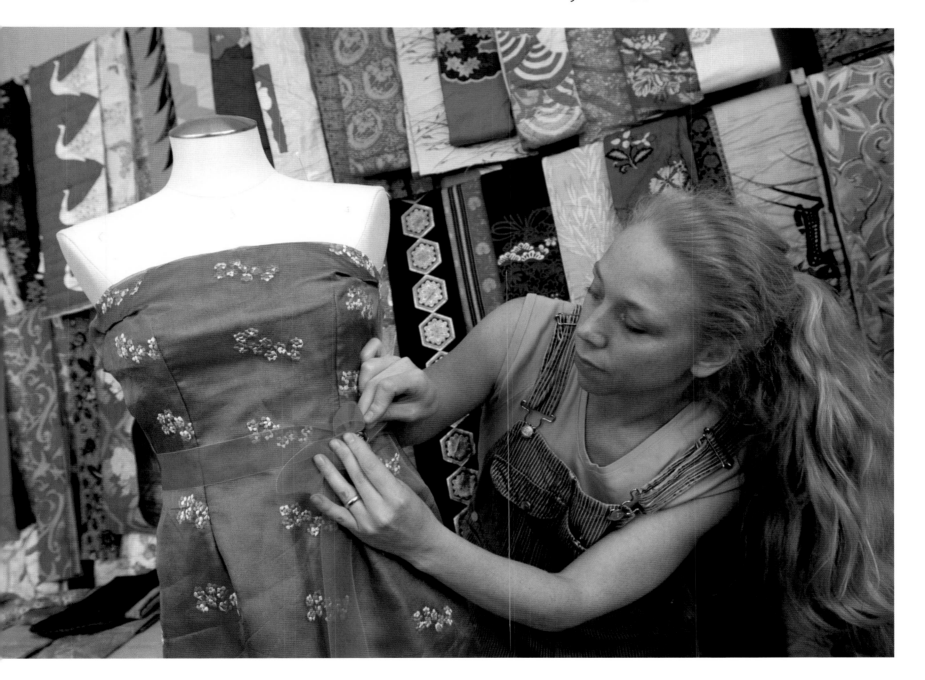

ROCHESTER
At Saint Marys Hospital, Dr. Dana Thompson (seated) and her team examine a patient with respiratory problems. Thompson is an otorhino-laryngologist (an ear, nose, and throat doctor) specializing in pediatric surgery.
Photos by Dean Riggott, www.riggottphoto.com

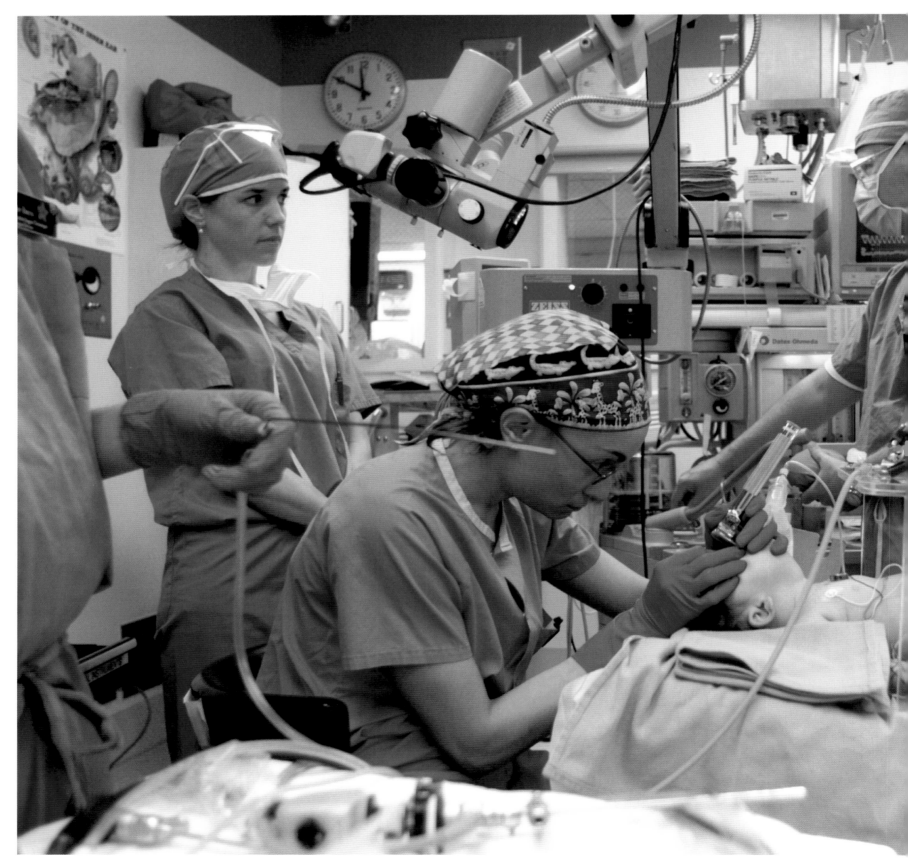

ROCHESTER
Dr. George Bartley and Dr. Dana Thompson have snacks in a break room at Saint Marys Hospital. The hospital is part of the Mayo Clinic, which also has locations in Florida and Arizona.

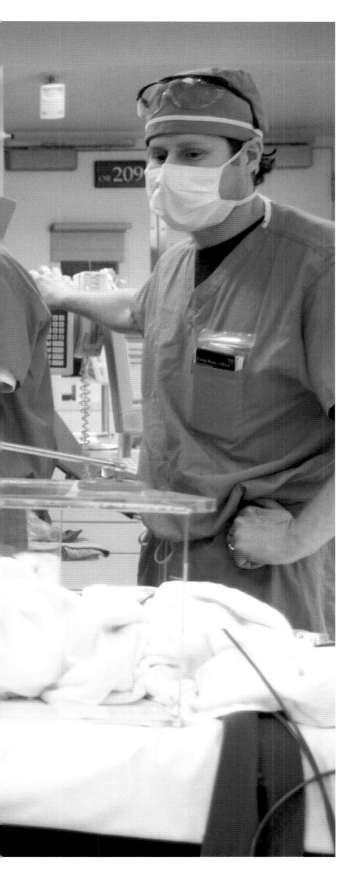

MOORHEAD

At Nails Pro, Charity Neighbour admires nail stylist Brian Nguyen's handiwork. It's her wedding day, and only a French manicure will do.
Photo by Ann Arbor Miller

GOODRIDGE

Lawrence Boutain fills his portable cattle feeder with rolled corn at the Farmers Cooperative Creamery Association. Minnesotans love their co-ops, which collectivize the buying and selling of wheat, health care, gasoline, telecommunications, and other commodities.
Photo by Thomas Whisenand,
The Minnesota Daily

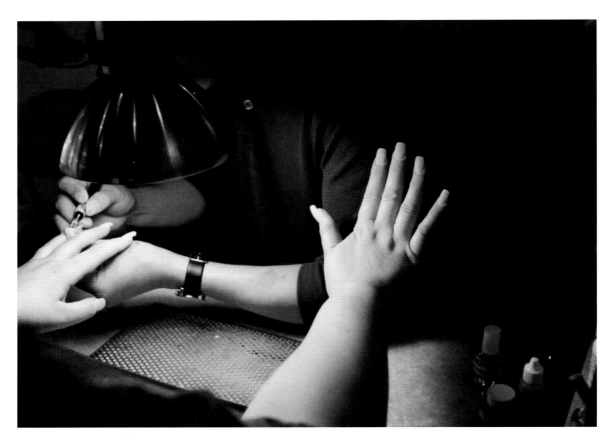

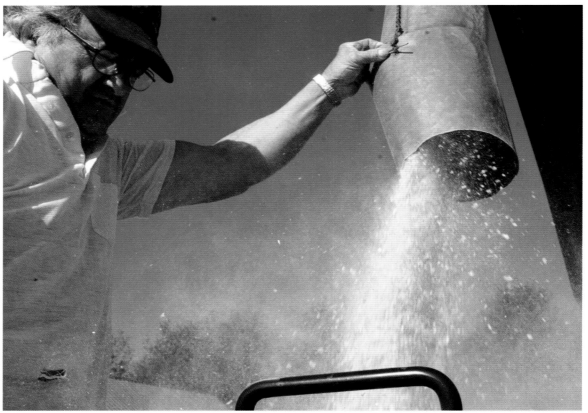

GOODRIDGE

At the town's only gas station, recent hire Jeremy Nelson removes a truck tire from its rim the old-fashioned way, with elbow grease and a pick ax.

Photo by Thomas Whisenand,
The Minnesota Daily

MINNEAPOLIS

In his historic Warehouse District studio, stained-glass artist Michael Watts works on a church window restoration. He blends powdered glass paint with water and gum arabic, creating a mixture he will brush onto the glass and stipple away for the desired effect. "It's like a reverse drawing process," he explains. "Instead of adding shadow, you add light."

Photo by Raoul Benavides

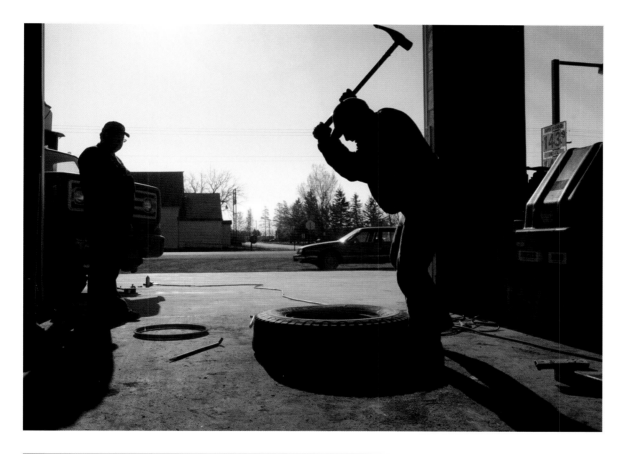

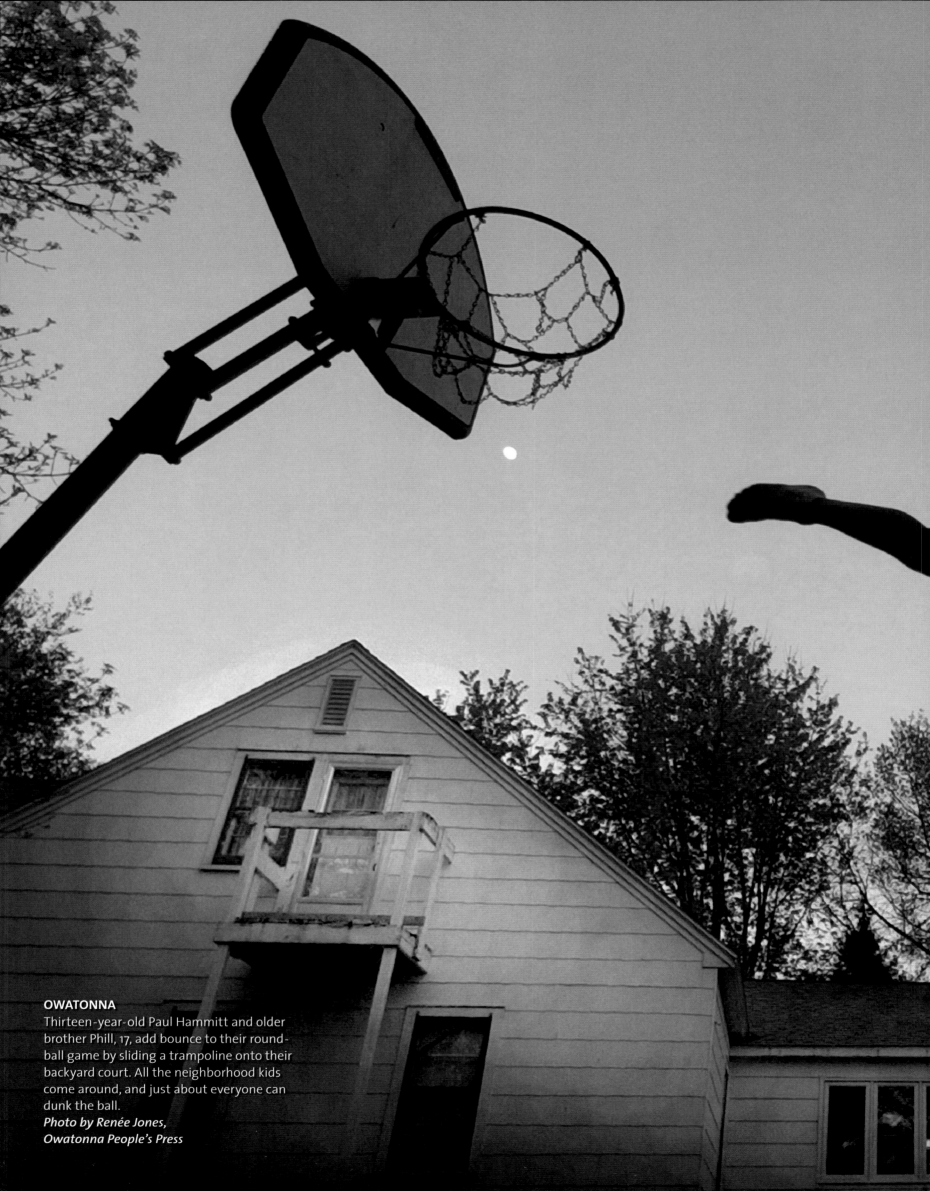

OWATONNA
Thirteen-year-old Paul Hammitt and older brother Phill, 17, add bounce to their round-ball game by sliding a trampoline onto their backyard court. All the neighborhood kids come around, and just about everyone can dunk the ball.
Photo by Renée Jones,
Owatonna People's Press

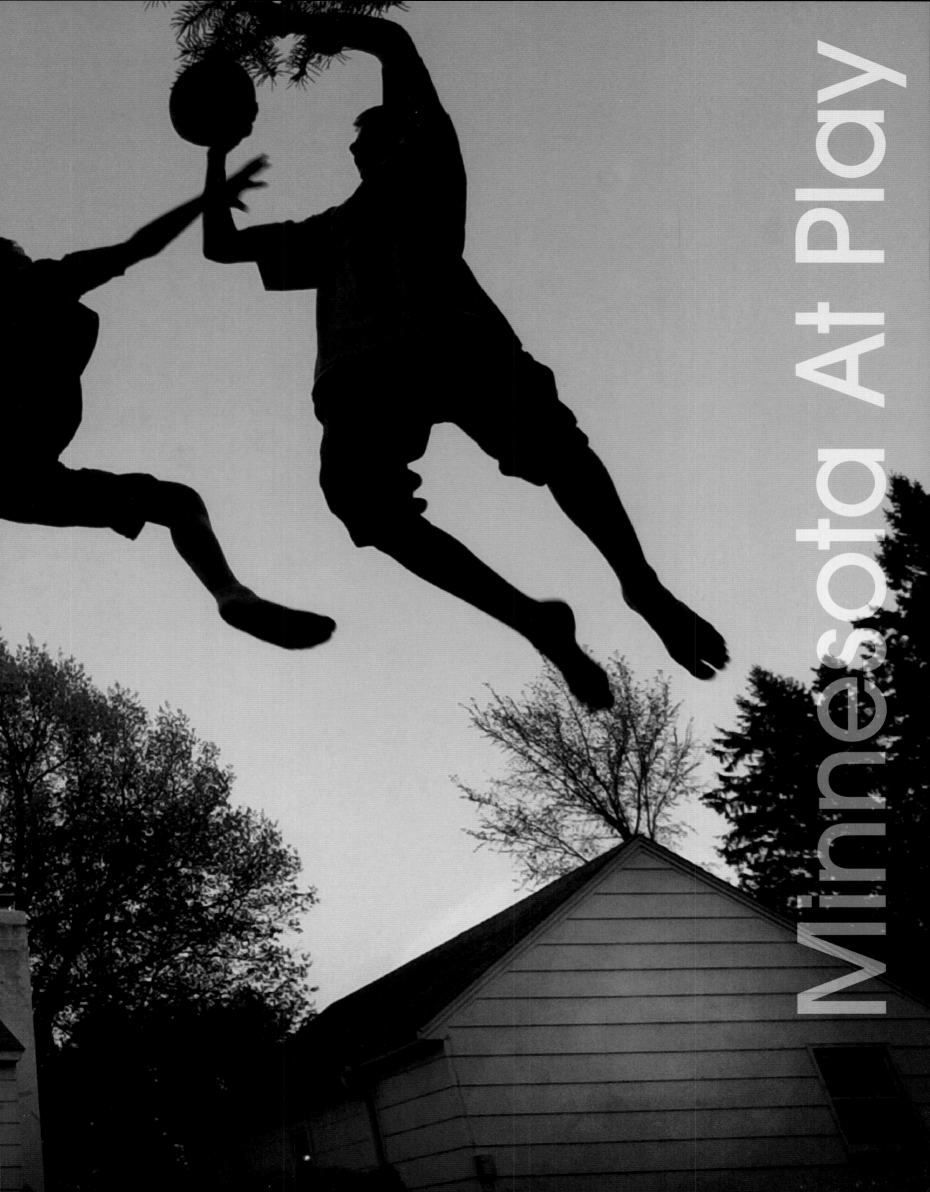

Minnesota At Play

LAKE IDA

Finn Peterson searches the waters of Lake Ida in Douglas County. He and dad Ken are fishing for lunkers.
Photo by Richard Hamilton Smith

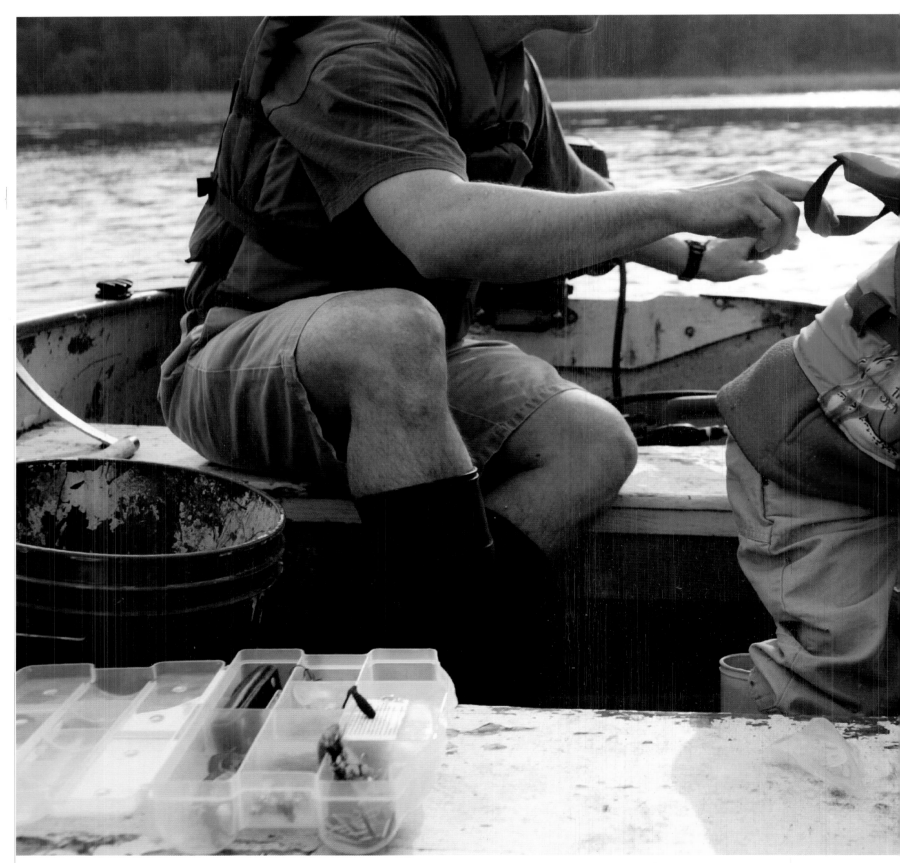

WATERVILLE

At sunrise, sport fisherman David Hoggard casts for elusive walleye in Upper Lake Sakatah. His day job is a fisherman's dream: Hoggard makes a complete line of tackle for walleye, bass, and trout and markets it from home on his website.
Photo by Renée Jones, Owatonna People's Press

WATERVILLE

Think walleye: Upper Lake Sakatah is among the best walleye spots in the Southern Lakes. This good-eating fish, which can travel 25 miles a day, swims freely between undammed Upper and Lower Lake Sakatah and Lake Tetonka—each a natural widening of the Cannon River.
Photo by Renée Jones, Owatonna People's Press

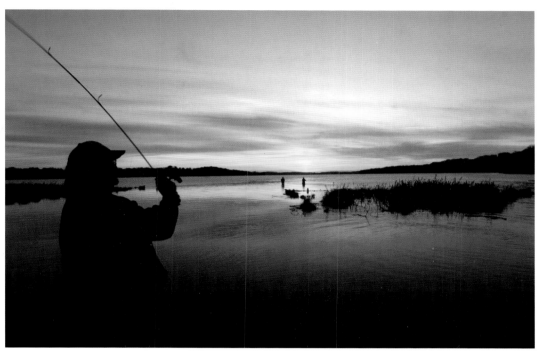

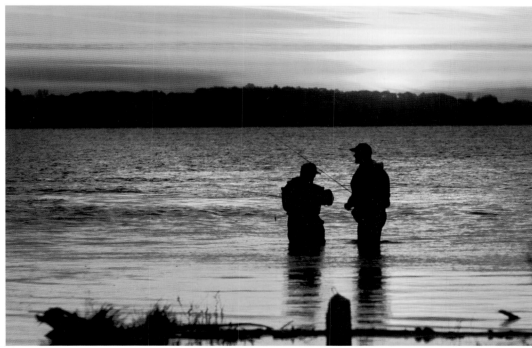

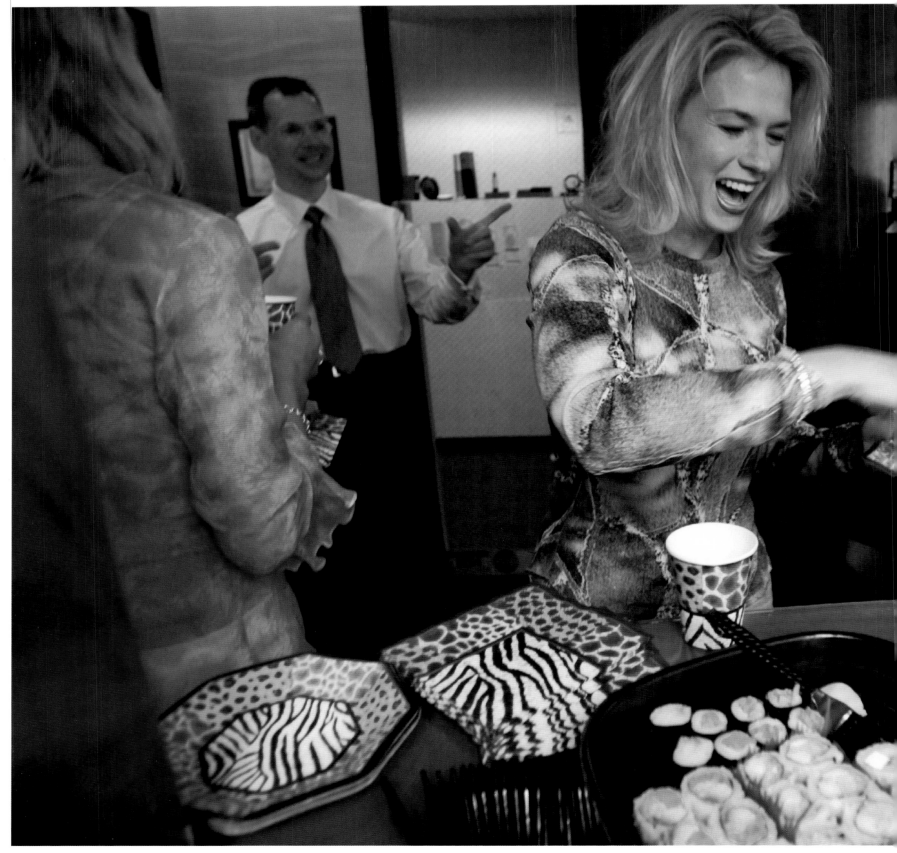

In preparation for her Botox treatment, Sharon Miller, manager of Dr. Szachowicz's office, has her face marked to indicate where the muscle relaxant will be injected. Used in the 1960s as a treatment for crossed eyes, Botox was approved by the FDA in 2002 for cosmetic purposes.

EDINA

Since 1998, Miller has had Botox treatments twice a year to reduce laugh and squint lines around her nose and eyes.

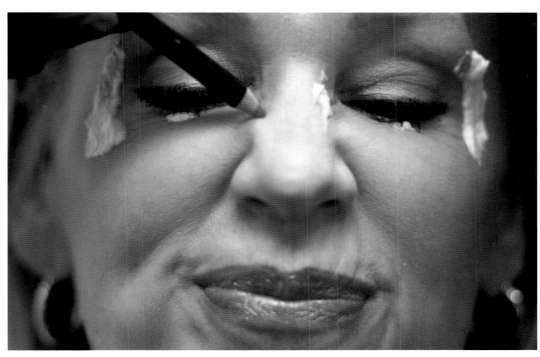

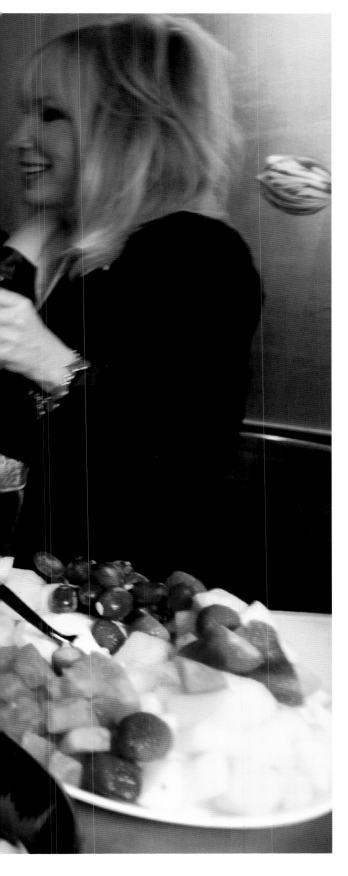

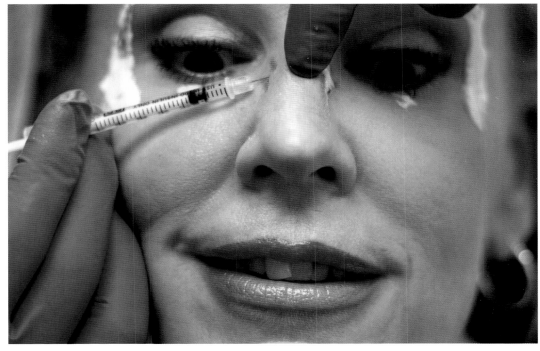

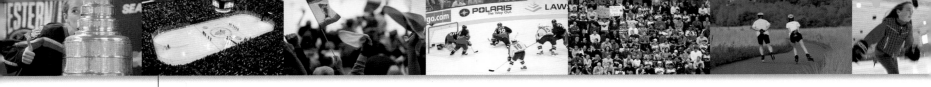

ST. PAUL

When Dallas used higher salaries to lure the Minnesota North Stars in 1993, Minnesota fans were devastated. In 1998, the state approved a loan to build a new arena, enabling St. Paul to attract a fresh crop of players. The Minnesota Wild hit the ice for the first time in 2000 and has played to sold-out crowds ever since.

Photos by Brian Peterson,
The Minneapolis Star-Tribune

ST. PAUL

The Wild faces off against the Anaheim Mighty Ducks during the Western Conference Playoff at Xcel Energy Center. The Ducks dashed Minnesota's Stanley Cup hopes with a 2–0 win.

ST. PAUL

The team pulled in more money in the 2003 season than any other franchise in the NHL. One of the reasons for their success? A crowd-pleasing star forward named Marian Gaborik who led the team with 65 points. Like three-quarters of the players on his team, the Slovakian sensation is foreign-born.

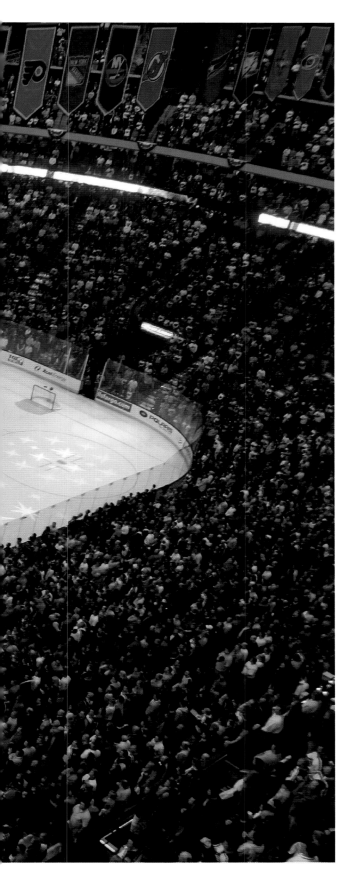

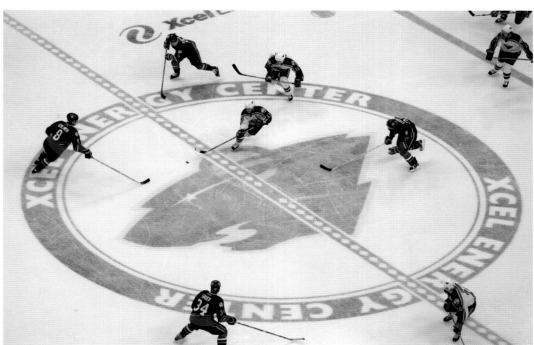

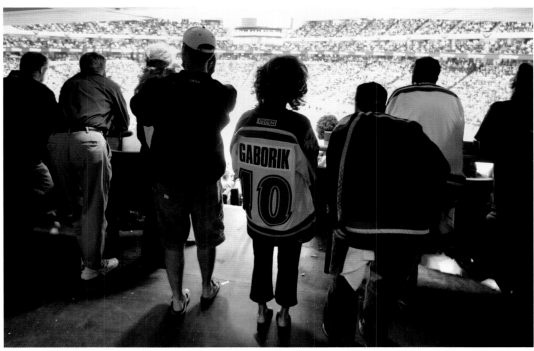

EDINA

Eli Krieter, 12, and sister Emma, 10, tune up for the next hockey season. With a multitude of venues, including 200 indoor skating rinks and thousands of freeze-friendly lakes and ponds, Minnesota is a leader in youth hockey.
Photo by Mike Krieter

SILVER BAY

On belay! A climber hand-jams his way up a chimney route at Palisade Head in Tettegouche State Park. The reward for climbers who squirm their way to the top: A panoramic view of Lake Superior.
Photo by Richard Hamilton Smith

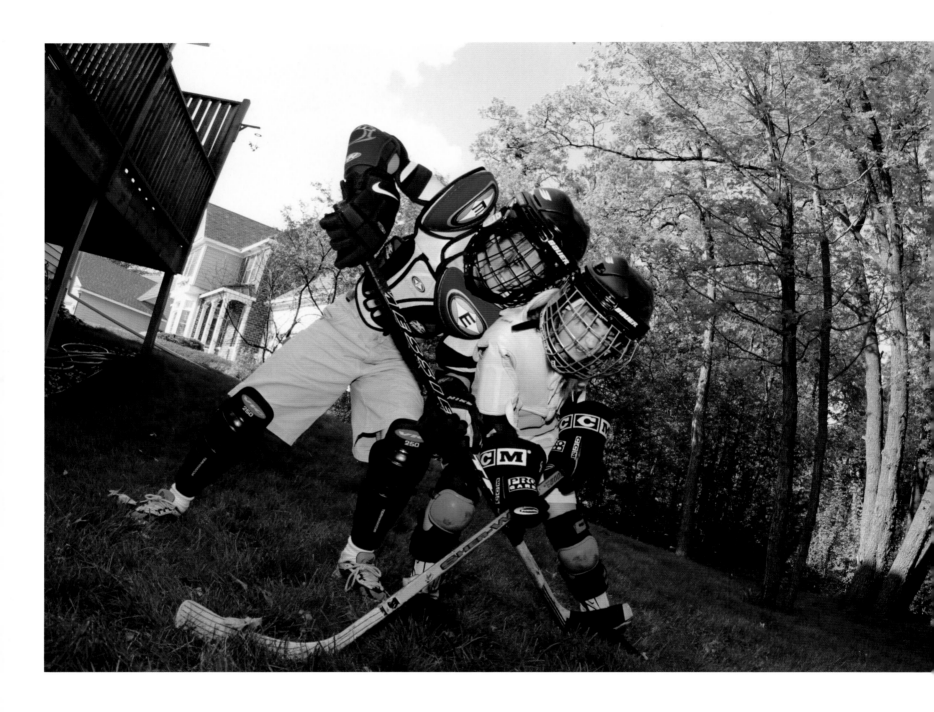

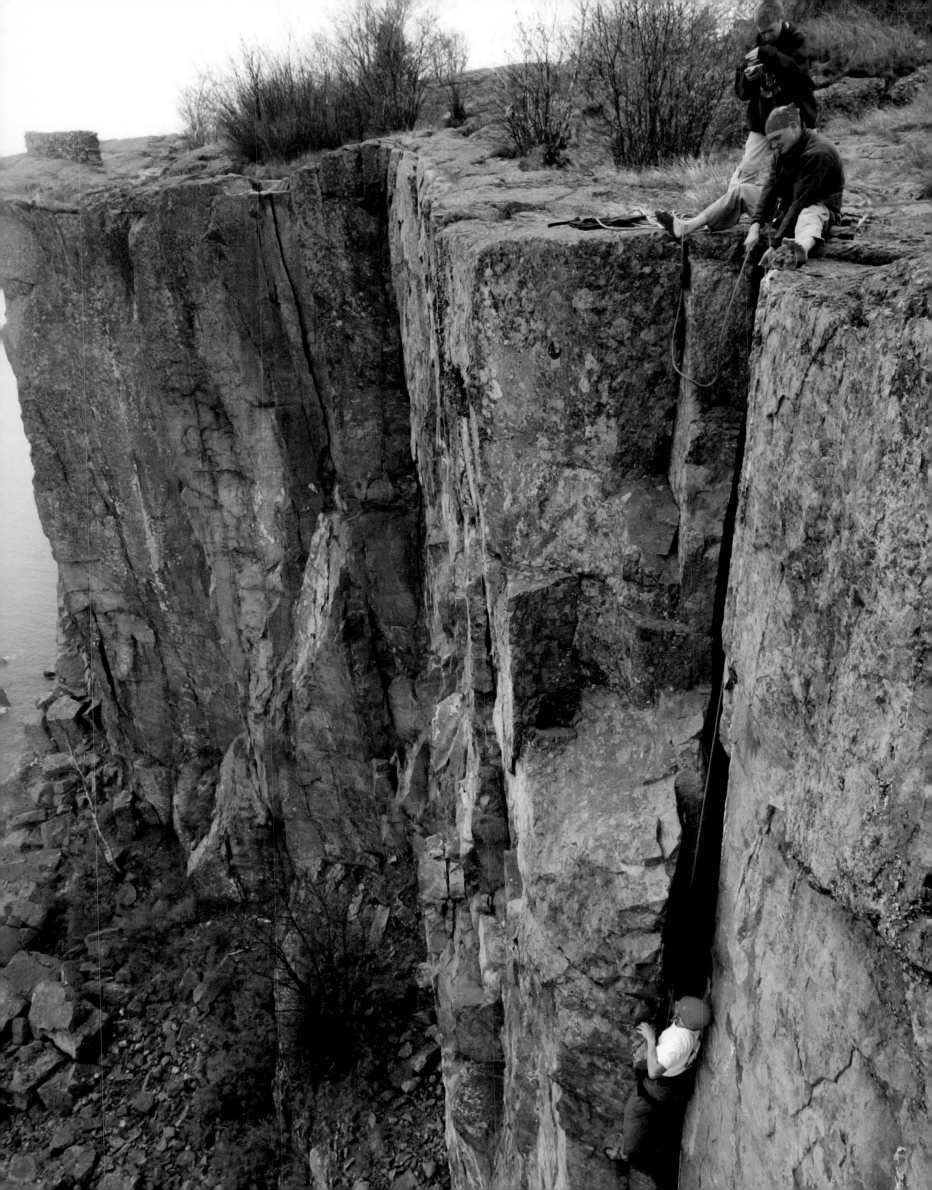

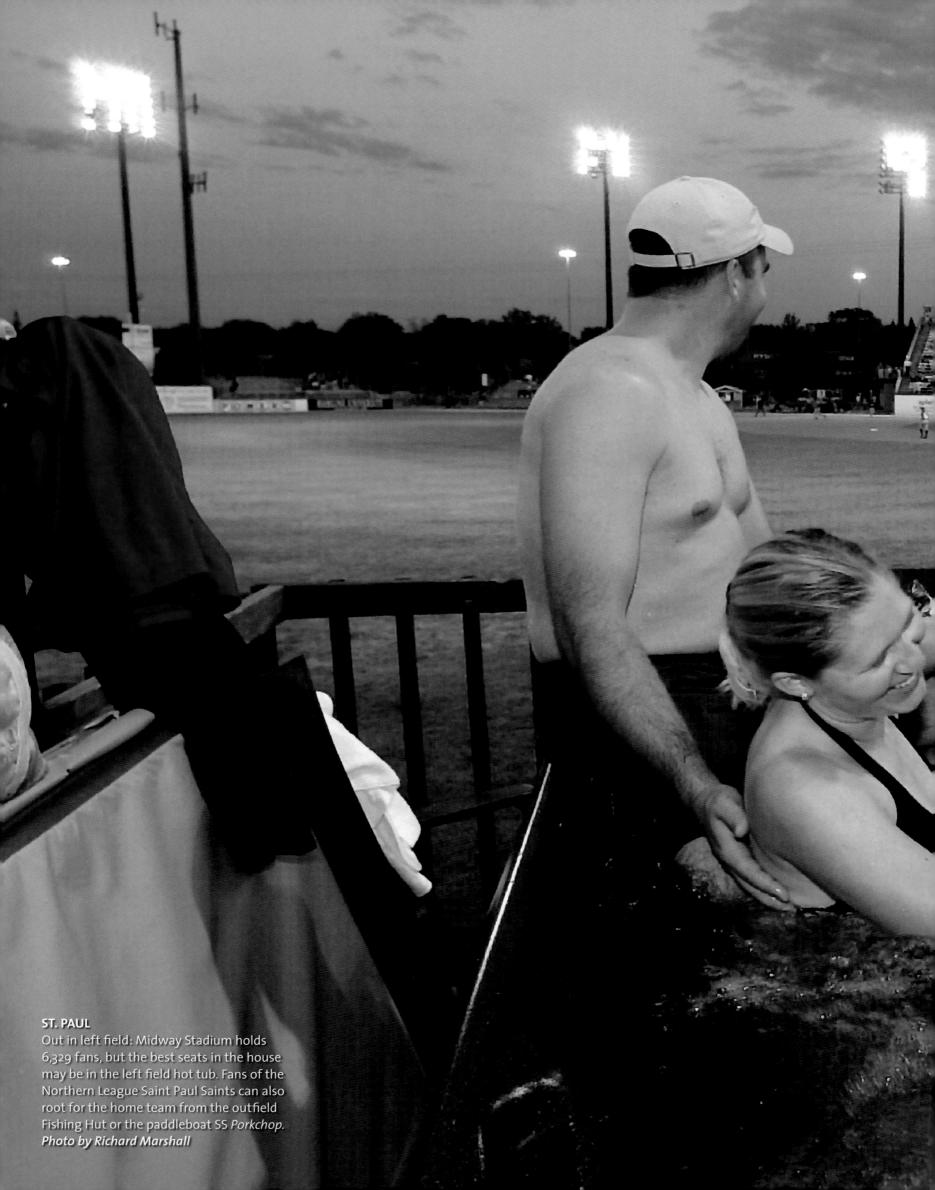

ST. PAUL
Out in left field: Midway Stadium holds
6,329 fans, but the best seats in the house
may be in the left field hot tub. Fans of the
Northern League Saint Paul Saints can also
root for the home team from the outfield
Fishing Hut or the paddleboat SS *Porkchop*.
Photo by Richard Marshall

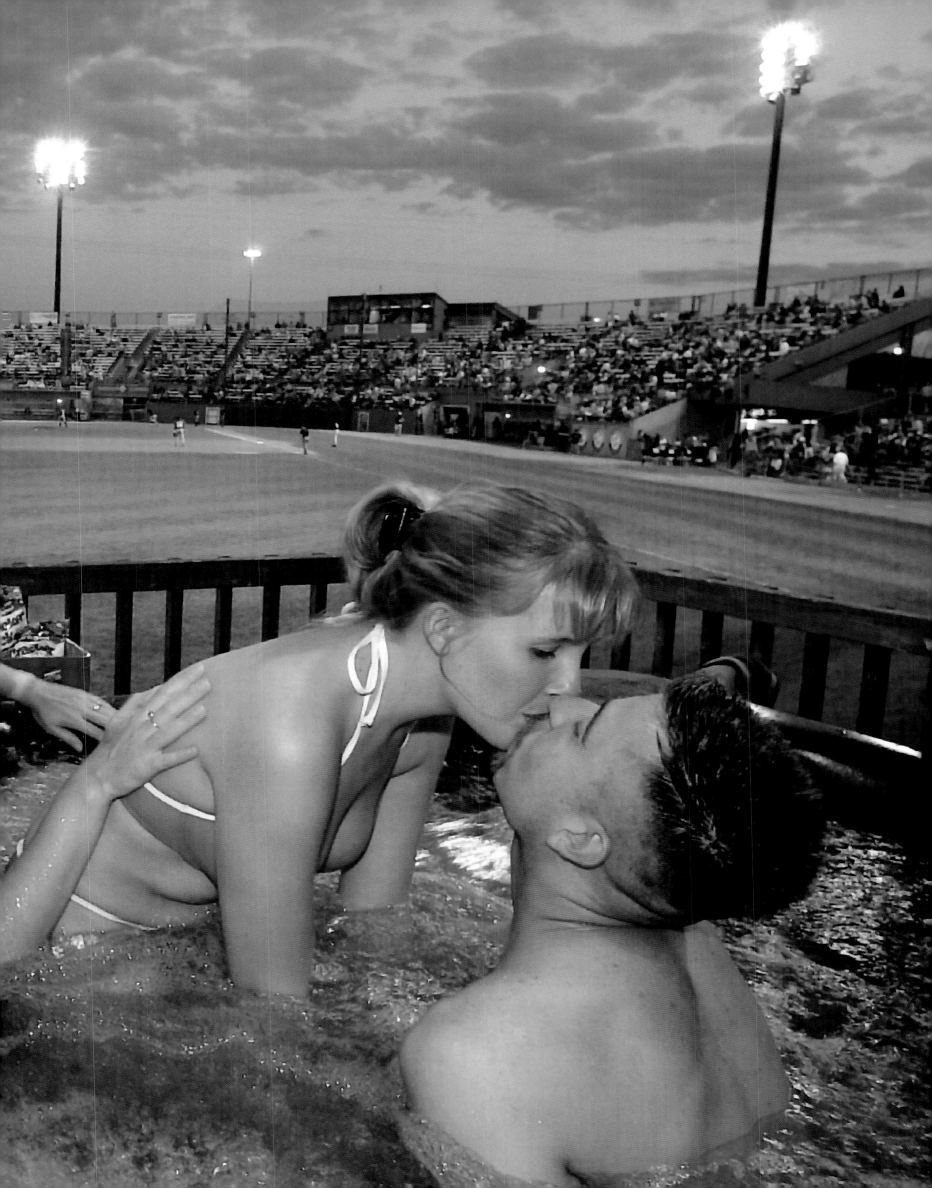

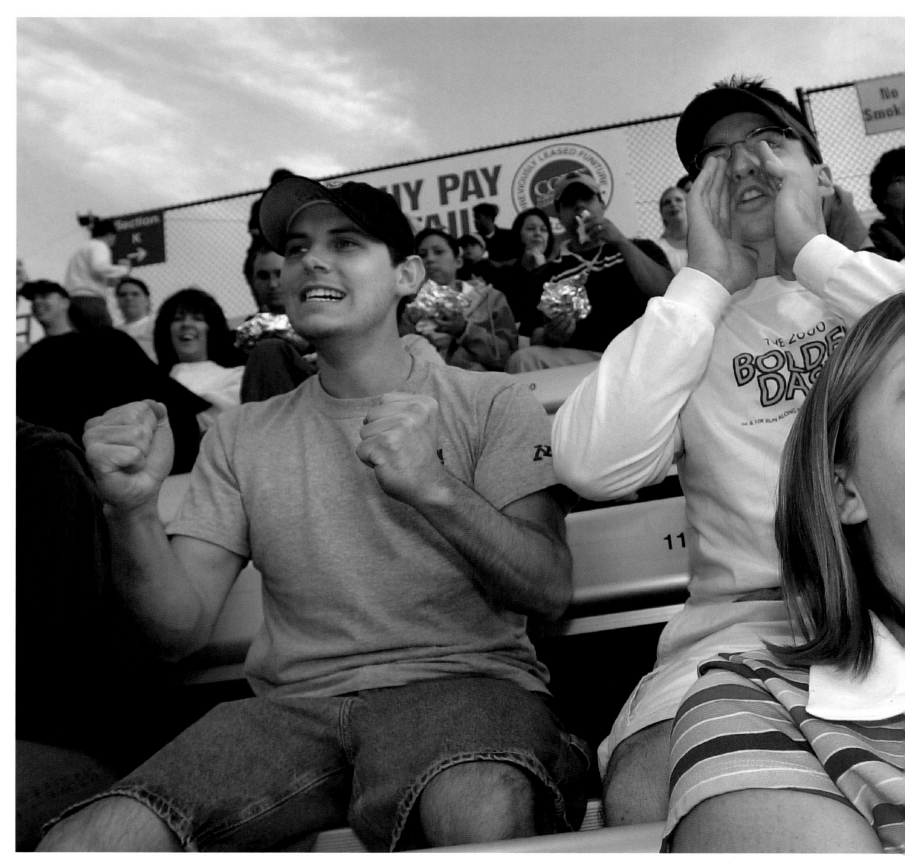

ST. PAUL

"Roast beef! Roast beef!" chant Jason Krob, George Beatty, and Lisa Hanson, taunting a Sioux Falls batter to strike out and earn each Saint Paul Saints fan a free roast beef sandwich. The minor league baseball team, whose motto is "Fun Is Good," has been a part of the Minnesota sports scene for nearly a century. Oh yeah: The batter grounded out.

Photos by Richard Marshall

ST. PAUL

Each year a new piglet is chosen as the Saints' mascot. Here, Notorious P.I.G., aka Piggy Smalls, gets a bottle of milk from umpire Mike Neubeck in exchange for the baseballs he delivers to home plate. Assisting with the handoff is Dennis Hauth, Notorious's owner.

ST. PAUL

Local singer and talent agent Jill Mikelson belts out the national anthem before the start of a Saints exhibition game at Midway Stadium. Mikelson has also sung for the Minnesota Twins in the Hubert H. Humphrey Metrodome. "It's a blast to be out in the open at Midway," she says.

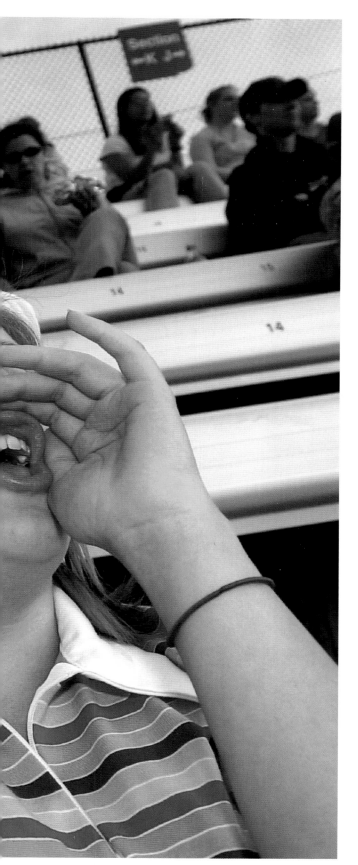

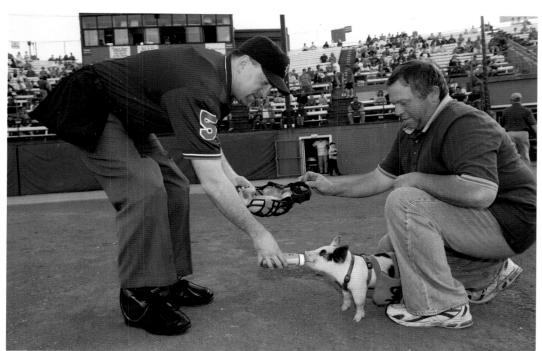

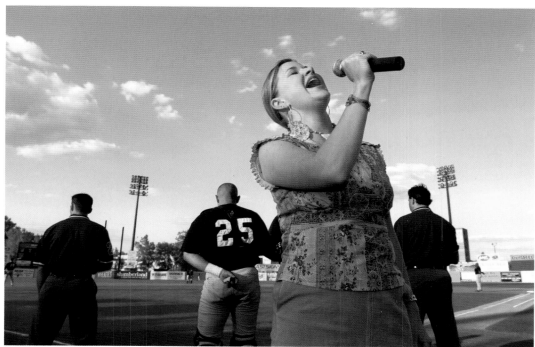

PRINCETON

Nathan Pullonese steadies his son Max while the 8-year-old fires a fully automatic machine gun at the Minnesota Machine Gunners Association Spring Machine Gun Shoot. More than 100 gun enthusiasts attend the semiannual event. Dealers display both historic and modern weaponry, which attendees are free to test drive. Kids less intrepid than Max can take tank rides.
Photo by Thomas Whisenand,
The Minnesota Daily

PRINCETON

Glenn Resman of Milaca shows off one of many fully automatic guns available for shooting at the Spring Machine Gun Shoot.
Photo by Thomas Whisenand,
The Minnesota Daily

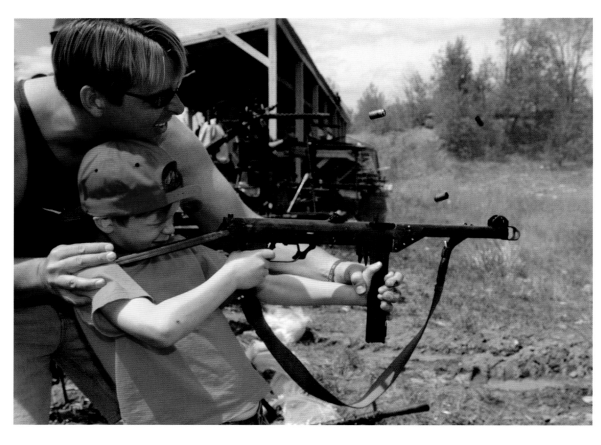

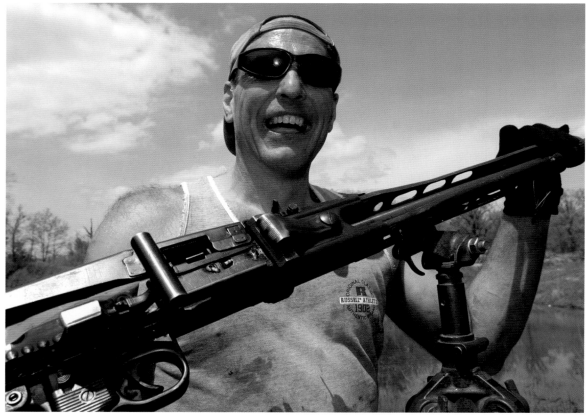

PRINCETON

Mark Hanson of Cedar fires 30 rounds from a Glock 9-millimeter handgun at the Spring Shoot fair. Dealers and vendors set up booths, and visitors can demo most weapons—$10 for a full magazine in a mag-fed gun or $25 for 50 rounds in a belt-fed weapon.

Photo by Thomas Whisenand,
The Minnesota Daily

HOPE

Once a year, retired truck driver Roger Olinger drops by the Hope town auction for a look-see. This time he bought a BB rifle for $20. "I'll use it to shoot the sparrows and crows that hang around the shed."

Photo by Renée Jones, Owatonna People's Press

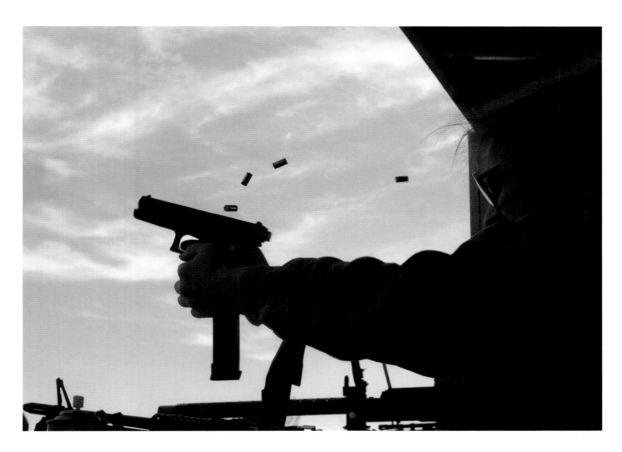

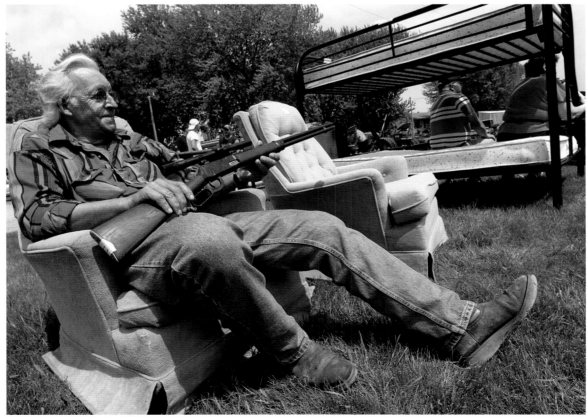

BEMIDJI
Maui, a year-old Italian greyhound–Jack Russell
terrier mix, inspects Jon Mussehl's call shot—11,
corner pocket—at Hard Times Saloon.
Photo by Bill Alkofer

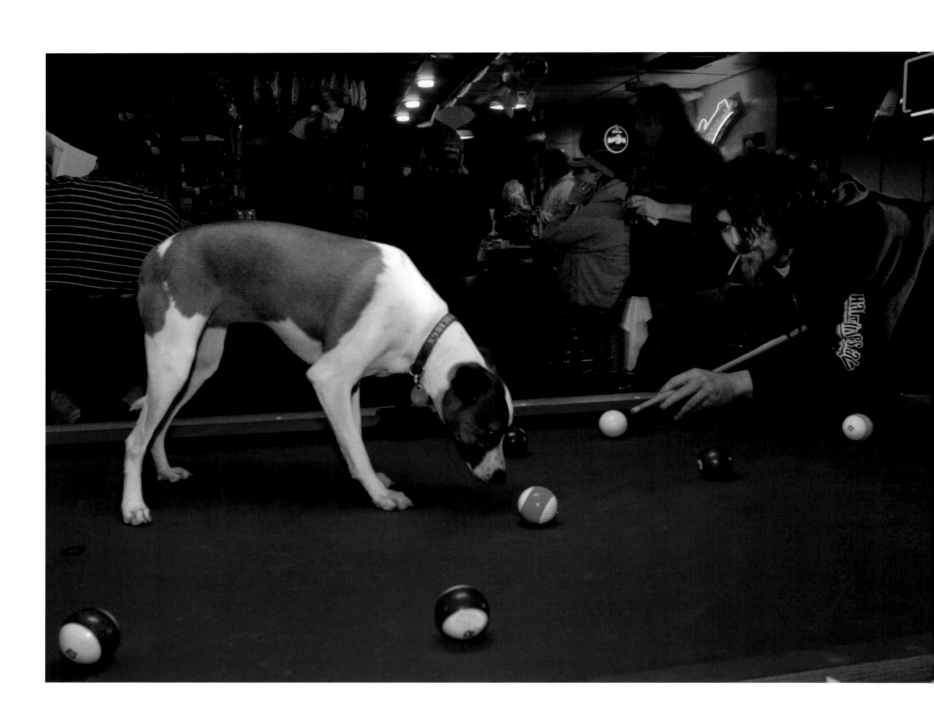

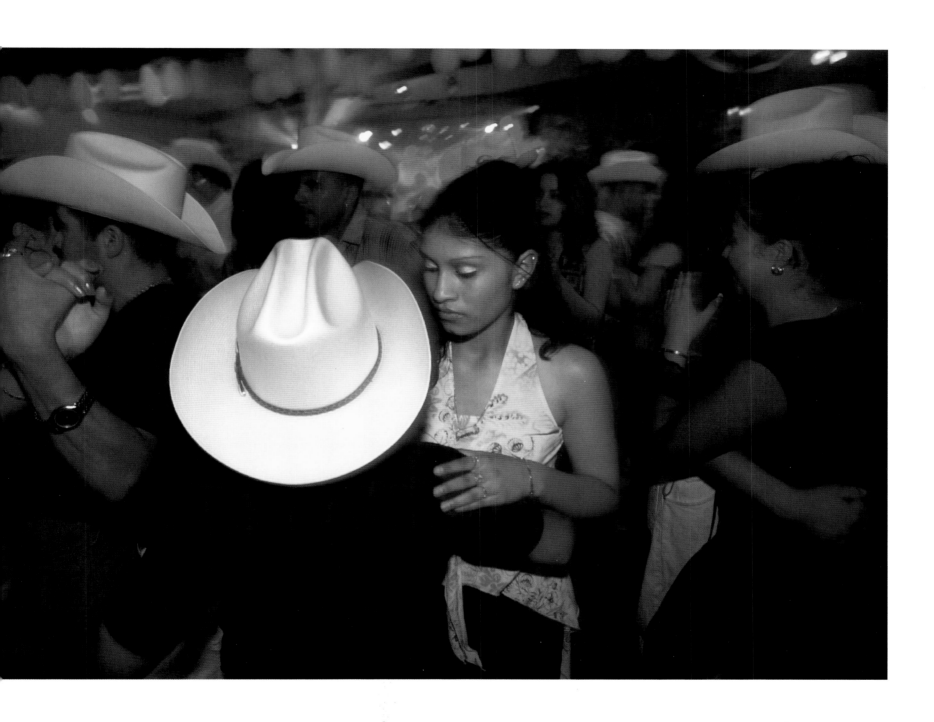

MELROSE

Songs from their native Mexico and Central America—Banda, Tejano, and Nuevo Canción hits—get couples swaying on the dance floor at El Portal bar. The 3,091-person town in the middle of the state is now 12.3 percent Hispanic.

Photo by Kimm Anderson

Some things never change. Cruising the main
drag of Cedar Avenue on Saturday night is one
of them. It's been a tradition since the late 1950s.
Ashley Sorensen, Amy Schirmacher, Melissa
Robeck, and Jill Boumeester do it 2003-style, in
the back of a pickup with cell phone connections
to the rest of their posse.
Photos by Renée Jones, Owatonna People's Press

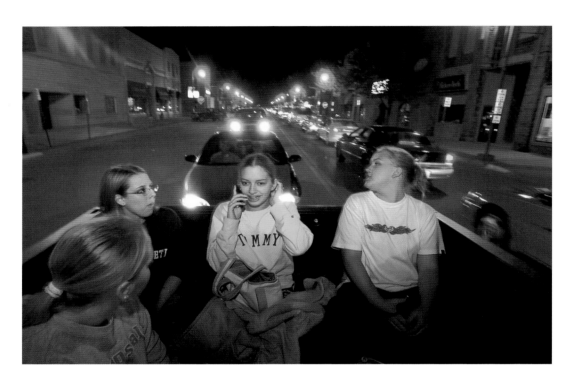

OWATONNA

Teen couch potatoes Jessica Schwartz, Shalaine Thomson, John Klotz, and Matt Berghoff stopped for fries after the police pulled them over, declaring the sofas in the back of their pickup unsafe. The gang had driven from Waterville to cruise Owatonna's Cedar Avenue strip but ended up in a McDonald's parking lot for the evening.

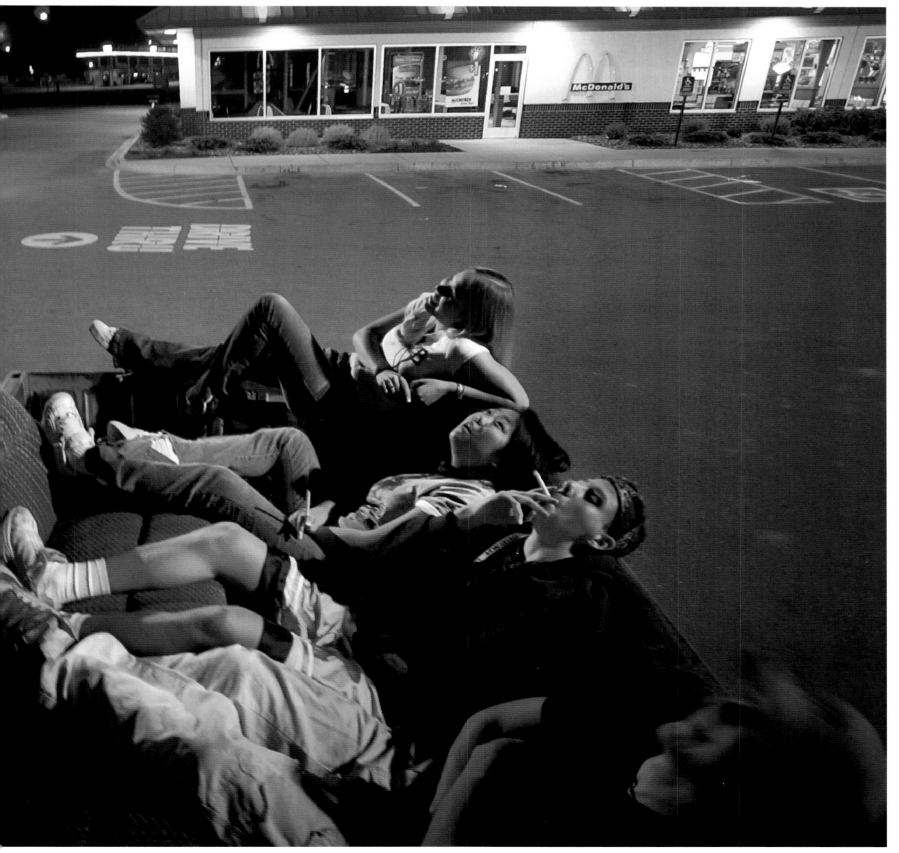

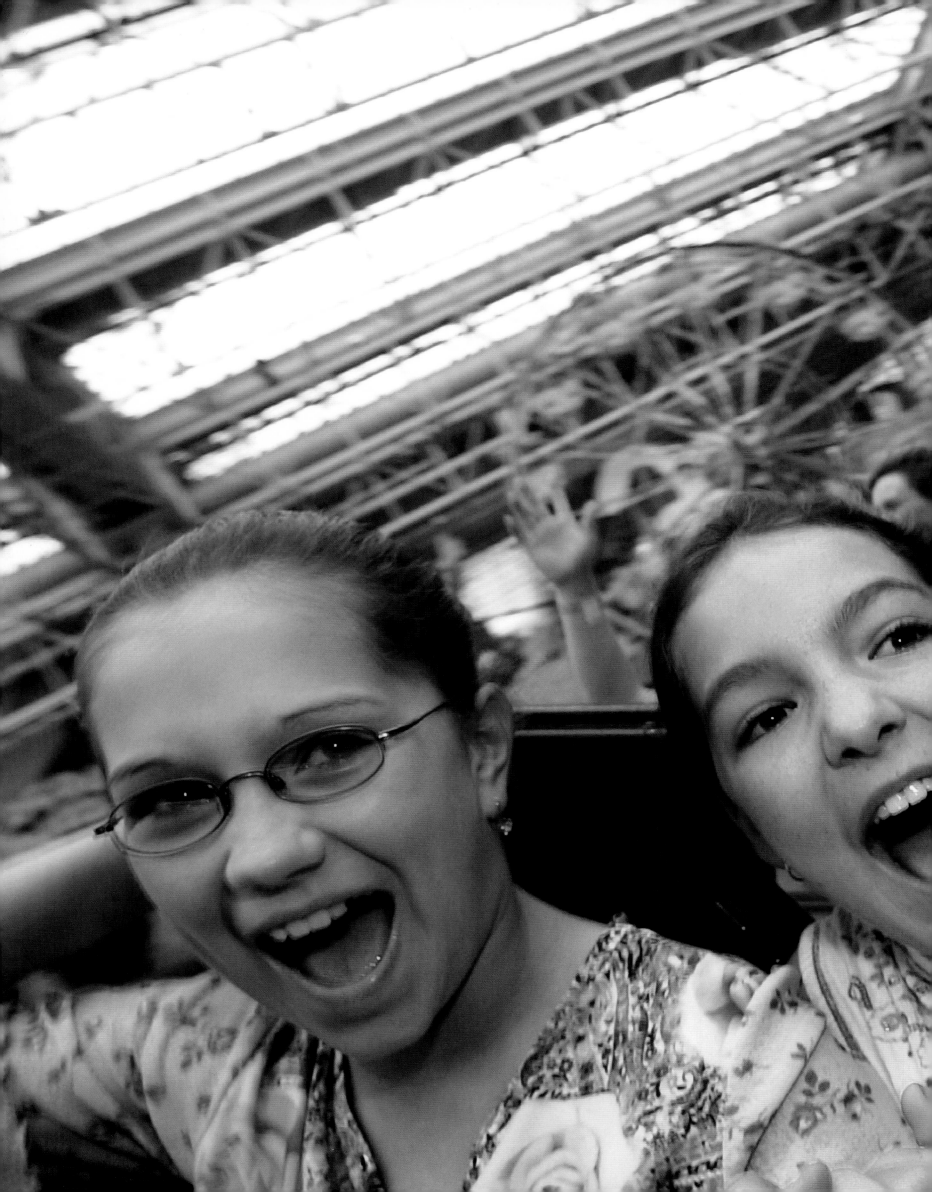

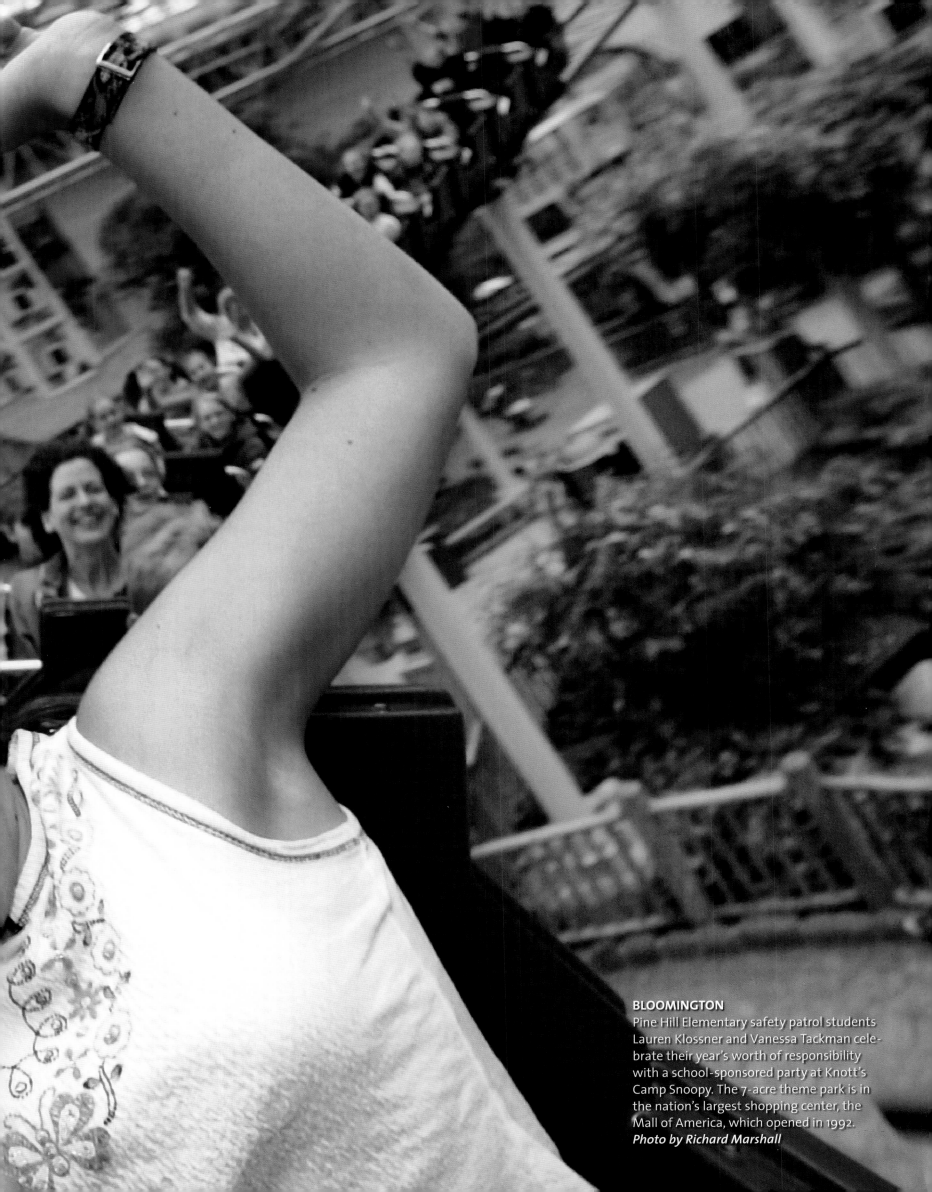

BLOOMINGTON
Pine Hill Elementary safety patrol students Lauren Klossner and Vanessa Tackman celebrate their year's worth of responsibility with a school-sponsored party at Knott's Camp Snoopy. The 7-acre theme park is in the nation's largest shopping center, the Mall of America, which opened in 1992.
Photo by Richard Marshall

NORTHFIELD

Bottoms up: Believe it or not, the legs belong to college junior Ted Johnson, enthusiastically celebrating the last day of finals at St. Olaf College, a liberal arts school affiliated with the Evangelical Lutheran Church.

Photos by Renée Jones, Owatonna People's Press

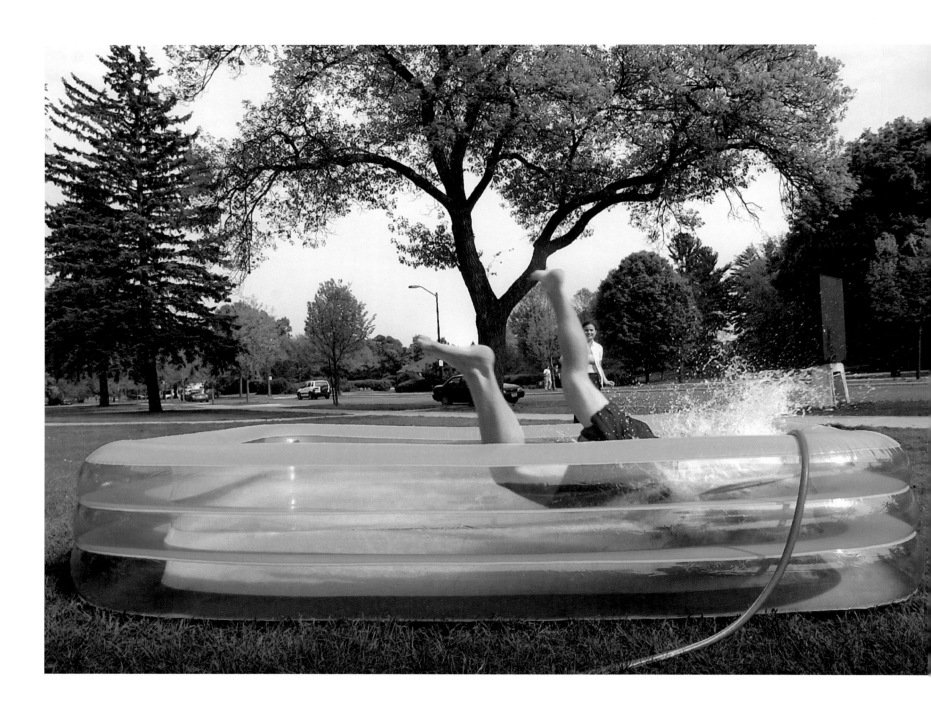

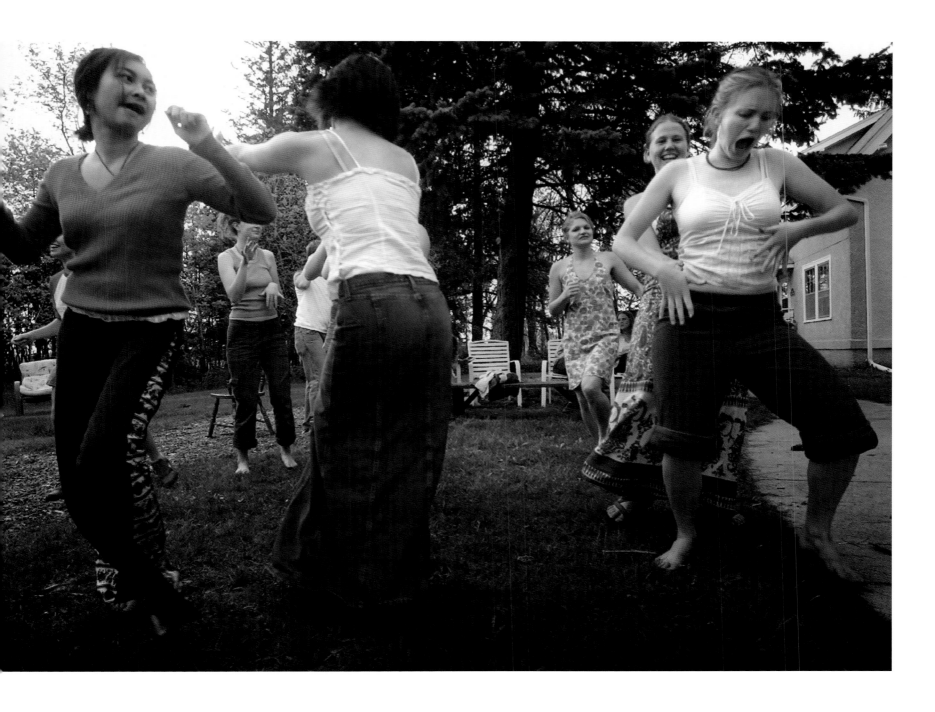

NORTHFIELD

Carleton College students shake a tail feather to the sounds of Juggernaut, a local rock band. The highly regarded liberal arts college, 40 miles south of the Twin Cities, was founded in 1866 with an enrollment of 23. Today it has 1,800 students from 50 states and several countries.

Somalian fourth-graders play at Longfellow Elementary School. Minnesota has 11,150 Somalian immigrants (more than any other state), and 1,200 of them live in Rochester. Minnesota has become a home for many refugees thanks to its social-service tradition and sponsorship activities of Lutheran and Catholic charities in the state.
Photo by Christina Paolucci

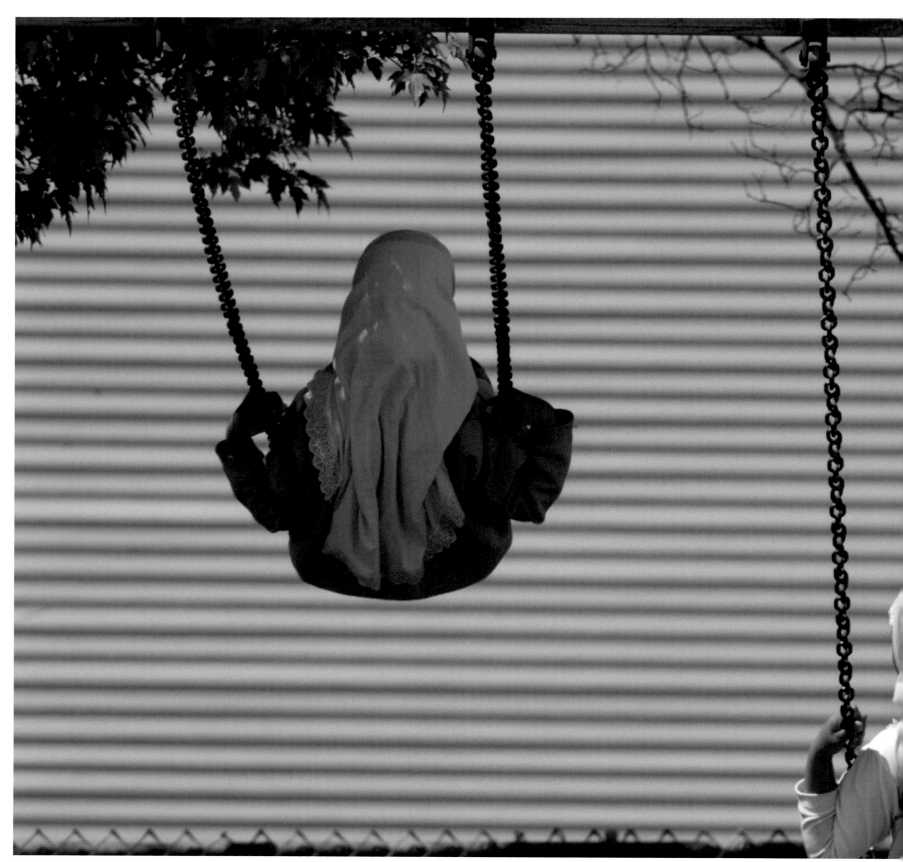

MINNEAPOLIS

Taylor Healy swings in the sunset on Lake Calhoun, one of southwest Minneapolis's Chain of Lakes. Living between Lake Calhoun and Lake Harriet, Taylor has her pick of summer swimming holes and winter skating rinks.

Photo by Judy Griesedieck

NORTHFIELD

Spring swing: During a party at "the Farmhouse," Carleton undergrads let off steam. The school occupies a 950-acre campus with a 400-acre arboretum and two small lakes.

Photo by Renée Jones, Owatonna People's Press

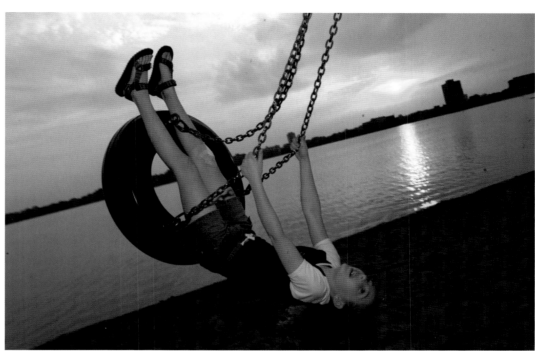

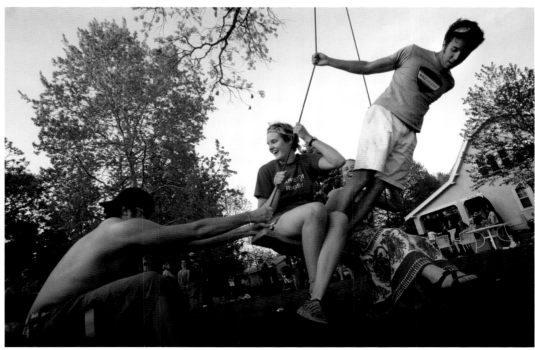

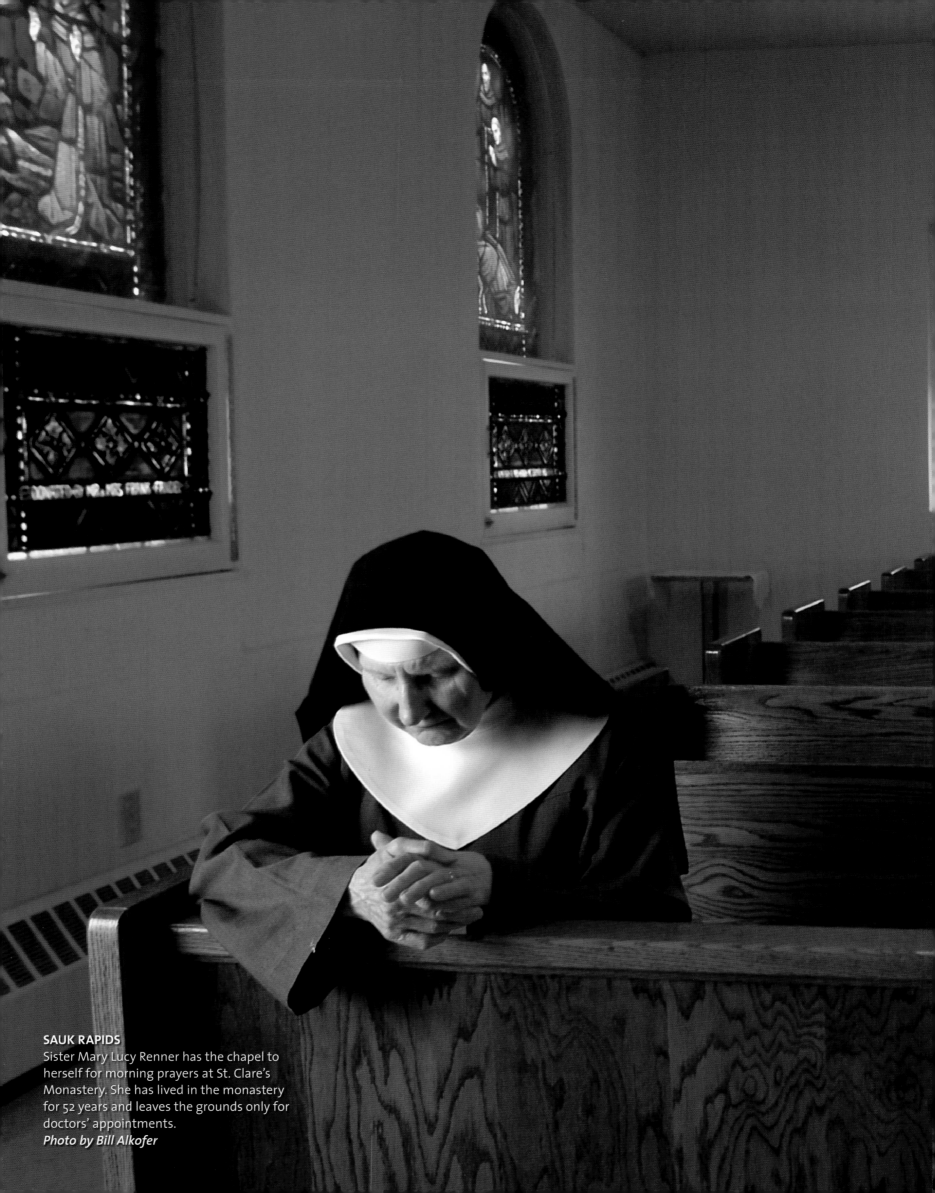

SAUK RAPIDS
Sister Mary Lucy Renner has the chapel to herself for morning prayers at St. Clare's Monastery. She has lived in the monastery for 52 years and leaves the grounds only for doctors' appointments.
Photo by Bill Alkofer

Reason To Believe

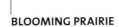

BLOOMING PRAIRIE

Head usher Marvin Bellach lights altar candles before the Sunday service, a job he's done for 20 of the 60 years he's belonged to Trinity Lutheran Church. The congregation formed in the spring of 1874 as Straight River Norwegian-Danish Evangelical Lutheran Church. The name was shortened in 1940.

Photos by Renée Jones, Owatonna People's Press

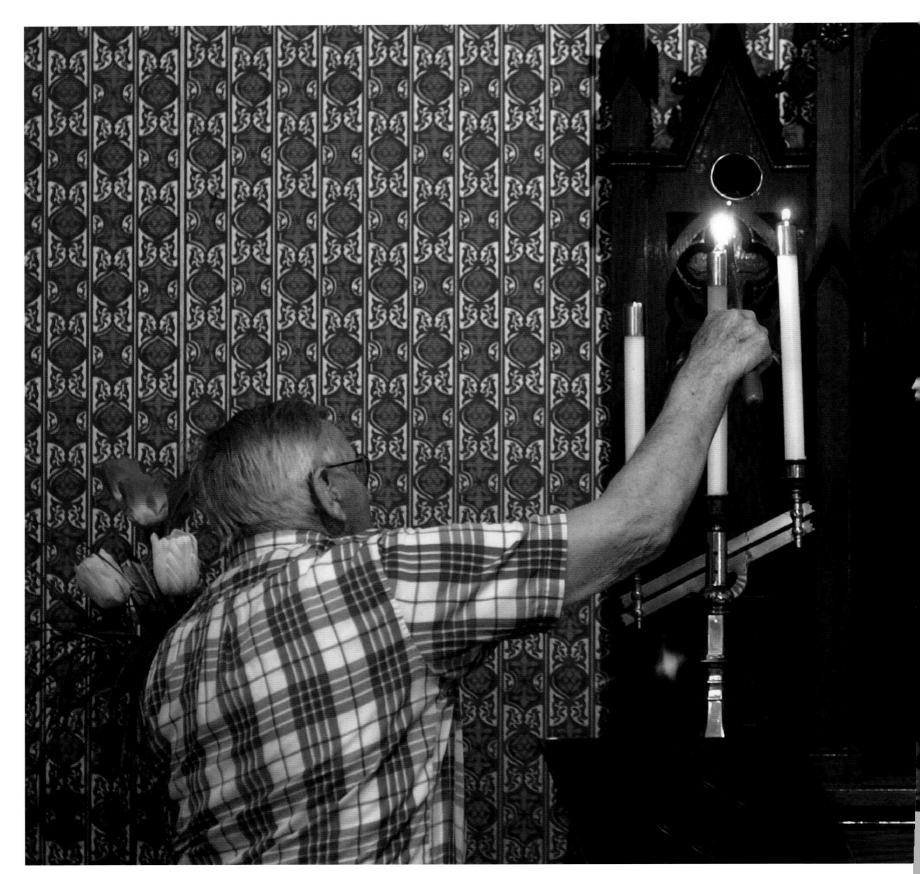

BLOOMING PRAIRIE

At Sunday morning service, Pastor Paul Nelson delivers his sermon to a sparse congregation. The church's membership has steadily decreased from a peak of 208 in 1937 to about 100 today. "It's a big week when 20 people come to church on Sunday," says Nelson, who has led the congregation for 25 years.

BLOOMING PRAIRIE

Sharon Lundahl prays after Pastor Nelson's sermon. The church is affiliated with the moderate Evangelical Lutheran Church in America, formed in 1988 by the merging of two opposing groups, one nicknamed "happy Danes," who adhered to a liberal interpretation of the Bible, the other called "sad Danes," who took a more conservative approach.

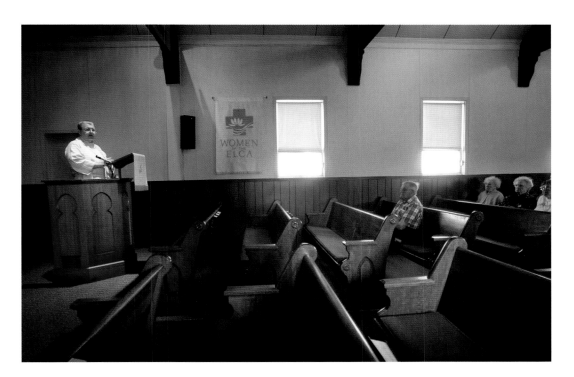

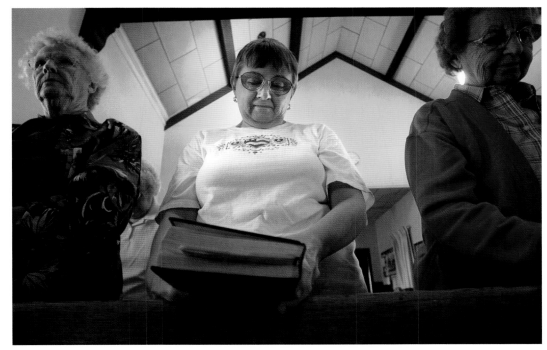

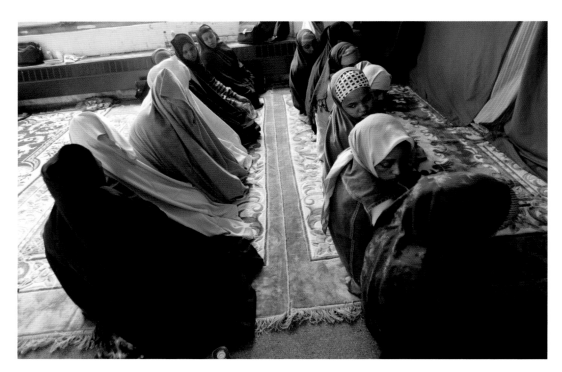

MINNEAPOLIS
Somalian and Ethiopian girls—separated by a
curtain from the men—pray at the LEAP English
Academy. Founded in 1994, the public high school
offers an intensive language program for 300
students from 41 countries.
Photos by Judy Griesedieck

At the LEAP English Academy, a Muslim girl displays her henna tattoos. Popular today in India, Africa, and the Middle East, the temporary body art originated in Egypt, where the fingernails of mummies were adorned with henna to prepare them for their journey to the next world.

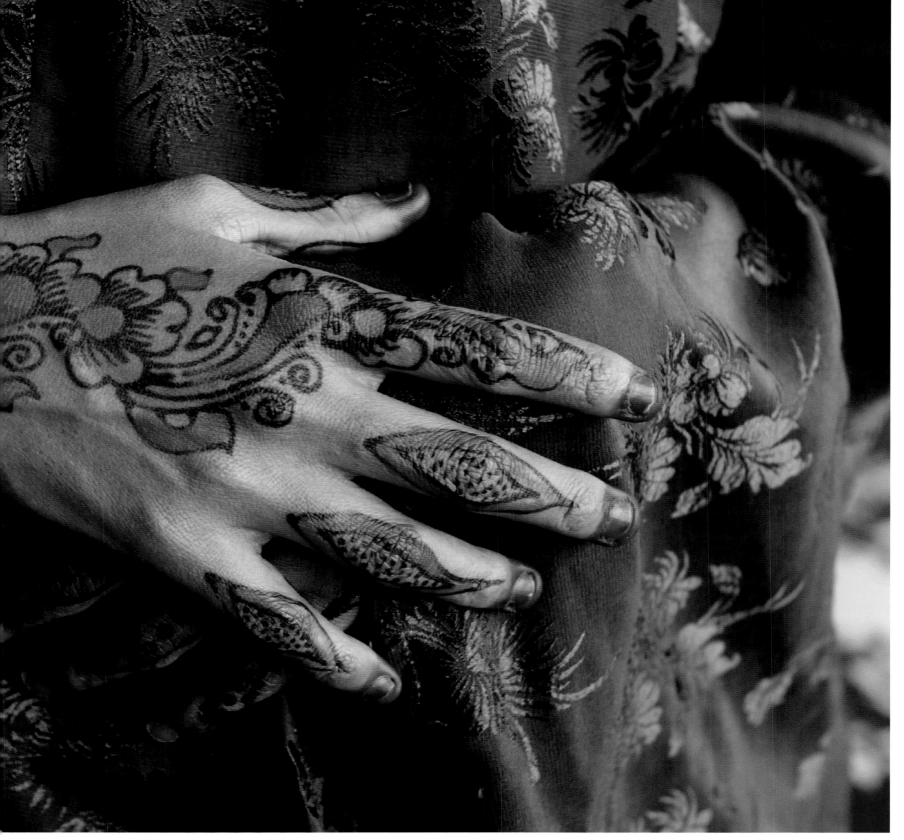

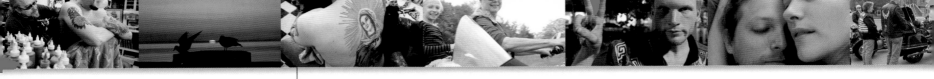

ST. PAUL

Opened in 1988, Acme Tattoo is owned by Don Nolan and enlivened by Lucy, the studio's mascot. Nolan is working on Andy Kriz, framing his Virgin Mary tattoo with a vine of red roses. The drawing took 12 hours to complete.
Photo by Scott Cohen

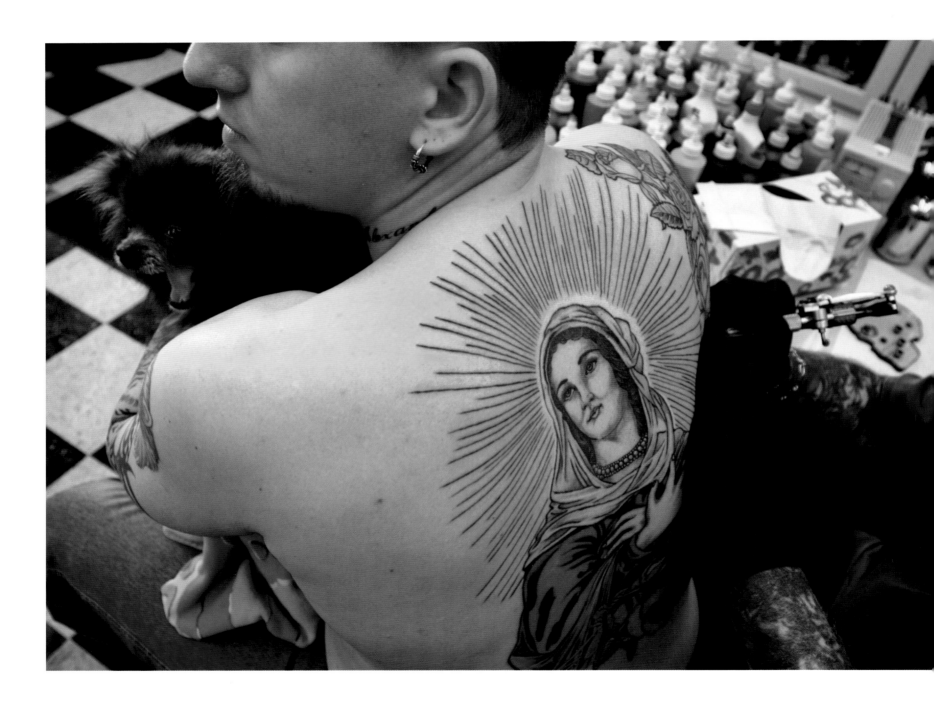

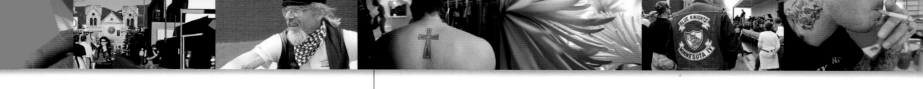

ST. PAUL

"I've always had some sort of cross on me, ever since I was a kid," says relief pitcher Chris Chavez, 28, in the locker room before his first game with the Saint Paul Saints. The Florida native has been playing pro ball since 1999.

Photo by Richard Marshall

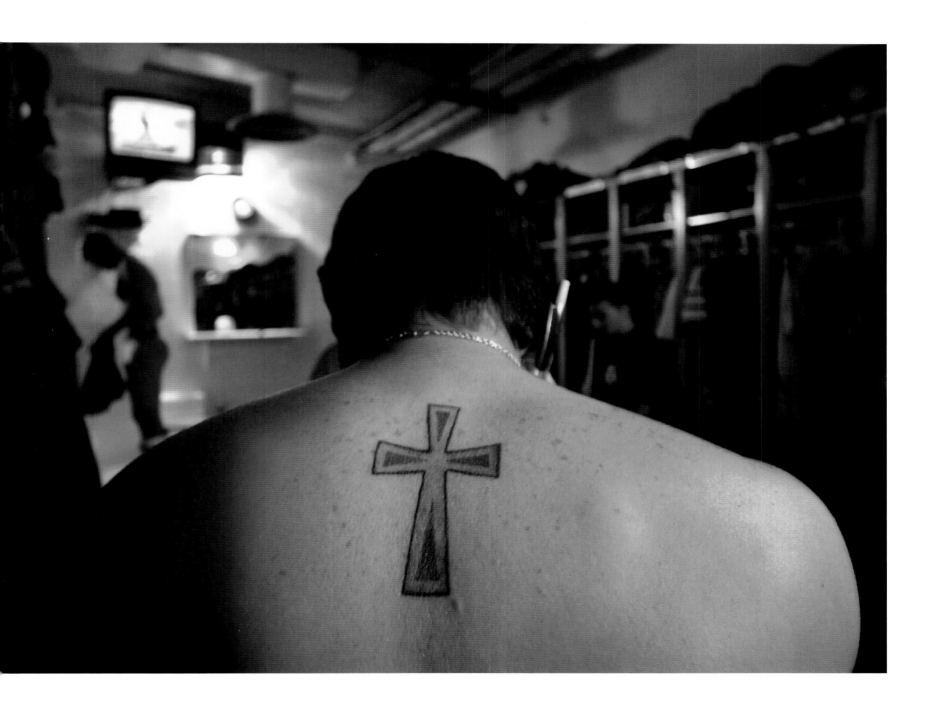

MANKATO

Sister Hermana Maurer and Sister Mary Eugene Braun, retired nuns at the School Sisters of Notre Dame, comfort each other while waiting out a tornado warning in an underground tunnel. Founded in 1912, the convent is one of 20 international provinces of the Rome-based order.
Photos by Judy Griesedieck

MANKATO

In the School Sisters of Notre Dame chapel, Sister Celeste Glovka and Sister Julianna Weiser participate in the laying-on of hands. The retired nuns entered the convent in the 1930s and did their ministry as teachers.

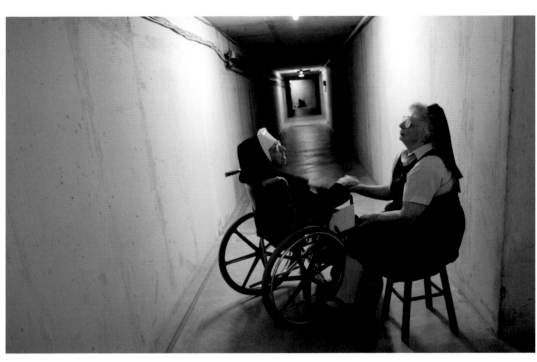

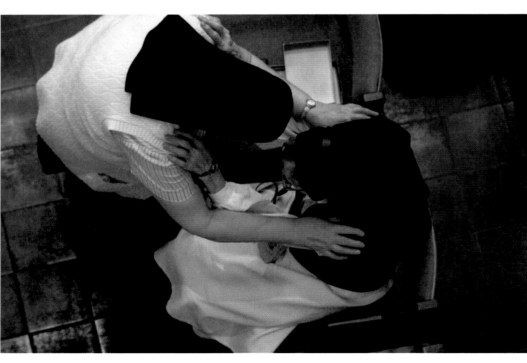

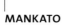

MANKATO

Using her wheelchair for stability, Sister Hermana Maurer takes her daily stroll through the convent cemetery. One of 150 retired nuns residing at the Provincial House, Sister Hermana, 93, entered the convent when she was 16 and taught music until her retirement.

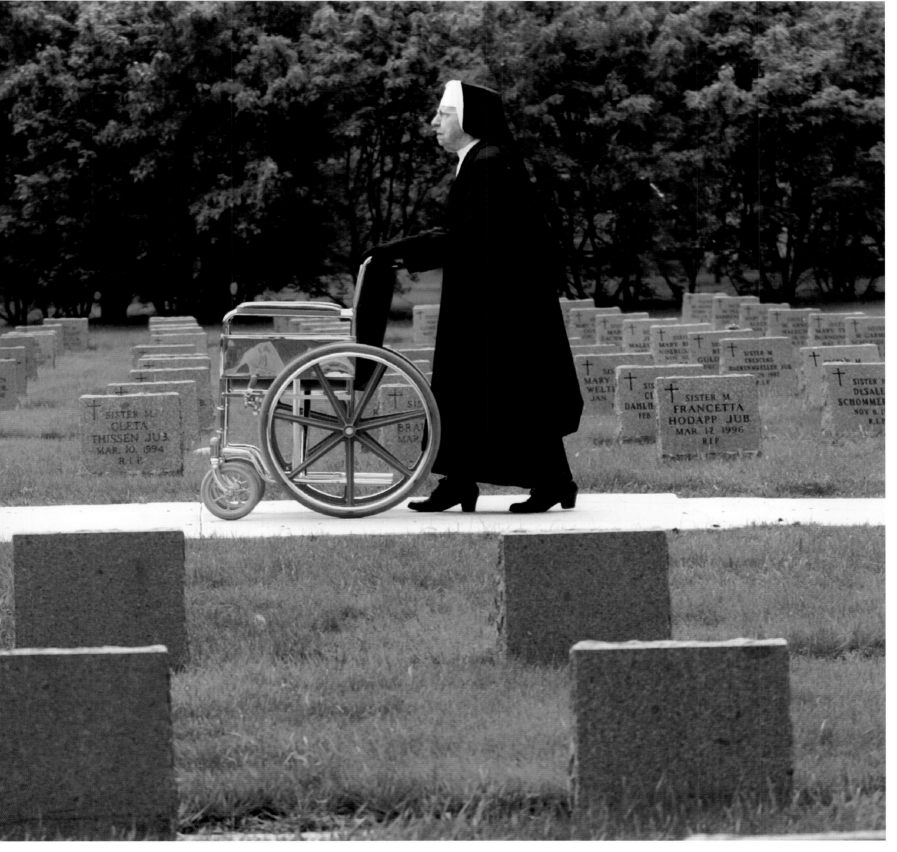

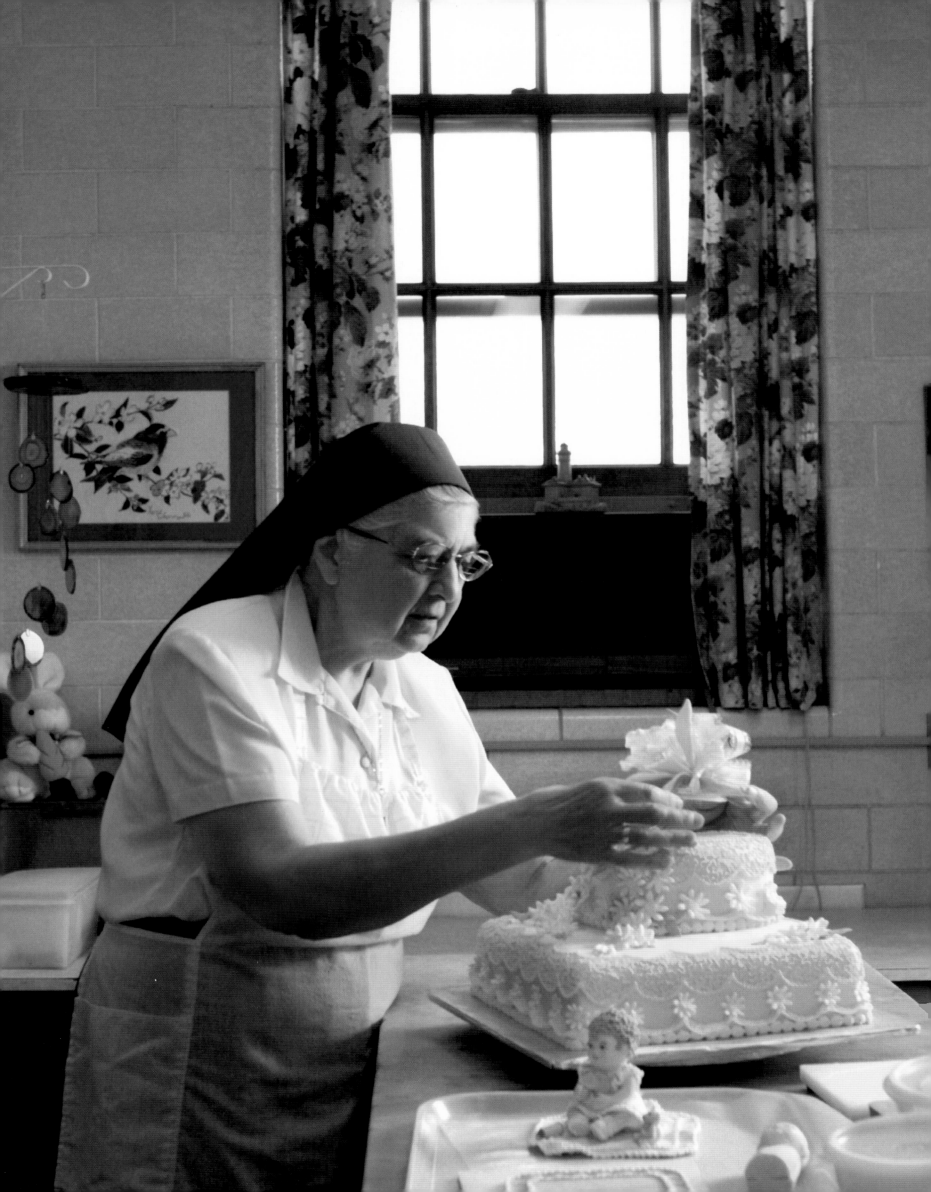

ROCHESTER

In the Assisi Heights Monastery, Sister Ralph Jahner, 82, puts the finishing touches on a cake. She's been baking and decorating for more than 60 years. Her creations include wedding cakes for students from the College of St. Teresa and, years later, for their daughters' weddings. One fond memory: A nine-tier extravaganza she climbed a stepladder to assemble.

Photo by Dean Riggott, www.riggottphoto.com

ST. CLOUD

The angel of hope, illuminated by afternoon sunlight, watches over parishioners at St. Scholastica Convent, a nursing home for retired nuns.

Photo by Kimm Anderson

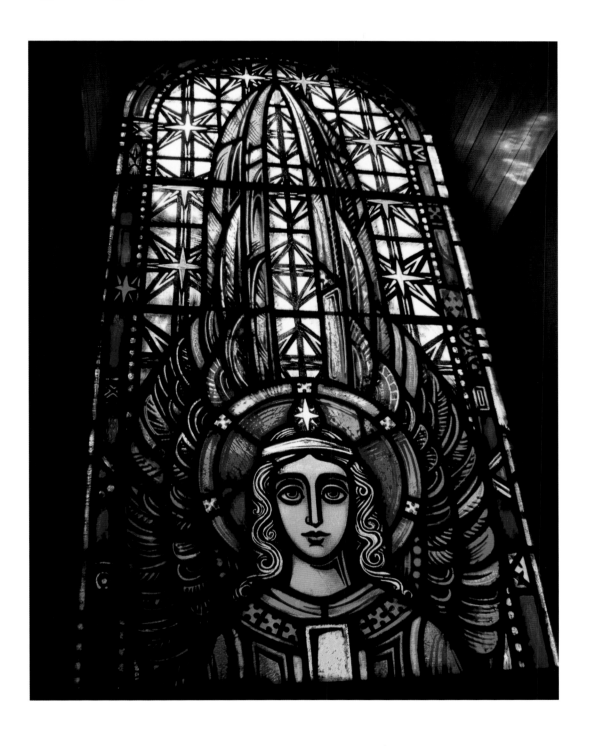

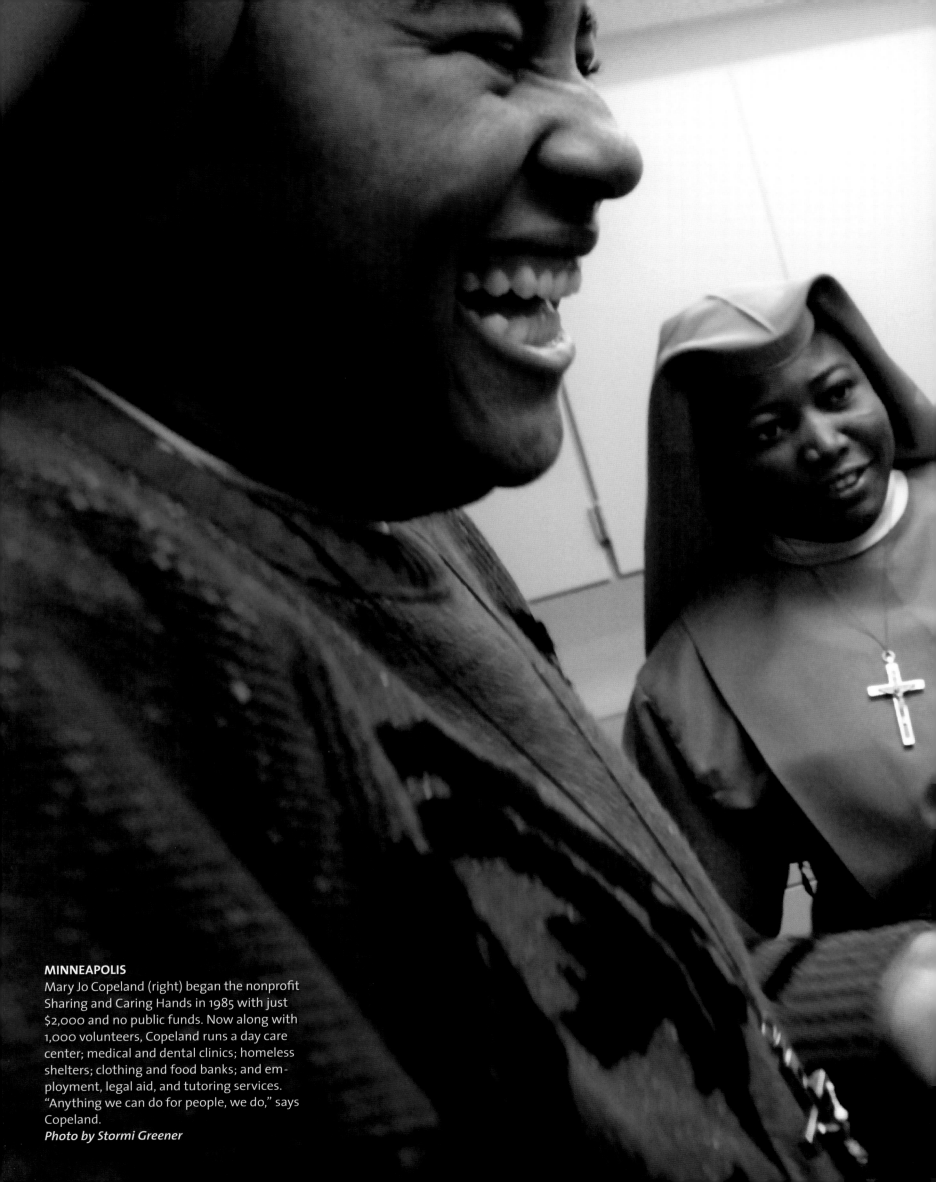

MINNEAPOLIS
Mary Jo Copeland (right) began the nonprofit Sharing and Caring Hands in 1985 with just $2,000 and no public funds. Now along with 1,000 volunteers, Copeland runs a day care center; medical and dental clinics; homeless shelters; clothing and food banks; and employment, legal aid, and tutoring services. "Anything we can do for people, we do," says Copeland.
Photo by Stormi Greener

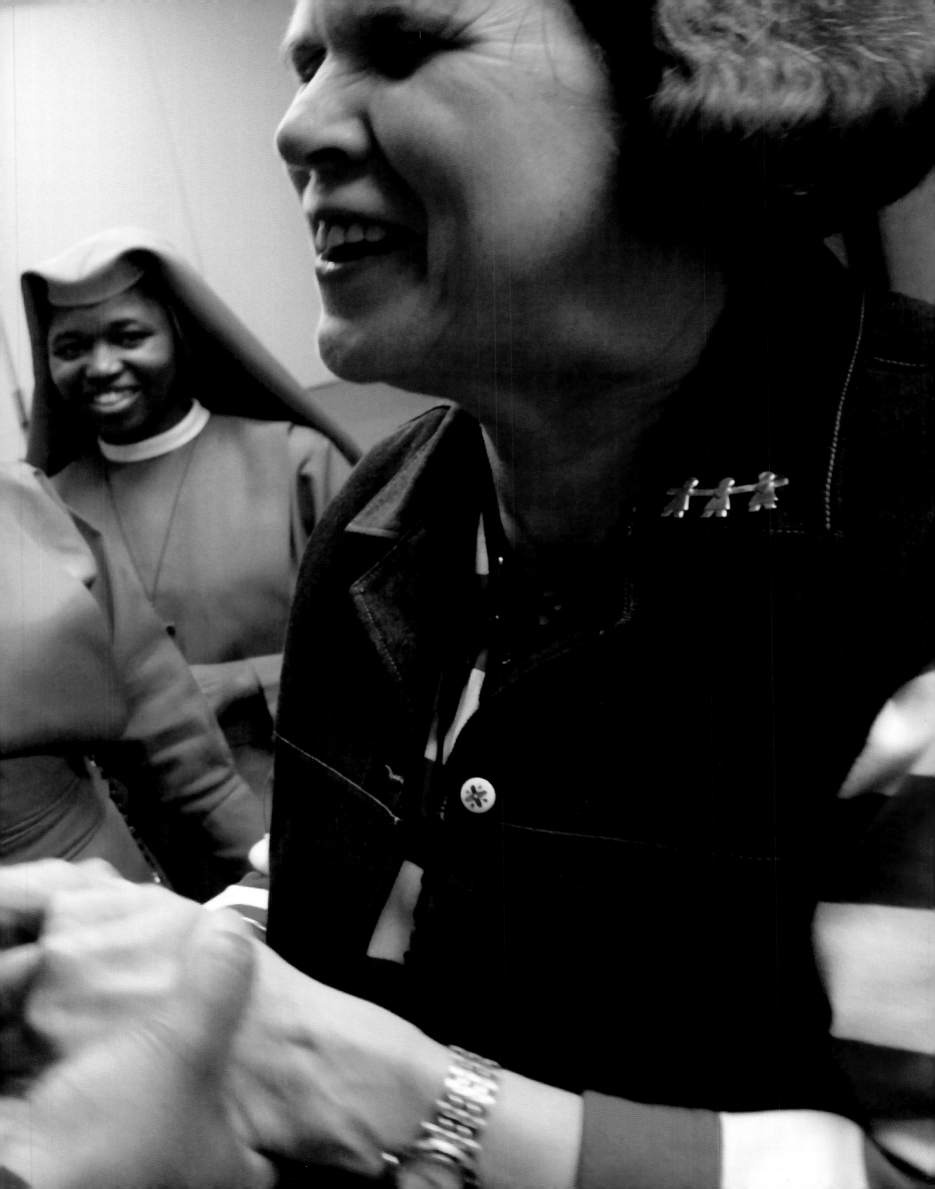

MINNEAPOLIS
Some are blistered, others are frostbitten, all could use some TLC at the foot care clinic, Caring and Sharing Hands.
Photos by Stormi Greener

MINNEAPOLIS
Each day, Copeland and her volunteers scrub, apply antibiotic ointment, and put new socks on the feet of the city's indigent and homeless. "A lot of people say, 'I've never been touched before,'" says Copeland. "It gives them a lot of dignity."

MINNEAPOLIS
Copeland gets a group bear hug from a few of the 400 children living in the program's transitional housing facility. "After raising my own 12 children, I still had a lot of love to share," says Copeland.

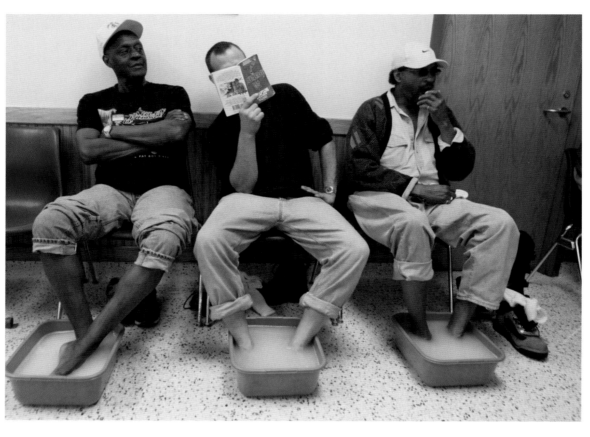

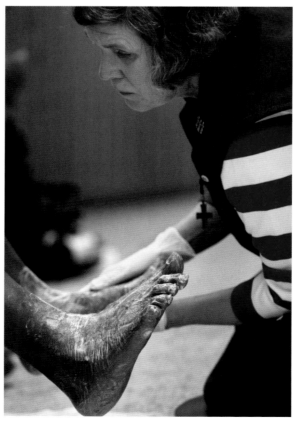

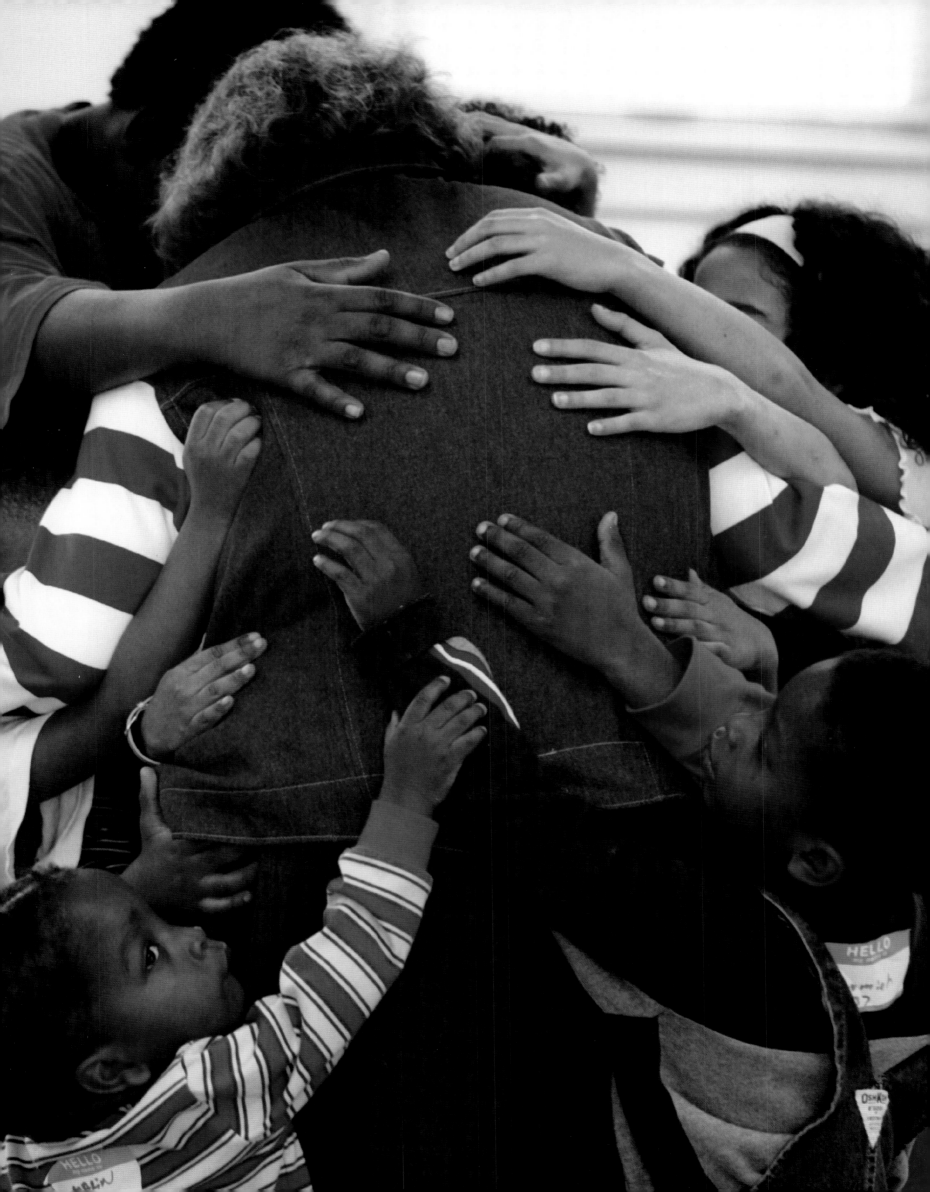

ARDEN HILLS
During a confirmation service at the North Heights Lutheran Church, Bruce Halstengard and Jonna Lenzen stand before a congregation of 1,200. The two were chosen from 100 ninth-grade confirmees to speak on the topic *What Confirmation Means to Me*. "This is a public admission of their faith in Jesus," says Jonna's mom, Joni Lenzen.
Photos by Joel W. Sheagren

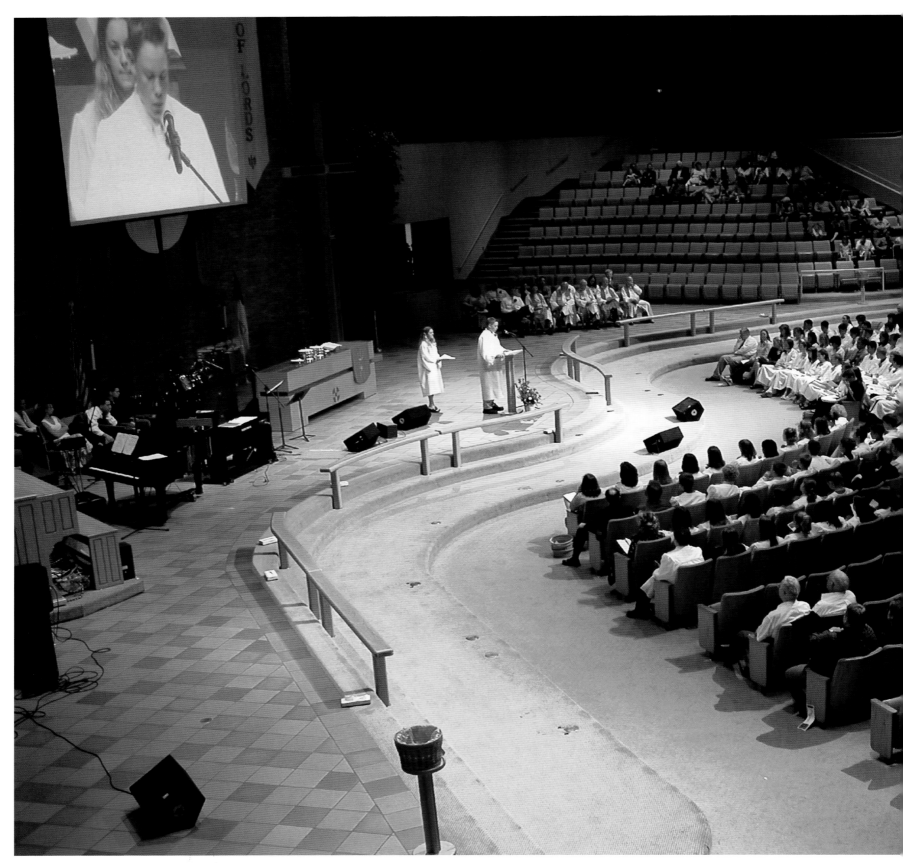

ARDEN HILLS

North Heights Lutheran Church, with 8,000 members, runs an active youth outreach at its locations in Arden Hills and Roseville. Kids can go on ski trips and cultural outings and attend a three-year confirmation program that annually enrolls 420 seventh- through ninth-grade students.

ARDEN HILLS

Pastor Bob Burmeister lays hands on Jonna Lenzen at her confirmation. "My greatest thrill," says the pastor, "is seeing young people fall in love with Jesus and move from despair to hope."

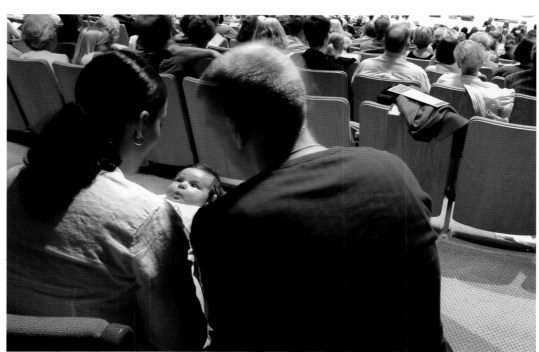

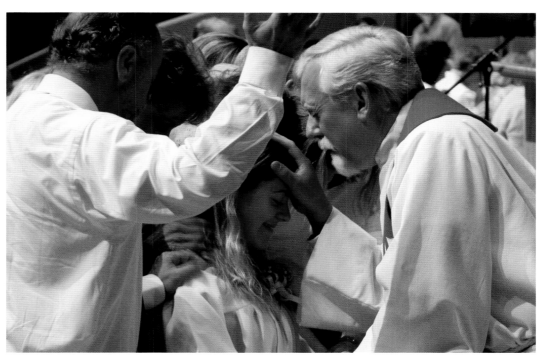

ROCHESTER

In her private cottage on the campus of Assisi Heights Monastery, Sister Clairvaux McFarland works on an icon of Mother Mary Alfred Moes, founder of the Sisters of St. Francis in Rochester. Sister Clairvaux studied under the Russian iconographer Vladislav Andrejev and works in his style, with natural tempera paints, rabbit-skin glue, and linseed oil.
Photo by Dean Riggott, www.riggottphoto.com

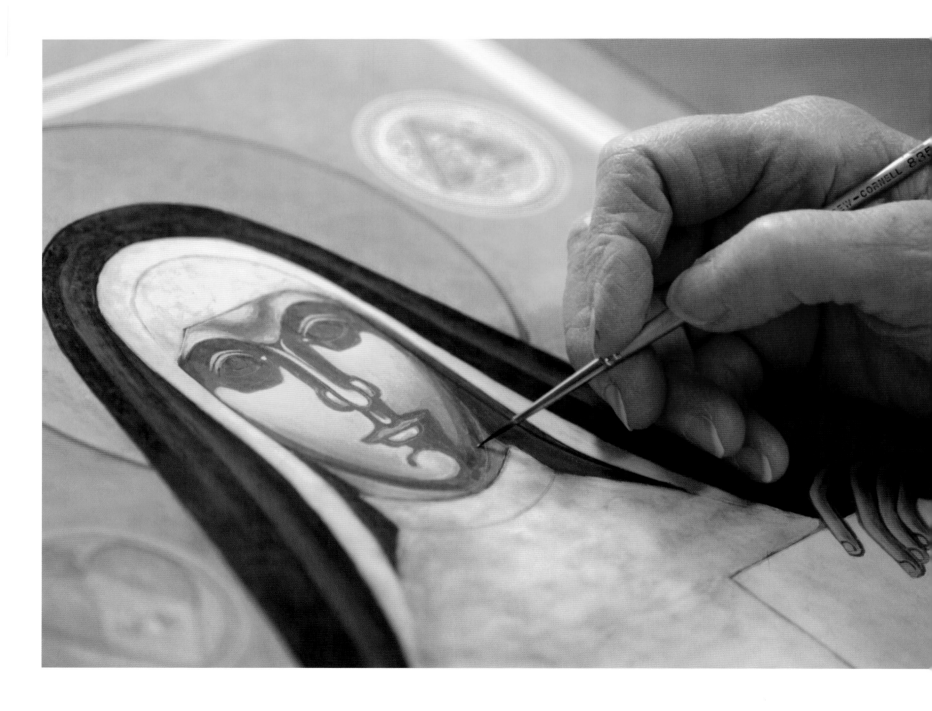

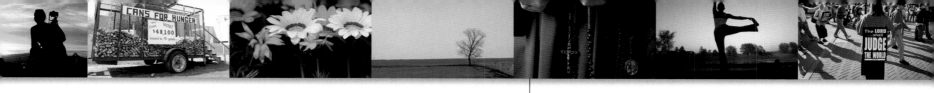

"Hail Mary, full of grace, the Lord is with thee."
Sister Mary Lucy Renner of St. Clare's Monastery
fingers her rosary as she prays.
Photo by Bill Alkofer

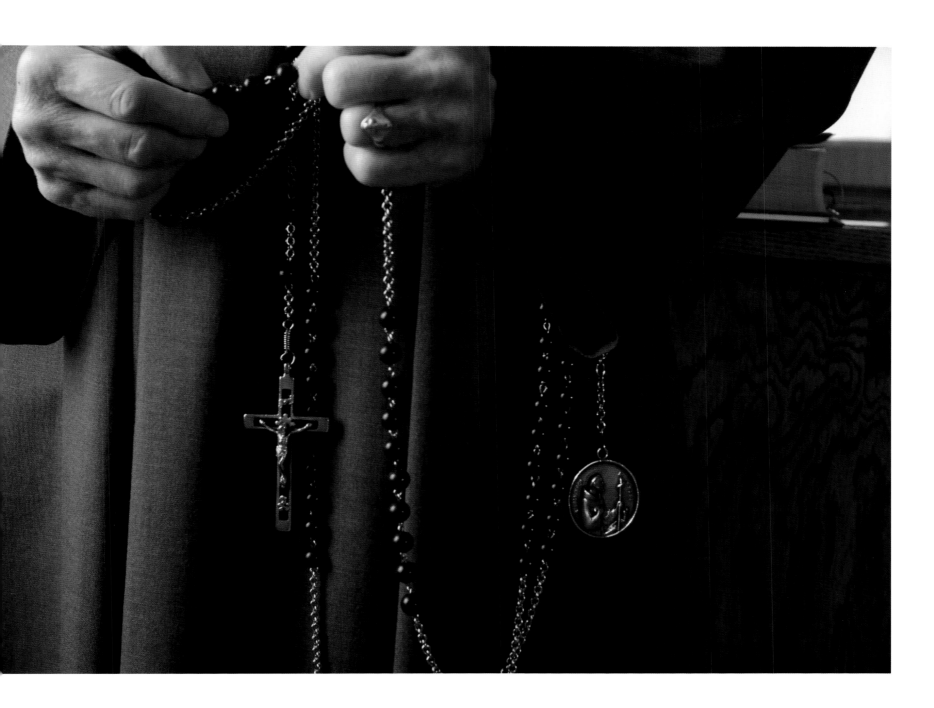

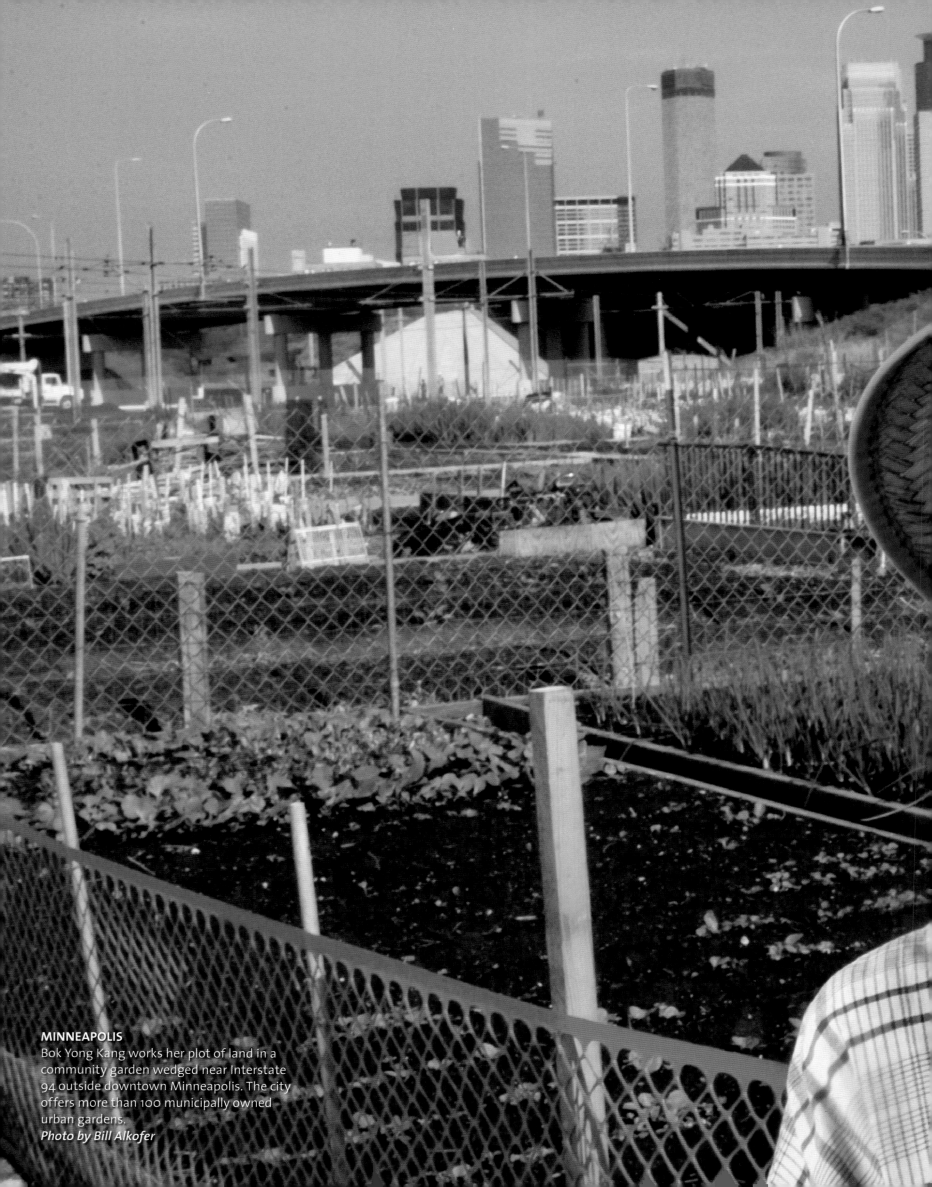

MINNEAPOLIS
Bok Yong Kang works her plot of land in a
community garden wedged near Interstate
94 outside downtown Minneapolis. The city
offers more than 100 municipally owned
urban gardens.
Photo by Bill Alkofer

ELYSIAN

Doris Coon peddles steel cut-out sculptures to passersby from her front lawn. Items in Coon's al fresco gallery go for $20 to $150.

Photo by John L. Cross, The Free Press, Mankato

NORTHFIELD

Don't know much twigonometry: Artist Patrick Dougherty made his twig sculpture with willow, buckhorn, and dogwood saplings harvested from the grounds of Carleton College. The sculpture sits on the north edge of "the bald spot," an open area in the center of campus.

Photo by Renée Jones, Owatonna People's Press

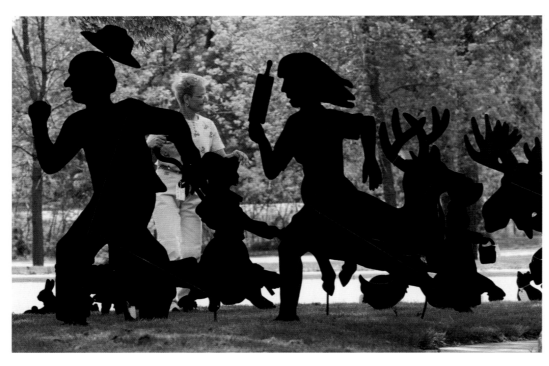

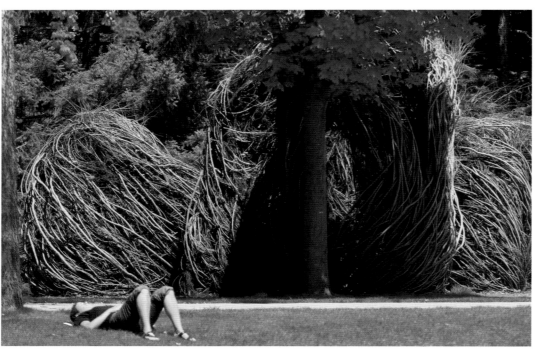

ROCHESTER

Former State Senator Nancy Brataas relaxes in her English garden. The first woman elected to the Minnesota Senate, Brataas served from 1975 to 1992. Retired now, she tends her garden of hosta, clematis, dogwoods, and pines. "I wanted to have beautiful views," she says. "I needed something worthy to look at."
Photo by Dean Riggott, www.riggottphoto.com

MANKATO

Loyola High School students hide out in an underground tunnel during a tornado warning, a common occurrence in a state where spring brings more than just showers and flowers. In 1998, a tornado destroyed 500 homes in the town of St. Peter, just 20 miles northwest of Mankato.

Photos by Judy Griesedieck

MINNEAPOLIS

Children on bicycles and tricycles and scooters circle the block during the Linden Hills Festival parade. The annual spring celebration has been bringing pony and fire engine rides, chess tournaments, and art booths to this southwest city neighborhood for 30 years.

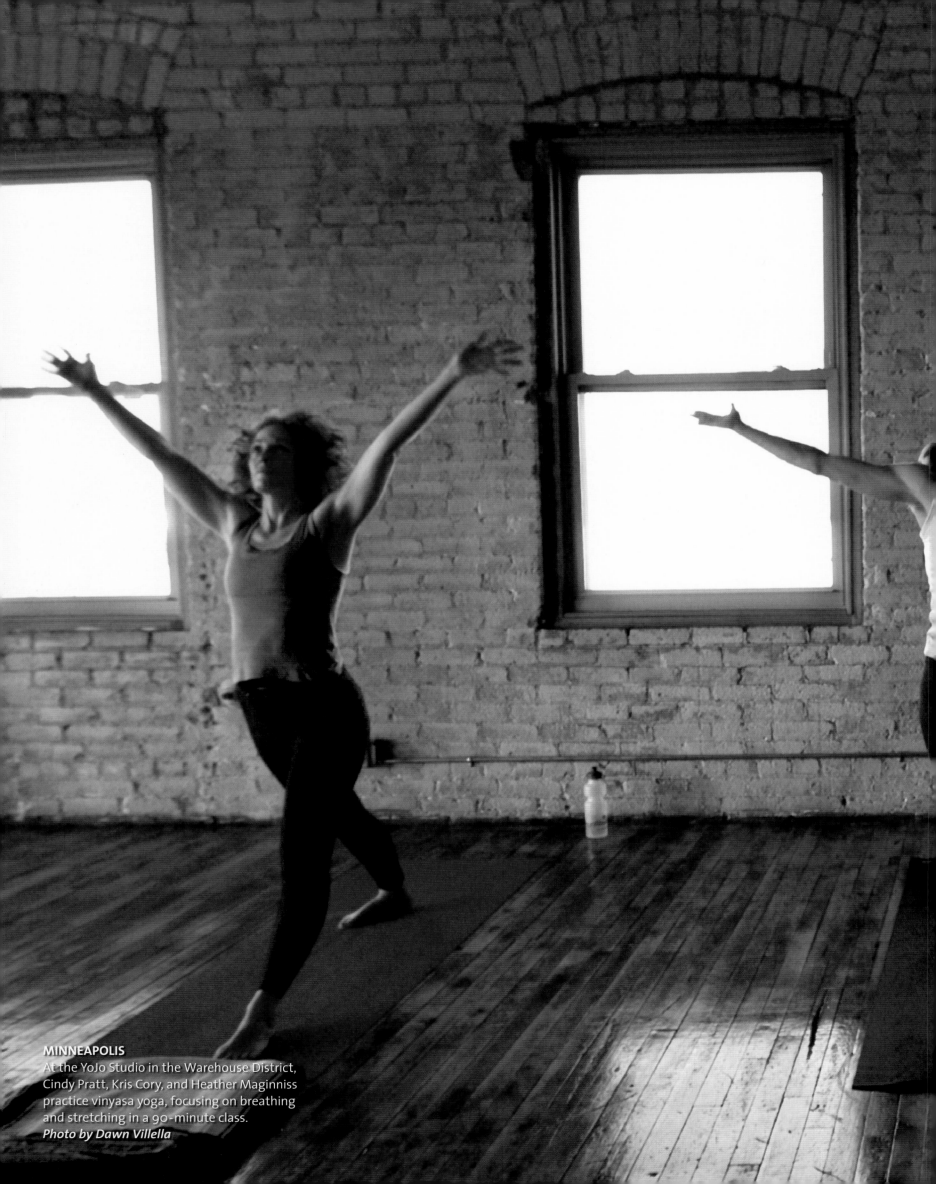

MINNEAPOLIS
At the YoJo Studio in the Warehouse District, Cindy Pratt, Kris Cory, and Heather Maginniss practice vinyasa yoga, focusing on breathing and stretching in a 90-minute class.
Photo by Dawn Villella

Fifth-graders at St. Francis Xavier School add to the 700 signatures on the hood of Richard Lahr's 1977 Ford pickup. The Vietnam vet created his "Life Truck" in 1990 because, he says, "I wanted to remind people what America is about." He painted "Life, Liberty, and Pursuit of Happiness" on the sides and has collected 3,000 veterans' signatures on the bed.

Photo by Dianne Towalski

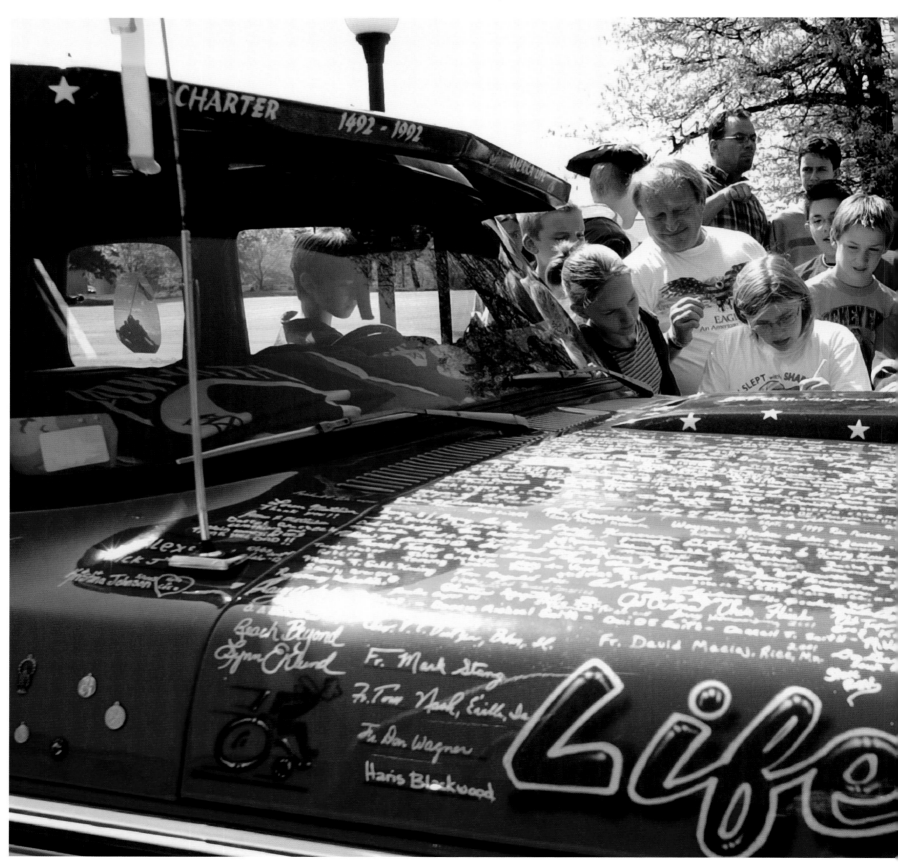

MINNEAPOLIS

Te'Erica Jones and Hamdi Hudle learn about each other's food traditions while planting seeds in the Lyndale Elementary School garden. The program, run by the Youth Farm and Market project, teaches students how to grow and cook food indigenous to the city's immigrant communities. On the menu this season: gourds, quinoa, lemongrass, and epazote.

Photo by Brian Peterson,
The Minneapolis Star-Tribune

ST. PAUL

"When I am an old woman I shall wear purple, with a red hat which doesn't go and doesn't suit me," goes the poem by Elizabeth Johnson that inspired the first Red Hat Society chapter in 2000. Since then, 5,000 groups have sprung up nationwide. The sole purpose of the society is for its members (women over 55) to have fun together.
Photo by Derek J. Dickinson

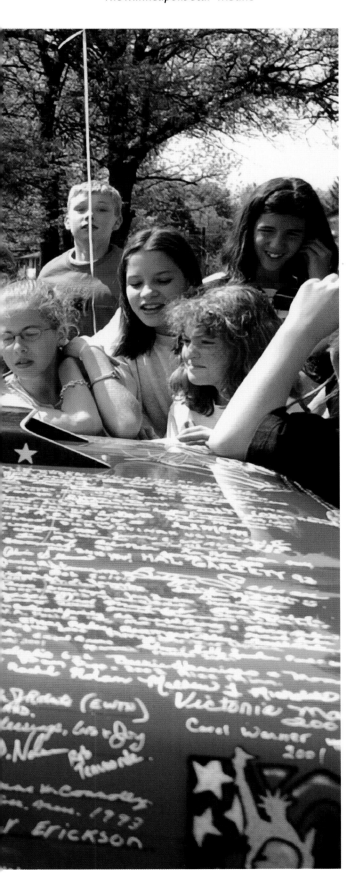

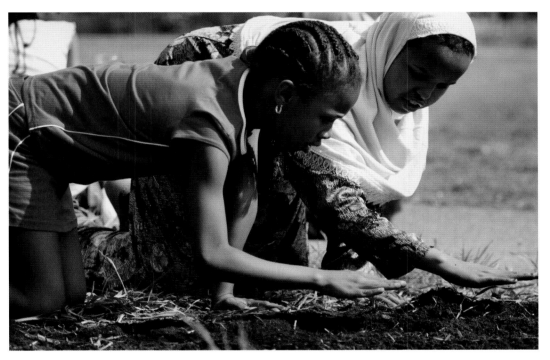

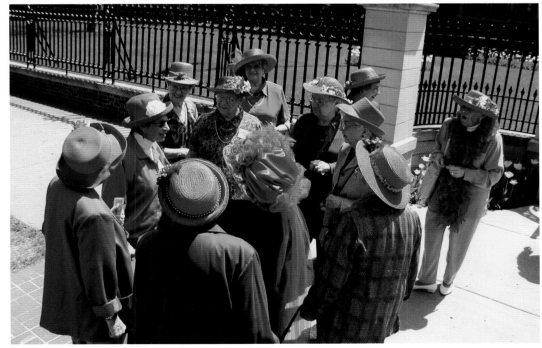

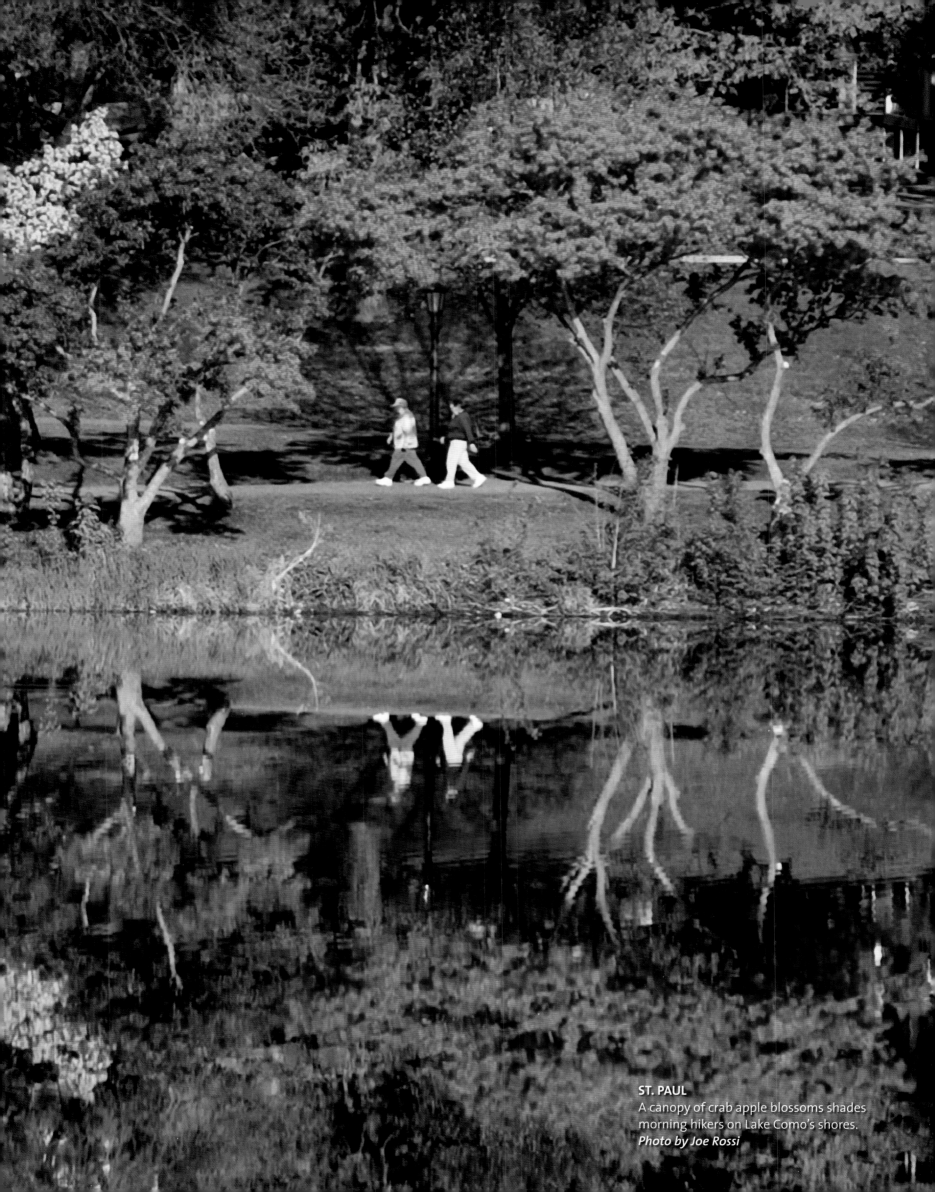

ST. PAUL
A canopy of crab apple blossoms shades
morning hikers on Lake Como's shores.
Photo by Joe Rossi

MINNEAPOLIS

With a cherry on top: Claes Oldenburg and
Coosje van Bruggen's *Spoonbridge and Cherry* is
on permanent display at the Minneapolis Sculp-
ture Garden. Those tempted to scale the enamel-
painted stainless steel and aluminum work are
better off appreciating it from a dry distance—
the cherry stem is also a fountain.
Photo by Todd Asher

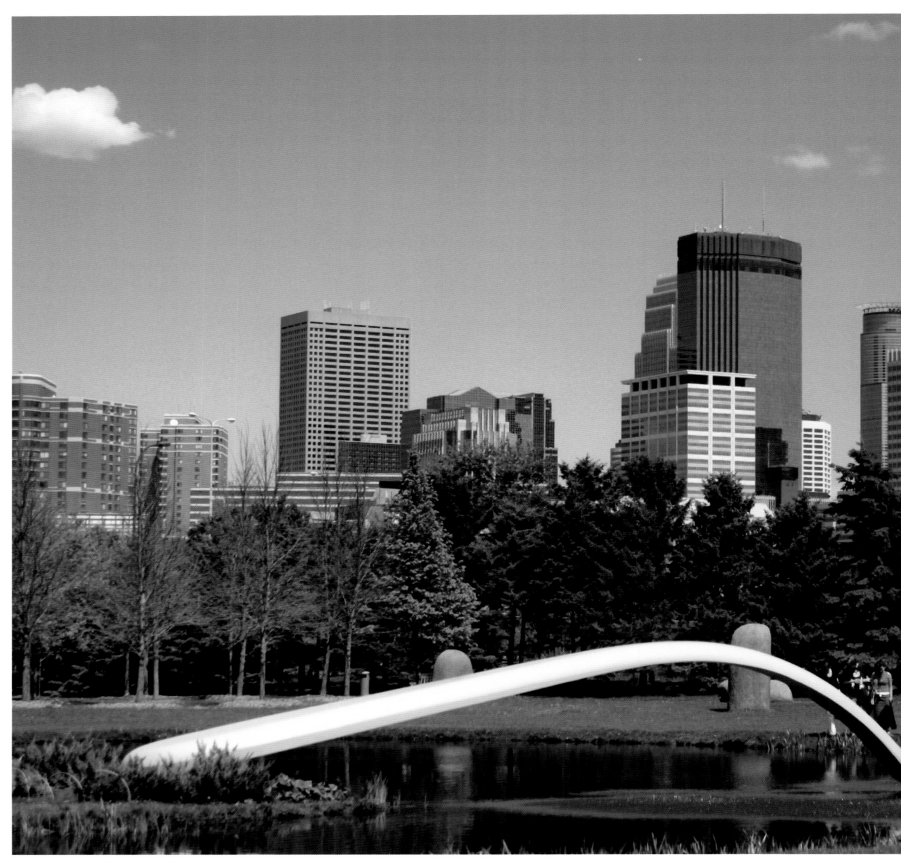

PAYNESVILLE

LuAnn Orbeck's homage to her family's 80 Holstein cows graces the north side of the barn. Dairy cows were brought to Paynesville in the 1880s and 1890s by the town's first Norwegian settlers, and Stearns County is still the top dairy-producing county in Minnesota.

Photo by Kimm Anderson

MINNEAPOLIS

Five sharp notes and two lines in bass clef kick off this movement of Maurice Ravel's notoriously difficult piano piece "Gaspard de la Nuit." The sheet music painted on the south wall of the former Schmitt Music headquarters was put to use only once; Van Cliburn performed the work from the parking lot during a 1977 visit.

Photo by Joe Rossi

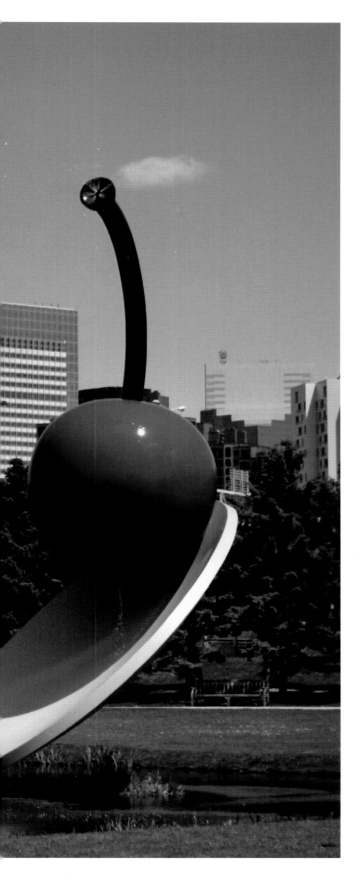

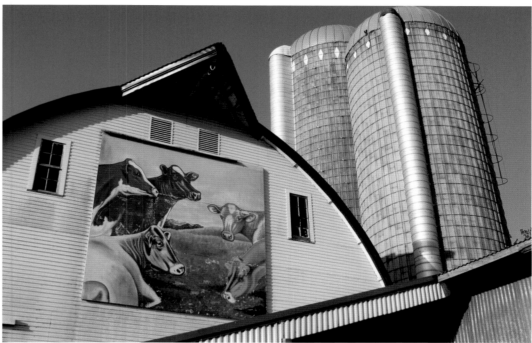

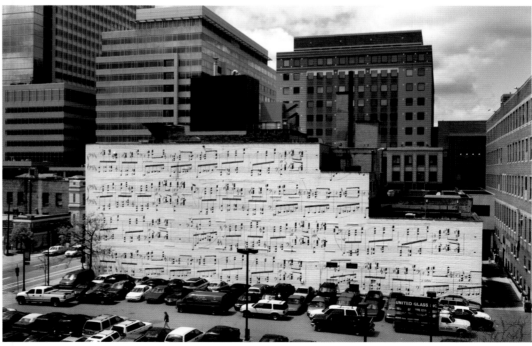

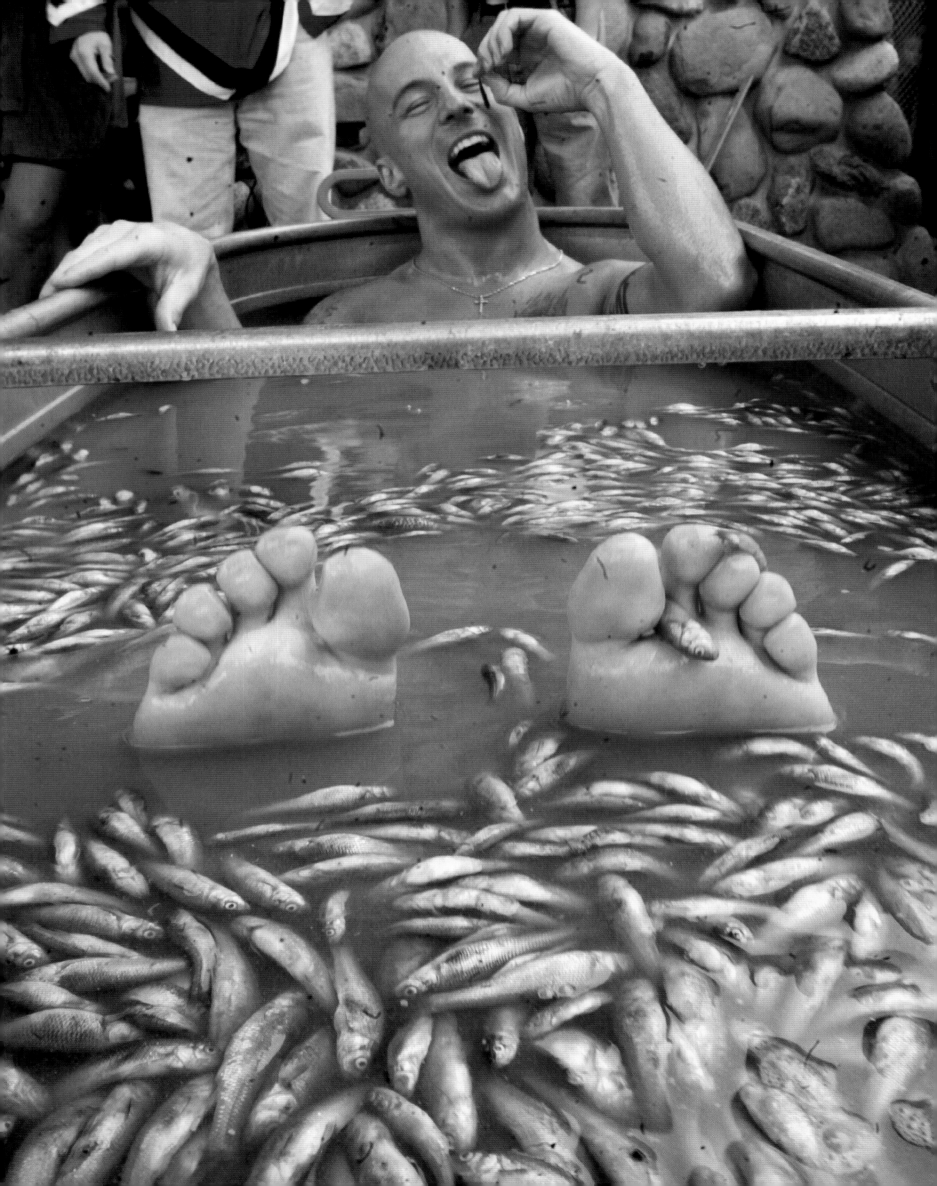

EAST GRAND FORKS

Give a man a fish, and he'll eat for a day. Give a man a tryout for NBC's reality gross-out show *Fear Factor*, and he'll bathe in a pool of cow's blood, leeches, and ground catfish. Brian LaChance also ate a cow's stomach lining and a bull's testicle on a bed of live night crawlers, but he still didn't make the cut.
Photo by Eric Hylden,
Grand Forks Herald

AUSTIN

Almost every week, "the girls"—Mary Belle Blanchard, Gloria Campbell, and Myrna Estrem—explore their backyard with a day trip. This time it's a visit to the Spam Museum, dedicated to the canned, processed ham invented here in 1937 and which soon became a staple for the Allies during World War II.
Photo by Renée Jones,
Owatonna People's Press

ST. PAUL

Ten-year-old Isaac Marshall devotes his afternoons to baseball, ceramics, and clowning. Here, he and fellow clown Mark Engelmeyer prepare for a dress rehearsal with Circus Juventas. Founded in 1995 and modeled after Cirque du Soleil, Circus Juventas trains 550 youth from ages 2 to 20 in acrobatics and physical comedy.
Photo by Scott Cohen

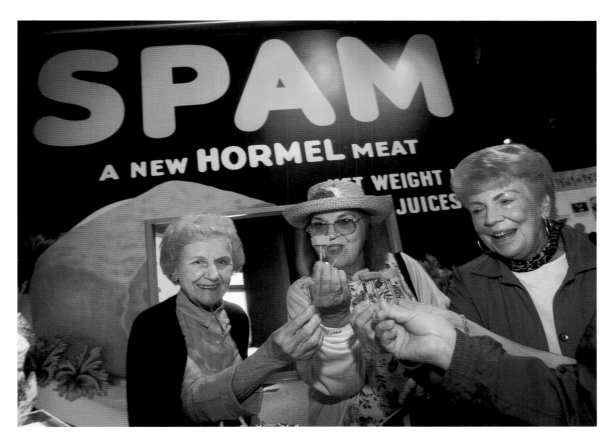

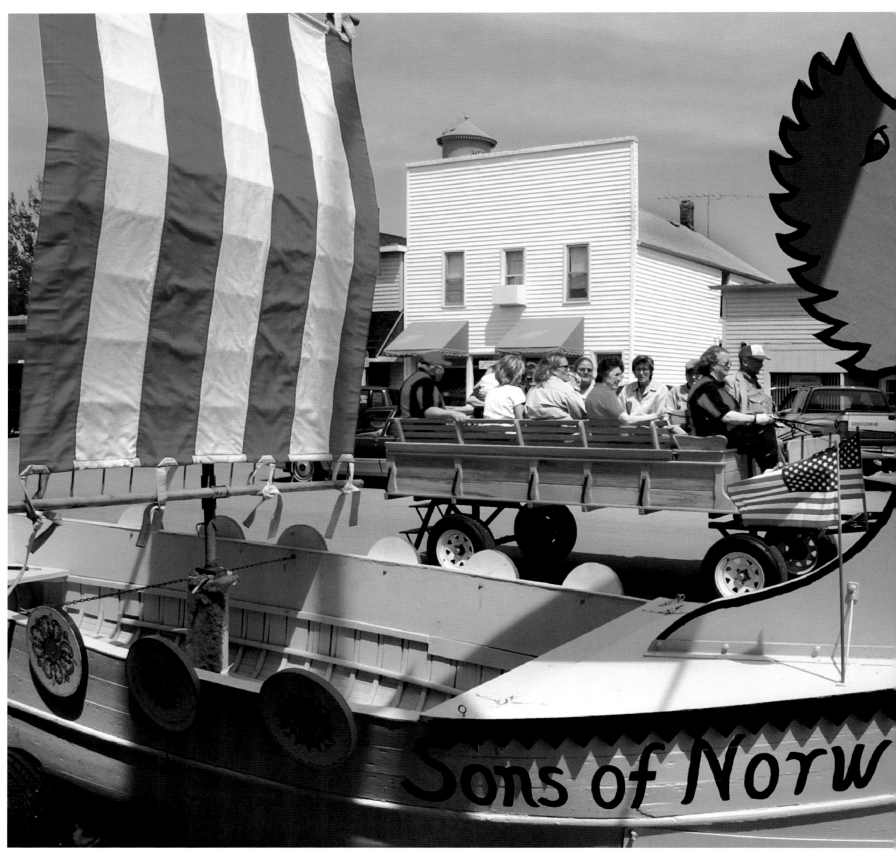

HENDRICKS

"The climate, the situation, and the character of the scenery agrees with our people," wrote Swedish settler Frederika Bremer of Minnesota in 1850. A century and a half later, Scandinavian culture is still alive and well. During the annual Syttende Mai celebration, Hendricks residents show off their Nordic roots with a parade of trolls, a lutefiske feast, and wagon rides.
Photo by Joe Rossi

MINNEAPOLIS

Russ Erickson marches down East 21st Street in the traditional Mindekirken Norwegian Lutheran Memorial Church parade celebrating Syttende Mai. The holiday marks Norway's 189 years of constitutional independence from Denmark and 98 years from Sweden.

Photo by Bill Alkofer

HENDRICKS

Viking-in-training Bobby Isbel tries on a warrior helmet for size during the coronation of "Ole" and "Lena," the king and queen of Syttende Mai, or the 17th of May. The honor is bestowed upon the hardest working, most civically active residents of Hendricks.

Photo by Joe Rossi

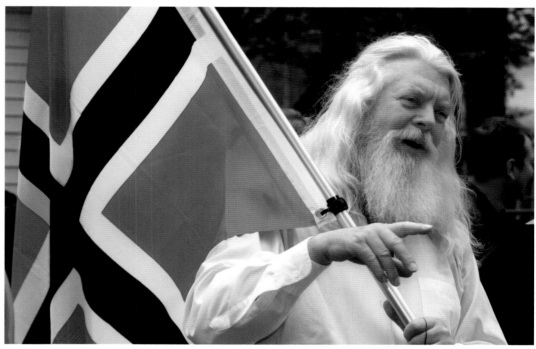

ST. PAUL

At the Fitzgerald Theater, Garrison Keillor weaves yarns about the mythical Minnesota town of Lake Wobegon, "where the women are strong, the men are good looking, and all of the children are above average." First broadcast in 1974, the live radio show is now carried by more than 530 stations worldwide.
Photo by Darlene Pfister Prois

MINNEAPOLIS

Sunset burnishes the Frederick R. Weisman Art Museum on the University of Minnesota campus. Designed by renowned architect Frank Gehry and completed in 1993, the 11,000-square-foot brick and stainless steel museum houses the world's largest collections of works by the American expressionist painter Marsden Hartley and the modernist Alfred Maurer.
Photo by Jayme Clifton Halbritter

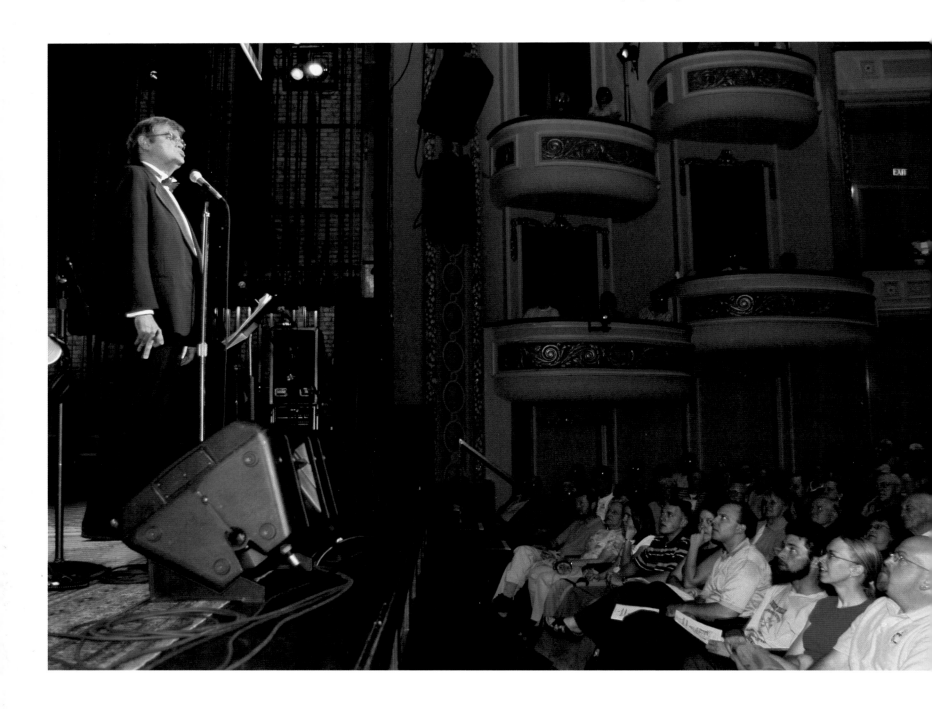

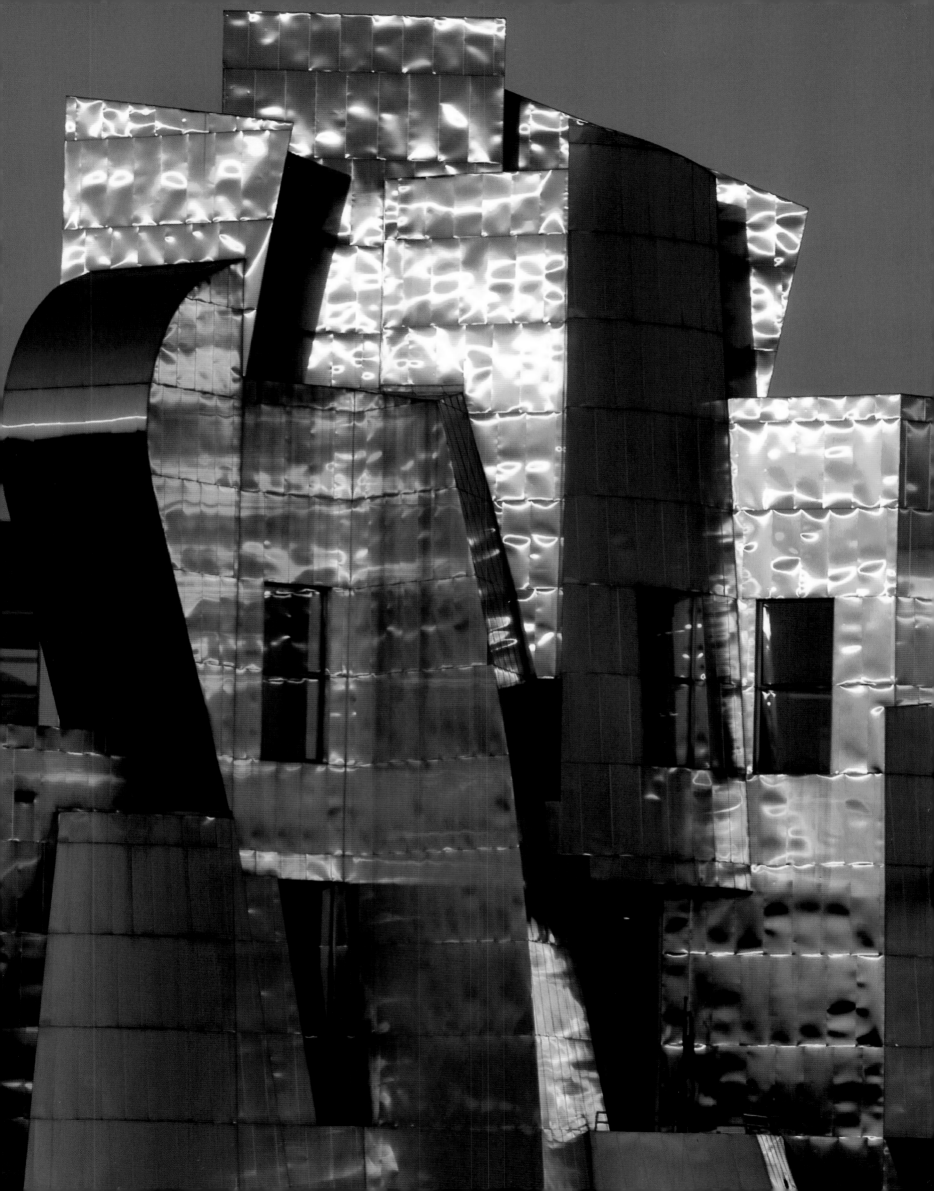

HENDRICKS

They save the family farm. For corn and grain growers in Lincoln County, wind farming is a god-send. Land leased to utility companies for turbine installation can bring in up to $5,000 per turbine per year, welcome funds in this poor area. In 2003, Lincoln County received 25 percent of its tax revenue from wind power.
Photo by Joe Rossi

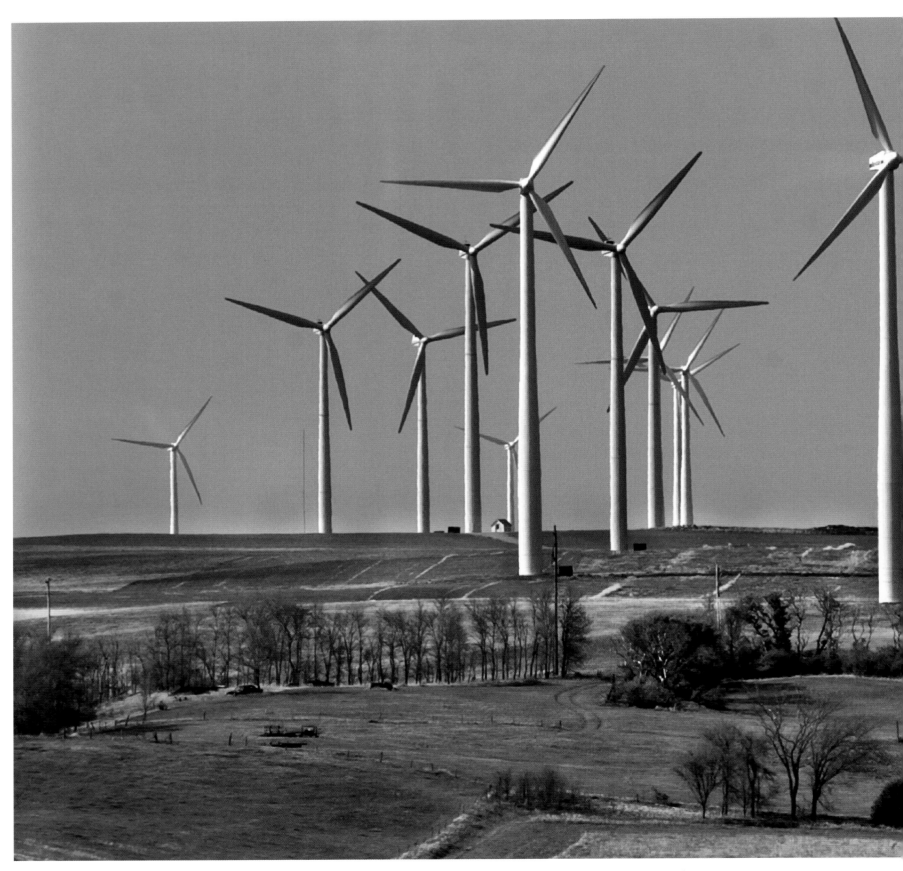

ROCHESTER

Kelly's Orchard, Thursday, May 15, 11:13 p.m. The moon begins its passage through the earth's shadow. The first total lunar eclipse in three years is visible across North and South America, as well as from Africa, Europe, and Antarctica.

Photo by Dean Riggott, www.riggottphoto.com

WINNEBAGO

"Small town...big dreams," reads the sign at the entrance to Winnebago, a farming community of 1,487 souls. At this homestead along Highway 169, those dreams might include a healthy grain harvest and a mild winter.

Photo by John L. Cross, The Free Press, Mankato

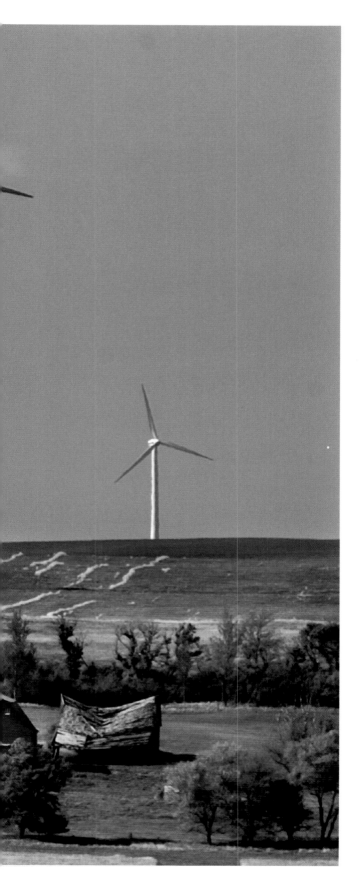

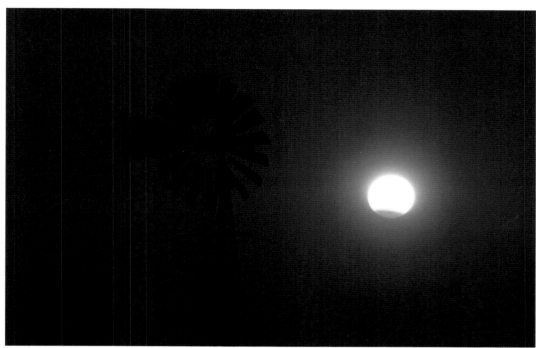

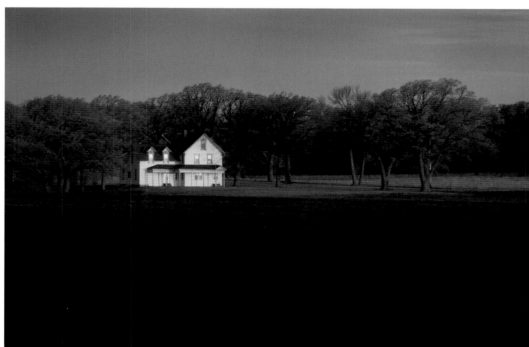

ISABELLA LAKE

The Boundary Waters Canoe Area Wilderness is home to 1,000 miles of lakes and streams and 400 miles of hiking trails. In winter, dogsledders and snowshoers traverse the forests and ice, and in spring, hikers and canoeists commune with a landscape of wildflowers, birch, and white pine.
Photo by Richard Hamilton Smith

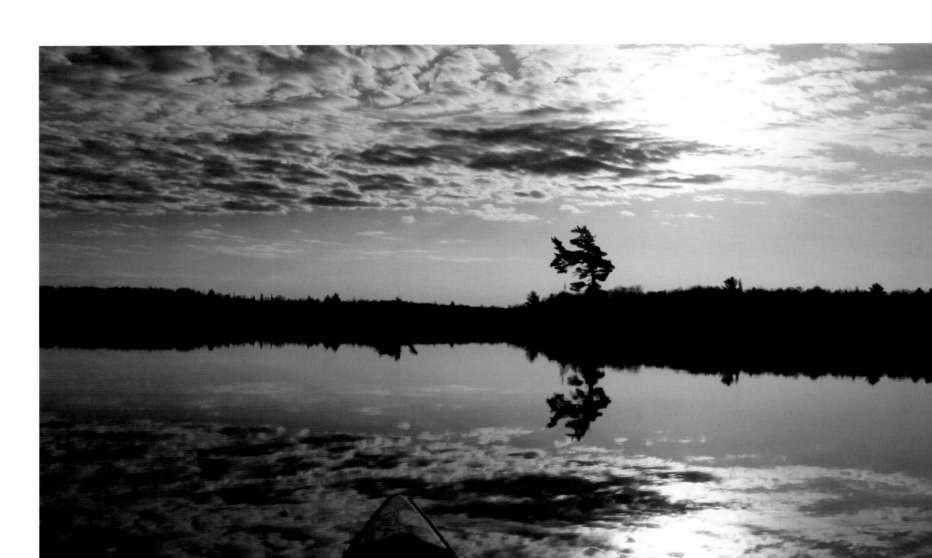

EDINA

The Krieter family's backyard slopes down to Garrison Pond, which is home to bugs, dragonflies, loons, and Canada geese in the summer. Come winter, locals with hockey sticks, pucks, and helmets turn the frozen pond into a popular hockey rink.
Photo by Mike Krieter

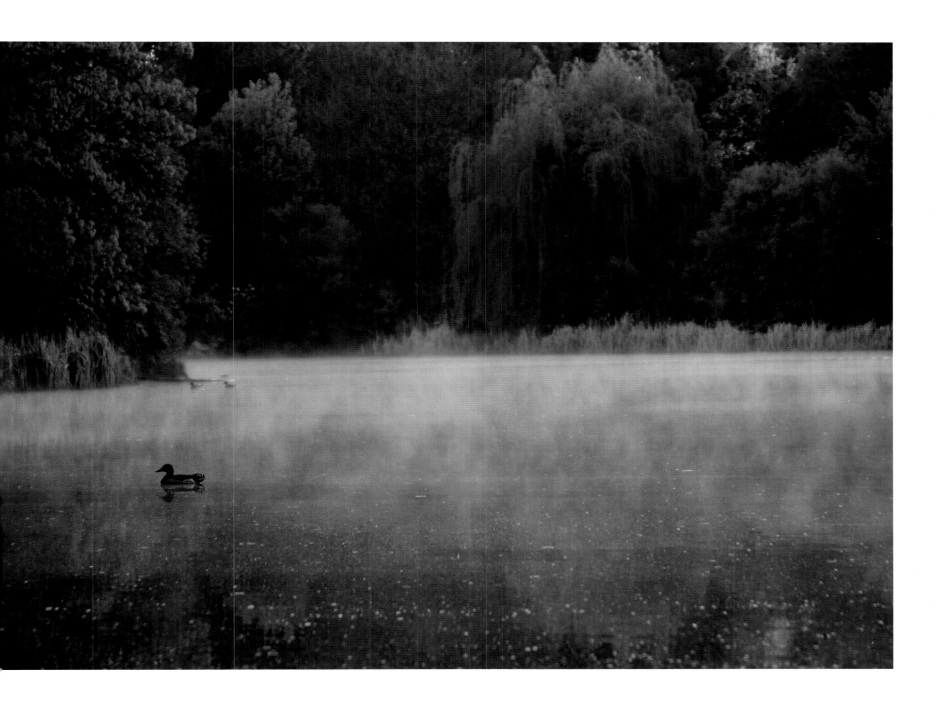

RED LAKE INDIAN RESERVATION
Spring is definitely in the air as two young moose canoodle on the reservation in northwestern Minnesota. September hunting season is limited to the northeastern part of the state—lucky for these two.
Photo by Bill Alkofer

ISABELLA LAKE
On the forest floor near the lake, fallen ne⟨⟩ and cones from white pine nestle into a tr⟨⟩ roots.
Photo by Richard Hamilton Smith

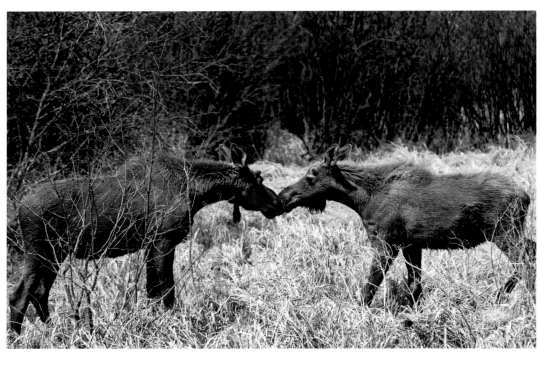

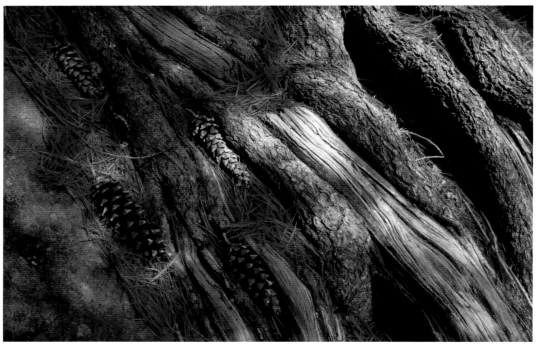

GRANITE FALLS
Twilight falls on American white pelicans perusing a dam's spillway on the Minnesota River for carp and walleye.
Photo by Joe Rossi

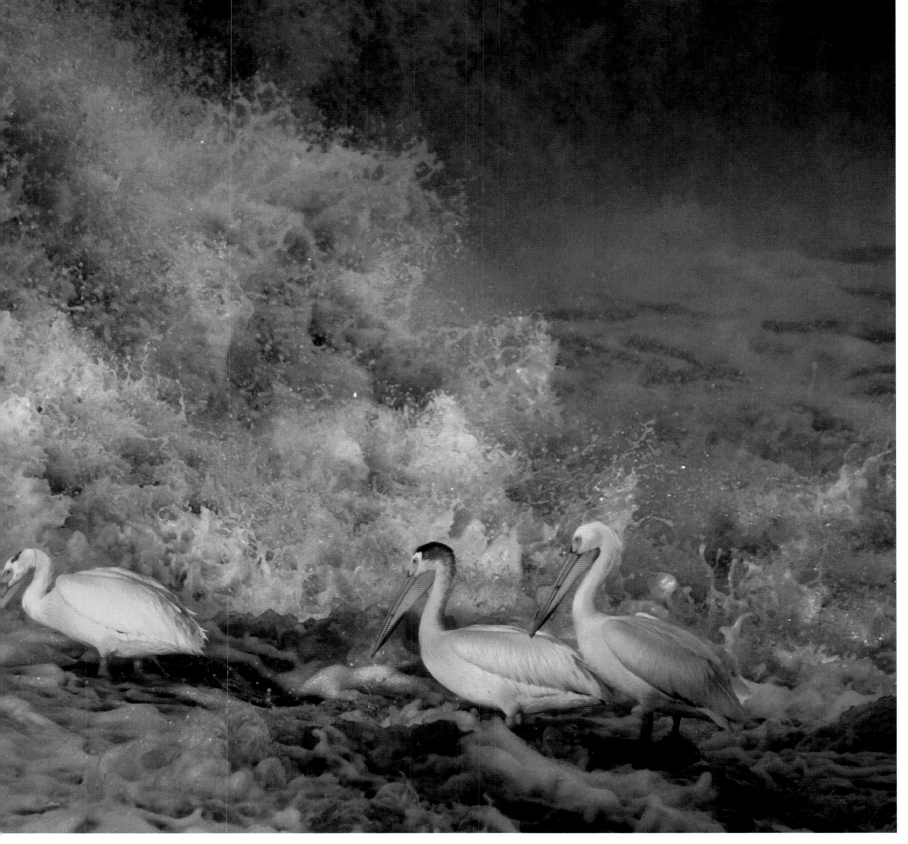

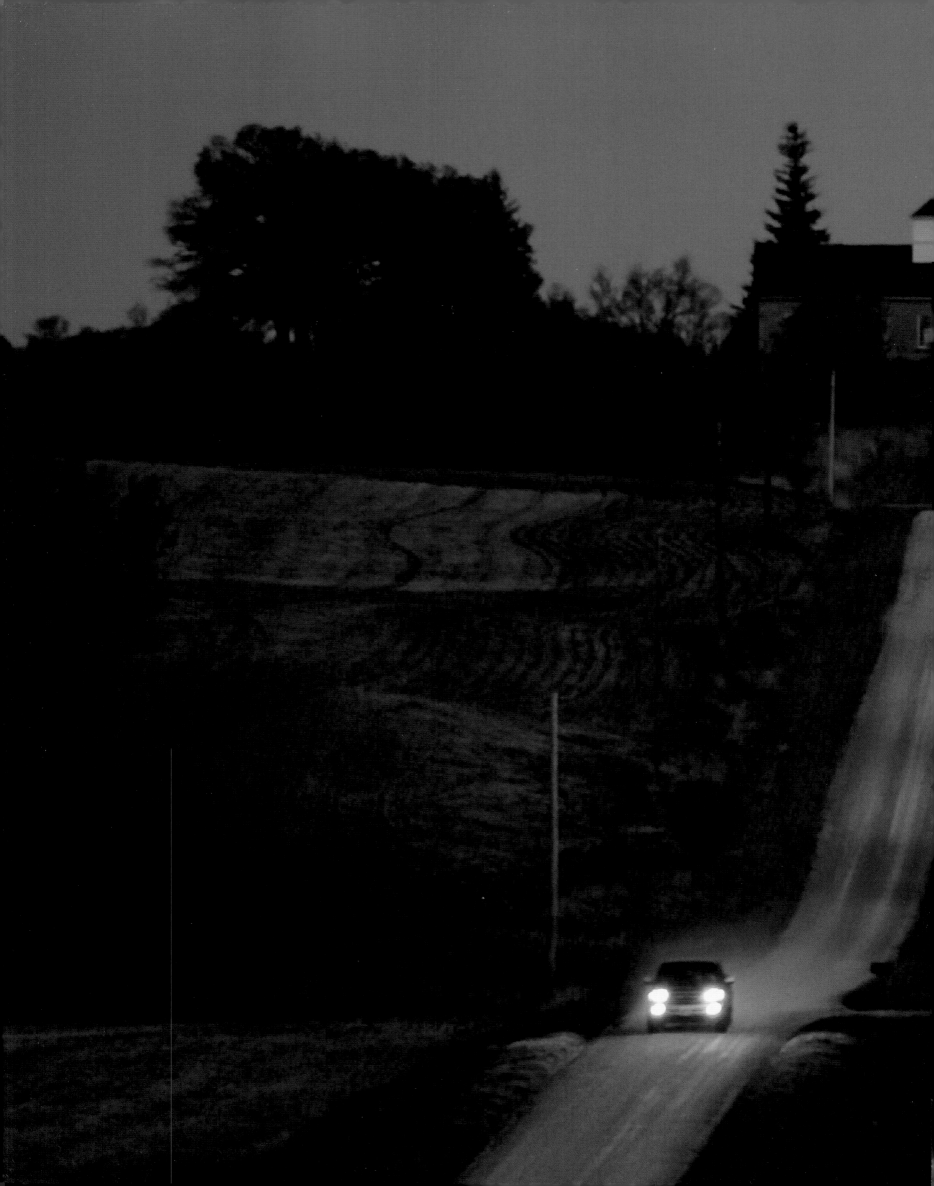

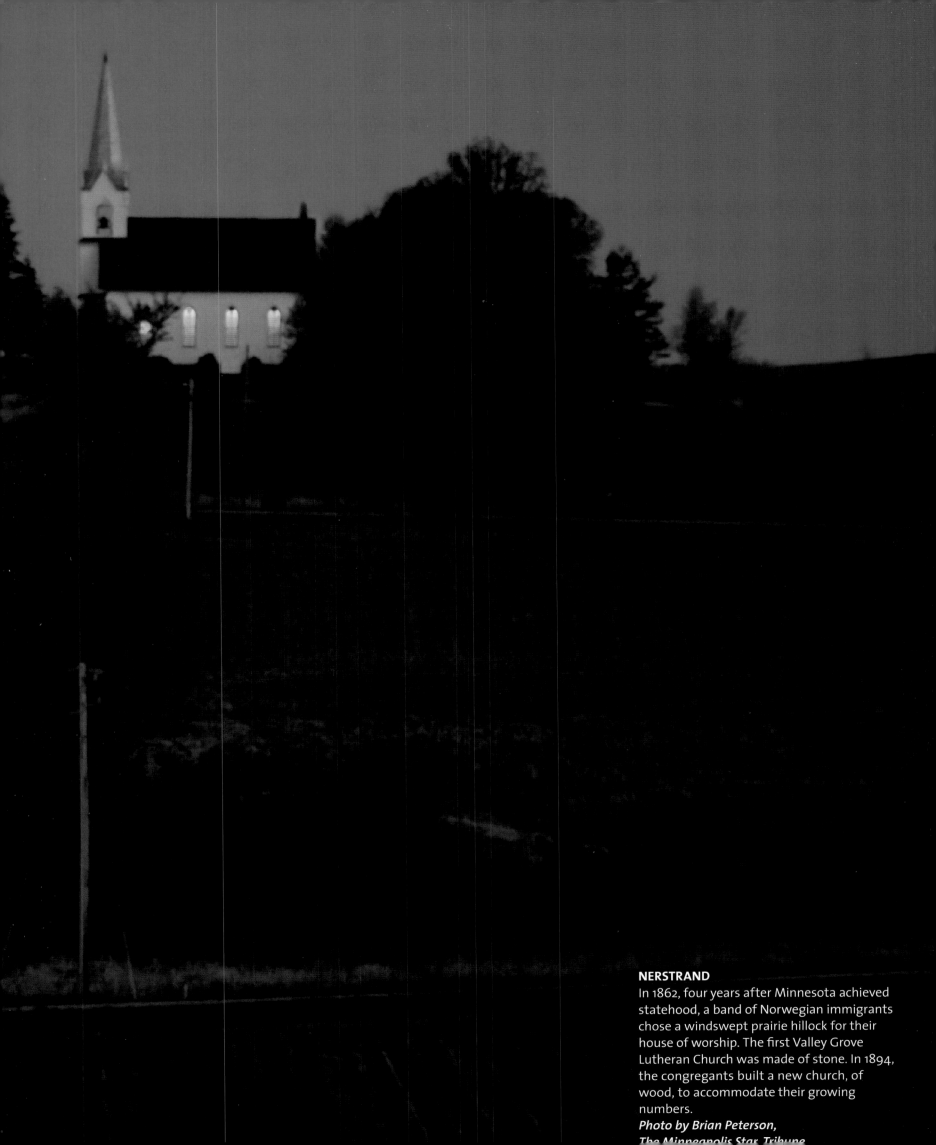

NERSTRAND

In 1862, four years after Minnesota achieved statehood, a band of Norwegian immigrants chose a windswept prairie hillock for their house of worship. The first Valley Grove Lutheran Church was made of stone. In 1894, the congregants built a new church, of wood, to accommodate their growing numbers.

Photo by Brian Peterson,
The Minneapolis Star Tribune

The week of May 12-18, 2003, more than 25,000 professional and amateur photographers spread out across the nation to shoot over a million digital photographs with the goal of capturing the essence of daily life in America.

The professional photographers were equipped with Adobe Photoshop and Adobe Album software, Olympus C-5050 digital cameras, and Lexar Media's high-speed compact flash cards.

The 1,000 professional contract photographers plus another 5,000 stringers and students sent their images via FTP (file transfer protocol) directly to the *America 24/7* website. Meanwhile, thousands of amateur photographers uploaded their images to Snapfish's servers.

At *America 24/7*'s Mission Control headquarters, located at CNET in San Francisco, dozens of picture editors from the nation's most prestigious publications culled the images down to 25,000 of the very best, using Photo Mechanic by Camera Bits. These photos were transferred into Webware's ActiveMedia Digital Asset Management (DAM) system, which served as a central image library and enabled the designers to track, search, distribute, and reformat the images for the creation of the 51 books, foreign language editions, web and magazine syndication, posters, and exhibitions.

Once in the DAM, images were optimized (and in some cases resampled to increase image resolution) using Adobe Photoshop. Adobe InDesign and Adobe InCopy were used to design and produce the 51 books, which were edited and reviewed in multiple locations around the world in the form of Adobe Acrobat PDFs. Epson Stylus printers were used for photo proofing and to produce large-format images for exhibitions. The companies providing support for the *America 24/7* project offer many of the essential components for anyone building a digital darkroom. We encourage you to read more on the following pages about their respective roles in making *America 24/7* possible.

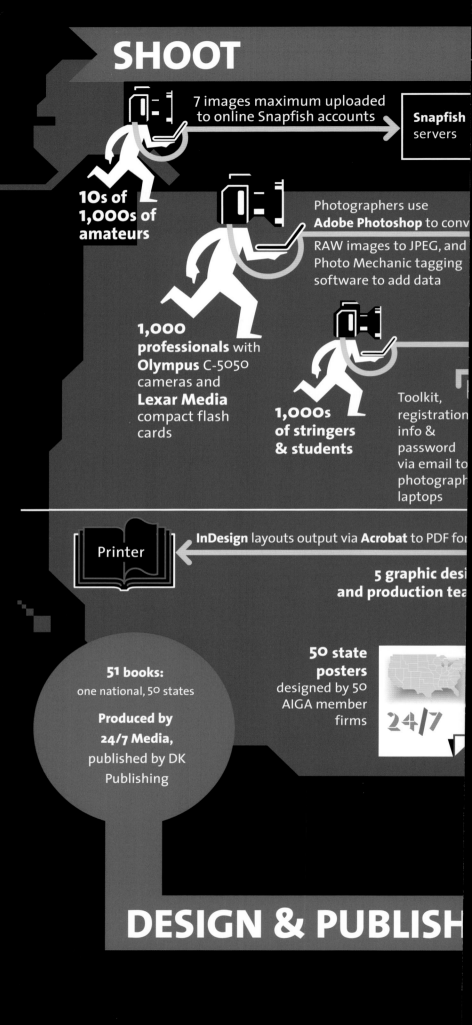

SHOOT

7 images maximum uploaded to online Snapfish accounts → **Snapfish** servers

10s of 1,000s of amateurs

Photographers use **Adobe Photoshop** to conv[ert] RAW images to JPEG, and Photo Mechanic tagging software to add data

1,000 professionals with **Olympus** C-5050 cameras and **Lexar Media** compact flash cards

1,000s of stringers & students

Toolkit, registration info & password via email to photograph[er] laptops

Printer ← **InDesign** layouts output via **Acrobat** to PDF fo[r]

5 graphic desi[gn] **and production tea**[m]

51 books: one national, 50 states

Produced by 24/7 Media, published by DK Publishing

50 state posters designed by 50 AIGA member firms

24/7

DESIGN & PUBLISH

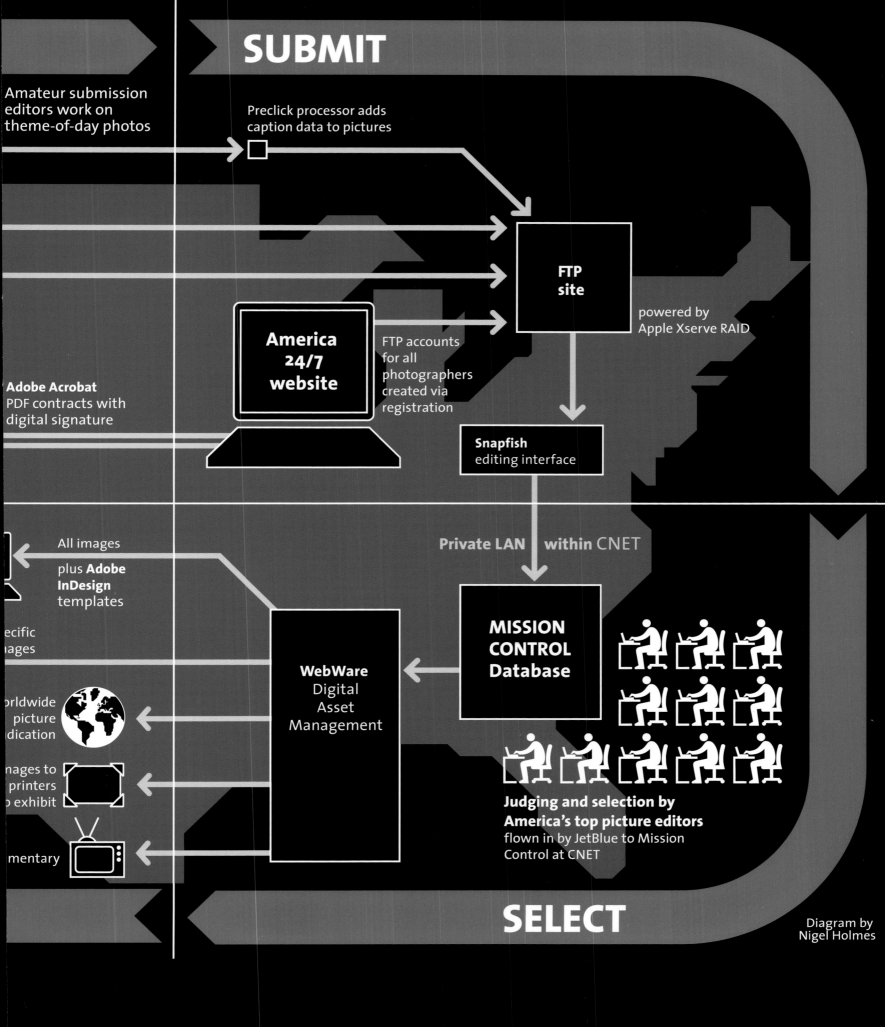

SUBMIT

Amateur submission
editors work on
theme-of-day photos

Preclick processor adds
caption data to pictures

FTP
site

powered by
Apple Xserve RAID

America
24/7
website

FTP accounts
for all
photographers
created via
registration

Adobe Acrobat
PDF contracts with
digital signature

Snapfish
editing interface

All images

plus Adobe
InDesign
templates

Private LAN within CNET

...ecific
...ages

MISSION
CONTROL
Database

WebWare
Digital
Asset
Management

...orldwide
picture
...dication

...nages to
...printers
...o exhibit

...mentary

Judging and selection by
America's top picture editors
flown in by JetBlue to Mission
Control at CNET

SELECT

Diagram by
Nigel Holmes

Minnesota 24/7

About Our Sponsors

Adobe

America 24/7 gave digital photographers of all levels the opportunity to share their visions of what it means to live in the United States. This project was made possible by a digital photography revolution that is dramatically changing and improving picture-taking for professionals and amateurs alike. And an Adobe product, Photoshop®, has been at the center of this sea change.

Adobe's products reflect our customers' passion for the creative process, be it the photographer, graphic designer, layout artist, or printer. Adobe is the Publishing and Imaging Software Partner for *America 24/7* and products such as Adobe InDesign®, Photoshop, Acrobat®, and Illustrator® were used to produce this stunning book in a matter of weeks. We hope that our software has helped do justice to the mythic images, contributed by well-known photographers and the inspired hobbyist.

Adobe is proud to be a lead sponsor of *America 24/7*, a project that celebrates the vibrancy of the American spirit: the same spirit that helped found Adobe and inspires our employees and customers to deliver the very best.

Bruce Chizen
President and CEO
Adobe Systems Incorporated

OLYMPUS

Olympus, a global technology leader in designing precision healthcare solutions and innovative consumer electronics, is proud to be the official digital camera sponsor of *America 24/7*. The opportunity to introduce Americans from coast to coast to the thrill, excitement, and possibility of digital photography makes the vision behind this book a perfect fit for Olympus, a leader in digital cameras since 1996.

For most people, the essence of digital photography is best grasped through firsthand experience with the technology, which is precisely what *America 24/7* is about. We understand that direct experience is the pathway to inspiration, and welcome opportunities like this sponsorship to bring the power of the digital experience into the lives of people everywhere. To Olympus, *America 24/7* offers a platform to help realize a core mission: to deliver and make accessible the power of the digital experience to millions of American photographers, amateurs, and professionals alike.

The 1,000 professional photographers contracted to shoot on the America 24/7 project were all equipped with Olympus C-5050 digital cameras. Like all Olympus products, the C-5050 is offered by a company well known for designing, manufacturing, and servicing products used by professionals to perform their work, every day. Olympus is a customer-centric company committed to working one-to-one with a diverse group of professionals. From biomedical researchers who use our clinical microscopes, to doctors who perform life-saving procedures with our endoscopes, to professional photographers who use cameras in their daily work, Olympus is a trusted brand.

The digital imaging technology involved with *America 24/7* has enabled the soul of America to be visually conveyed, not just by professional observers, but by the American public who participated in this project—the very people who collectively breath life into this country's existence each day.

We are proud to be enabling so many photographers to capture the pictures on these pages that tell the story of who we are as a nation. From sea to shining sea, digital imagery allows us to connect to one another in ways we never dreamed possible.

At Olympus, our ideas have proliferated as rapidly as technology has evolved. We have channeled these visions into breakthrough products and solutions to meet the demands of our changing world-products like microscopes, endoscopes, and digital voice recorders, supported by the highly regarded training, educational, and consulting services we offer our customers.

Today, 83 years after we introduced our first microscope, we remain as young, as curious, and as committed as ever.

LEXAR *Media*™

Lexar Media has grown from the digital photography revolution, which is why we are proud to have supplied the digital memory cards used in the America 24/7 project. Lexar Media's high-performance memory cards utilize our unique and patented controller coupled with high-speed flash memory from Samsung, the world's largest flash memory supplier. This powerful combination brings out the ultimate performance of any digital camera.

Photographers who demand the most from their equipment choose our products for their advanced features like write speeds up to 40X, Write Acceleration technology for enabled cameras, and Image Rescue, which recovers previously deleted or lost images. Leading camera manufacturers bundle Lexar Media digital memory cards with their cameras because they value its performance and reliability.

Lexar Media is at the forefront of digital photography as it transforms picture-taking worldwide, and we will continue to be a leader with new and innovative solutions for professionals and amateurs alike.

Snapfish, which developed the technology behind the *America 24/7* amateur photo event, is a leading online photo service, with more than 5 million members and 100 million photos posted online. Snapfish enables both film and digital camera owners to share, print, and store their most important photo memories, at prices that cannot be equaled. Digital camera users upload photos into a password-protected online album for free. Users can also order film-quality prints on professional photographic paper for as low as 25¢. Film camera users get a full set of prints, plus online sharing and storage, for just 2.99 per roll.

Founded in 1995, eBay created a powerful platform for the sale of goods and services by a passionate community of individuals and businesses. On any given day, there are millions of items across thousands of categories for sale on eBay. eBay enables trade on a local, national and international basis with customized sites in markets around the world.

Through an array of services, such as its payment solution provider PayPal, eBay is enabling global e-commerce for an ever-growing online community.

JetBlue Airways is proud to be *America 24/7's* preferred carrier, flying photographers, photo editors, and organizers across the United States.

Winner of Condé Nast Traveler's Readers' Choice Awards for Best Domestic Airline 2002, JetBlue provides friendly service and low fares for travelers in 22 cities in nine states across America.

On behalf of JetBlue's 5,000 crew members, we're excited to be involved in this remarkable project, and for the opportunity to serve American travelers each and every day, coast to coast, 24/7.

DIGITAL POND

Digital Pond has been a leading creator of large graphic displays for museums, corporations, trade shows, retail environments and fine art since 1992.

We were proud to bring together our creative, print and display capabilities to produce signage and displays for mission control, critical retouching for numerous key images for the book, and art galleries for the New York Public Library and Bryant Park.

The Pond's team and SplashPic® Online service enabled us to nimbly design, produce and install over 200 large graphic panels in two NYC locations within the truly "24/7" production schedule of less than ten days.

WebWare Corporation is pleased to be a major sponsor of the America 24/7 project. We take pride in being part of a groundbreaking adventure that is stretching the boundaries—and the imagination—in digital photography, digital asset management, publishing, news, and global events.

Our ActiveMedia Enterprise™ digital asset management software is the "nerve center" of *America 24/7,* the central repository for managing, sharing, and collaborating on the project's photographs. From photo editors and book publishers to 24/7's media relations and marketing personnel, ActiveMedia provides the application support that links all facets of the project team to the content worldwide.

WebWare helps Global 2000 firms securely manage, reuse, and distribute media assets locally or globally. Its suite of ActiveMedia software products provide powerful media services platforms for integrating rich media into content management systems marketing and communication portals; web publishing systems; and e-commerce portals.

Google's mission is to organize the world's information and make it universally accessible and useful.

With our focus on plucking just the right answer from an ocean of data, we were naturally drawn to the America 24/7 project. The book you hold is a compendium of images of American life distilled from thousands of photographs and infinite possibilities. Are you looking for emotion? Narrative? Shadows? Light? It's all here, thanks to a multitude of photographers and writers creating links between you, the reader, and a sea of wonderful stories. We celebrate the connections that constitute the human experience and are pleased to help engender them. And we're pleased to have been a small part of this project, which captures the results of that interaction so vividly, so dynamically, and so dramatically.

Special thanks to additional contributors: FileMaker, Apple, Camera Bits, LaCie, Now Software, Preclick, Outpost Digital, Xerox, Microsoft, WoodWing Software, net-linx Publishing Solutions, and Radical Media. The Savoy Hotel, San Francisco; The Pan Pacific, San Francisco; Four Seasons Hotel, San Francisco; and The Queen Anne Hotel. Photography editing facilities were generously hosted by CNET Networks, Inc.

Participating Photographers

Coordinator: Christina Paolucci

Bill Alkofer
Kimm Anderson
Todd Asher
Ginger Baker
Raoul Benavides
James Bird
Scott Cohen
John L. Cross, *The Free Press*, Mankato
Derek J. Dickinson
Julie Geiger-Schutz
Carlos Gonzalez
Stormi Greener
Judy Griesedieck
Jayme Clifton Halbritter
Richard Hamilton Smith
Kyndell Harkness
Eric Hylden, *Grand Forks Herald*
Lisa Johnson
Renée Jones, *Owatonna People's Press*
Brenda Kiehl

Andy King
Ken Klotzbach
Mike Krieter
Jackie Lorentz
Richard Marshall
Ann Arbor Miller
Richard Osborne
Christina Paolucci
Brian Peterson, *The Minneapolis Star-Tribune*
Darlene Pfister Prois
Dean Riggott, www.riggottphoto.com
Joe Rossi
Joel W. Sheagren
Dianne Towalski
Dawn Villella
Les Weber
Thomas Whisenand, *The Minnesota Daily*
Liz Zurek-Beaudry

Thumbnail Picture Credits

Credits for thumbnail photographs are listed by the page number and are in order from left to right.

20 John Keenan, johnkeenan.com
Bill Alkofer
Jackie Lorentz
Dean Riggott, www.riggottphoto.com
Christina Paolucci
Jayme Clifton Halbritter
Julie Geiger-Schutz

21 Rowan Gillson
John L. Cross, *The Free Press*, Mankato
Rowan Gillson
Renée Jones, *Owatonna People's Press*
Jessica 'laine Walters Rogers
Jackie Lorentz
Jayme Clifton Halbritter

22 Luis Sanchez Saturno
Stormi Greener
Stormi Greener
Luis Sanchez Saturno
Stormi Greener
Luis Sanchez Saturno
Ann Arbor Miller

23 Joel W. Sheagren
Luis Sanchez Saturno
Stormi Greener
Stormi Greener
Ann Arbor Miller
Stormi Greener
Laurie Hernandez

24 Dawn Villella
Dawn Villella
Julie Geiger-Schutz
Dawn Villella
Dawn Villella
Andy King
Dawn Villella

26 Christina Paolucci
Dean Riggott, www.riggottphoto.com
Renée Jones, *Owatonna People's Press*
Ken Klotzbach
Dawn Villella
Jackie Lorentz
Renée Jones, *Owatonna People's Press*

27 Ken Klotzbach
Christina Paolucci
Rowan Gillson
Richard Marshall
Jackie Lorentz
Richard Marshall
Renée Jones, *Owatonna People's Press*

28 Darlene Pfister Prois
Renée Jones, *Owatonna People's Press*
Kimm Anderson
Darlene Pfister Prois

Darlene Pfister Prois
Darlene Pfister Prois
Joel W. Sheagren

29 Renée Jones, *Owatonna People's Press*
Renée Jones, *Owatonna People's Press*
Darlene Pfister Prois
Renée Jones, *Owatonna People's Press*
Renée Jones, *Owatonna People's Press*
Renée Jones, *Owatonna People's Press*
Renée Jones, *Owatonna People's Press*

30 Kimm Anderson
Bill Alkofer
Kimm Anderson
Bill Alkofer
Bill Alkofer
Kimm Anderson
Bill Alkofer

31 Kimm Anderson
Bill Alkofer
Ken Klotzbach
Kimm Anderson
Bill Alkofer
Kimm Anderson
Renée Jones, *Owatonna People's Press*

32 Christina Paolucci
Dawn Villella
Laurie Hernandez
Dawn Villella
Dawn Villella
Dawn Villella
Dawn Villella

33 Richard Marshall
Dawn Villella
Carlos Gonzalez
Kyndell Harkness
Mike Krieter
Jackie Lorentz
Dawn Villella

37 Brian Peterson, *The Minneapolis Star-Tribune*
Brian Peterson, *The Minneapolis Star-Tribune*
Brian Peterson, *The Minneapolis Star-Tribune*
Brian Peterson, *The Minneapolis Star-Tribune*
Renée Jones, *Owatonna People's Press*
Brian Peterson, *The Minneapolis Star-Tribune*
Richard Marshall

38 Jessica 'laine Walters Rogers
Dawn Villella
Dean Riggott, www.riggottphoto.com
Ann Arbor Miller
Joel W. Sheagren
Dean Riggott, www.riggottphoto.com
Carlos Gonzalez

40 Carlos Gonzalez
Andy King
Ann Arbor Miller
Ann Arbor Miller
Ann Arbor Miller
Ann Arbor Miller
Ann Arbor Miller

41 Ann Arbor Miller
Ann Arbor Miller
Ann Arbor Miller
Bill Alkofer
Ann Arbor Miller
Carlos Gonzalez
Ann Arbor Miller

42 John Keenan, johnkeenan.com
Richard Marshall
Jayme Clifton Halbritter
Richard Marshall
Laurie Hernandez
Richard Marshall
Richard Marshall

43 Richard Marshall
Renée Jones, *Owatonna People's Press*
Richard Marshall
Renée Jones, *Owatonna People's Press*
Richard Marshall
John L. Cross, *The Free Press*, Mankato
Richard Marshall

44 Ann Arbor Miller
Ken Klotzbach
Joel W. Sheagren
Bill Alkofer
Christina Paolucci
Dean Riggott, www.riggottphoto.com
Ken Klotzbach

45 Ken Klotzbach
Dean Riggott, www.riggottphoto.com
Ken Klotzbach
Ken Klotzbach
Raoul Benavides
Dean Riggott, www.riggottphoto.com
Thomas Whisenand, *The Minnesota Daily*

46 Christina Paolucci
Christina Paolucci
Christina Paolucci
Jayme Clifton Halbritter
Christina Paolucci
Christina Paolucci
Richard Hamilton Smith

47 Joel W. Sheagren
Christina Paolucci
Christina Paolucci
Jessica 'laine Walters Rogers
Christina Paolucci
Christina Paolucci
Renée Jones, *Owatonna People's Press*

55 John L. Cross, *The Free Press*, Mankato
John L. Cross, *The Free Press*, Mankato
John L. Cross, *The Free Press*, Mankato
John L. Cross, *The Free Press*, Mankato
Bill Alkofer
John L. Cross, *The Free Press*, Mankato
Renée Jones, *Owatonna People's Press*

56 Derek J. Dickinson
Richard Hamilton Smith
Ken Klotzbach
Richard Hamilton Smith
Joel W. Sheagren
Ken Klotzbach
Renée Jones, *Owatonna People's Press*

57 Ken Klotzbach
Richard Hamilton Smith
Richard Hamilton Smith
Richard Hamilton Smith
Richard Hamilton Smith
Richard Hamilton Smith
Richard Hamilton Smith

58 Derek J. Dickinson
Stormi Greener
Stormi Greener
Stormi Greener
Derek J. Dickinson
Stormi Greener
Stormi Greener

59 Stormi Greener
Stormi Greener
Stormi Greener
Stormi Greener
Stormi Greener
Stormi Greener
Stormi Greener

60 Derek J. Dickinson
Dean Riggott, www.riggottphoto.com
Dean Riggott, www.riggottphoto.com
Dean Riggott, www.riggottphoto.com

Dean Riggott, www.riggottphoto.com
Renée Jones, *Owatonna People's Press*
Dean Riggott, www.riggottphoto.com

61 Dean Riggott, www.riggottphoto.com
Thomas Whisenand, *The Minnesota Daily*
Renée Jones, *Owatonna People's Press*
Dawn Villella
Dean Riggott, www.riggottphoto.com
John Keenan, johnkeenan.com
Jayme Clifton Halbritter

62 John L. Cross, *The Free Press*, Mankato
Christina Paolucci
Christina Paolucci
John L. Cross, *The Free Press*, Mankato
Christina Paolucci
John L. Cross, *The Free Press*, Mankato
Christina Paolucci

63 John L. Cross, *The Free Press*, Mankato
Christina Paolucci
John L. Cross, *The Free Press*, Mankato
John L. Cross, *The Free Press*, Mankato
Christina Paolucci
Christina Paolucci
John L. Cross, *The Free Press*, Mankato

64 John L. Cross, *The Free Press*, Mankato
John Keenan, johnkeenan.com
Kimm Anderson
Jayme Clifton Halbritter
Kimm Anderson
John L. Cross, *The Free Press*, Mankato
Kimm Anderson

65 Kimm Anderson
Kimm Anderson
Kimm Anderson
Jayme Clifton Halbritter
Kimm Anderson
Kimm Anderson
John L. Cross, *The Free Press*, Mankato

66 Jessica 'laine Walters Rogers
Brian Peterson, *The Minneapolis Star-Tribune*
Thomas Whisenand, *The Minnesota Daily*
Keri Pickett
Kimm Anderson
Bill Alkofer
Joel W. Sheagren

67 Julie Geiger-Schutz
Renée Jones, *Owatonna People's Press*
Thomas Whisenand, *The Minnesota Daily*
Renée Jones, *Owatonna People's Press*
Thomas Whisenand, *The Minnesota Daily*
Penny Bonnar
Thomas Whisenand, *The Minnesota Daily*

68 Joe Rossi
Dean Riggott, www.riggottphoto.com
Dawn Villella
Joe Rossi
Dean Riggott, www.riggottphoto.com
Julie Geiger-Schutz
Joe Rossi

69 Dawn Villella
Joe Rossi
Luis Sanchez Saturno
Dean Riggott, www.riggottphoto.com
Joe Rossi
Jayme Clifton Halbritter
Richard Marshall

70 Ann Arbor Miller
Ann Arbor Miller
Dawn Villella
Ann Arbor Miller
Renée Jones, *Owatonna People's Press*
Ann Arbor Miller
Derek J. Dickinson

71 Renée Jones, *Owatonna People's Press*
Ann Arbor Miller
Derek J. Dickinson
Jayme Clifton Halbritter
Dean Riggott, www.riggottphoto.com
Renée Jones, *Owatonna People's Press*
Dawn Villella

72 Bill Alkofer
Derek J. Dickinson
Andy King
Richard Hamilton Smith
Dean Riggott, www.riggottphoto.com
Andy King
Judy Griesedieck

73 Andy King
Richard Hamilton Smith
Jayme Clifton Halbritter
Andy King
Renée Jones, *Owatonna People's Press*
Jayme Clifton Halbritter
Richard Hamilton Smith

Rowan Gillson
lie Geiger-Schutz
ott Cohen
hard Marshall
awn Villella
ssica 'laine Walters Rogers
ssica 'laine Walters Rogers

Derek J. Dickinson
hn Keenan, johnkeenan.com
ean Riggott, www.riggottphoto.com
erek J. Dickinson
ean Riggott, www.riggottphoto.com
andee Gerbers
hristina Paolucci

Andy King
hn Keenan, johnkeenan.com
andy King
hristina Paolucci
enée Jones, *Owatonna People's Press*
ean Riggott, www.riggottphoto.com

Judy Griesedieck
nn Arbor Miller
is Sanchez Saturno
homas Whisenand, *The Minnesota Daily*
aoul Benavides
homas Whisenand, *The Minnesota Daily*
ll Alkofer

Carlos Gonzalez
homas Whisenand, *The Minnesota Daily*
homas Whisenand, *The Minnesota Daily*
aoul Benavides
homas Whisenand, *The Minnesota Daily*
aoul Benavides
is Sanchez Saturno

John L. Cross, *The Free Press*, Mankato
chard Hamilton Smith
chard Hamilton Smith
awn Villella
chard Hamilton Smith
chard Hamilton Smith

Derek J. Dickinson
enée Jones, *Owatonna People's Press*
homas Whisenand, *The Minnesota Daily*
chard Hamilton Smith
enée Jones, *Owatonna People's Press*
awn Villella
chard Hamilton Smith

Carlos Gonzalez
nn Arbor Miller
arlos Gonzalez
nn Arbor Miller
arlos Gonzalez
arlos Gonzalez
arlos Gonzalez

Carlos Gonzalez
arlos Gonzalez
arlos Gonzalez
mm Anderson
arlos Gonzalez
hn L. Cross, *The Free Press*, Mankato
mm Anderson

Richard Marshall
rian Peterson, *The Minneapolis Star-Tribune*
rian Peterson, *The Minneapolis Star-Tribune*
rian Peterson, *The Minneapolis Star-Tribune*
rian Peterson, *The Minneapolis Star-Tribune*
arlene Pfister Prois
ike Krieter

Richard Marshall
rian Peterson, *The Minneapolis Star-Tribune*
rian Peterson, *The Minneapolis Star-Tribune*
rian Peterson, *The Minneapolis Star-Tribune*
rian Peterson, *The Minneapolis Star-Tribune*
ike Krieter
rian Peterson, *The Minneapolis Star-Tribune*

Richard Hamilton Smith
ike Krieter
chard Hamilton Smith
erek J. Dickinson
chard Hamilton Smith
ike Krieter
chard Hamilton Smith

Bill Alkofer
chard Marshall
ll Alkofer
chard Marshall
ean Riggott, www.riggottphoto.com
ayme Clifton Halbritter
erek J. Dickinson

Renée Jones, *Owatonna People's Press*
chard Marshall
chard Marshall
ean Riggott, www.riggottphoto.com
chard Marshall
chard Marshall
chard Marshall

94 Judy Griesedieck
Thomas Whisenand, *The Minnesota Daily*
Renée Jones, *Owatonna People's Press*
Thomas Whisenand, *The Minnesota Daily*
Thomas Whisenand, *The Minnesota Daily*
Andy King
Thomas Whisenand, *The Minnesota Daily*

95 Thomas Whisenand, *The Minnesota Daily*
Thomas Whisenand, *The Minnesota Daily*
Andy King
Thomas Whisenand, *The Minnesota Daily*
Renée Jones, *Owatonna People's Press*
Thomas Whisenand, *The Minnesota Daily*
Thomas Whisenand, *The Minnesota Daily*

96 Judy Griesedieck
Dawn Villella
Judy Griesedieck
Bill Alkofer
Judy Griesedieck
Rowan Gillson
Richard Marshall

97 Laurie Hernandez
Rowan Gillson
Kimm Anderson
Richard Hamilton Smith
Kimm Anderson
Scott Cohen
Kimm Anderson

98 Renée Jones, *Owatonna People's Press*
Renée Jones, *Owatonna People's Press*
Christina Paolucci
Renée Jones, *Owatonna People's Press*
Renée Jones, *Owatonna People's Press*
Renée Jones, *Owatonna People's Press*
Dean Riggott, www.riggottphoto.com

99 Thomas Whisenand, *The Minnesota Daily*
Renée Jones, *Owatonna People's Press*
Renée Jones, *Owatonna People's Press*
Renée Jones, *Owatonna People's Press*
Renée Jones, *Owatonna People's Press*
Derek J. Dickinson
Renée Jones, *Owatonna People's Press*

102 Richard Marshall
Renée Jones, *Owatonna People's Press*
Julie Geiger-Schutz
Justin Piehowski
Mike Krieter
Renée Jones, *Owatonna People's Press*
Mike Krieter

103 Justin Piehowski
Renée Jones, *Owatonna People's Press*
Renée Jones, *Owatonna People's Press*
Renée Jones, *Owatonna People's Press*
Richard Hamilton Smith
Judy Griesedieck
Renée Jones, *Owatonna People's Press*

104 Richard Marshall
Brian Peterson, *The Minneapolis Star-Tribune*
Christina Paolucci
Brian Peterson, *The Minneapolis Star-Tribune*
Christina Paolucci
Brian Peterson, *The Minneapolis Star-Tribune*
Mike Krieter

105 Richard Marshall
Judy Griesedieck
Richard Marshall
Brian Peterson, *The Minneapolis Star-Tribune*
Renée Jones, *Owatonna People's Press*
Brian Peterson, *The Minneapolis Star-Tribune*
Richard Marshall

108 Renée Jones, *Owatonna People's Press*
Christina Paolucci
Renée Jones, *Owatonna People's Press*
Ann Arbor Miller
Brian Peterson, *The Minneapolis Star-Tribune*
Judy Griesedieck
Kimm Anderson

109 Justin Piehowski
Renée Jones, *Owatonna People's Press*
Darlene Pfister Prois
Renée Jones, *Owatonna People's Press*
Renée Jones, *Owatonna People's Press*
Renée Jones, *Owatonna People's Press*
Tara C. Patty

110 Keri Pickett
Judy Griesedieck
Bill Alkofer
Judy Griesedieck
Keri Pickett
Christina Paolucci
Jeanna Duerscherl

111 Keri Pickett
Judy Griesedieck
Kimm Anderson
Judy Griesedieck

Keri Pickett
Kimm Anderson
Keri Pickett

112 Scott Cohen
Andy King
Scott Cohen
John Keenan, johnkeenan.com
Jayme Clifton Halbritter
Jayme Clifton Halbritter
Dianne Towalski

113 Kimm Anderson
Luis Sanchez Saturno
John Keenan, johnkeenan.com
Richard Marshall
Richard Hamilton Smith
John Keenan, johnkeenan.com
Richard Marshall

114 Dianne Towalski
Judy Griesedieck
Dean Riggott, www.riggottphoto.com
John L. Cross, *The Free Press*, Mankato
Judy Griesedieck
John L. Cross, *The Free Press*, Mankato
Dean Riggott, www.riggottphoto.com

115 Rowan Gillson
Kimm Anderson
Judy Griesedieck
Luis Sanchez Saturno
John L. Cross, *The Free Press*, Mankato
Richard Hamilton Smith
Judy Griesedieck

117 Joe Rossi
Dean Riggott, www.riggottphoto.com
Kimm Anderson
Dean Riggott, www.riggottphoto.com
Kimm Anderson
Dean Riggott, www.riggottphoto.com
Kimm Anderson

120 Stormi Greener
Stormi Greener
Stormi Greener
Stormi Greener
Stormi Greener
Stormi Greener
Stormi Greener

122 Ann Arbor Miller
Brian Peterson, *The Minneapolis Star-Tribune*
Joel W. Sheagren
Darlene Pfister Prois
Brian Peterson, *The Minneapolis Star-Tribune*
Jayme Clifton Halbritter
Joel W. Sheagren

123 Brian Peterson, *The Minneapolis Star-Tribune*
Joel W. Sheagren
Judy Griesedieck
Darlene Pfister Prois
Joel W. Sheagren
Kimm Anderson
Brian Peterson, *The Minneapolis Star-Tribune*

124 Brian Peterson, *The Minneapolis Star-Tribune*
Brian Peterson, *The Minneapolis Star-Tribune*
Brian Peterson, *The Minneapolis Star-Tribune*
Dean Riggott, www.riggottphoto.com
Brian Peterson, *The Minneapolis Star-Tribune*
Dean Riggott, www.riggottphoto.com
Christina Paolucci

125 Luis Sanchez Saturno
John Keenan, johnkeenan.com
Jessica 'laine Walters Rogers
Kimm Anderson
Bill Alkofer
Renée Jones, *Owatonna People's Press*
Brian Peterson, *The Minneapolis Star-Tribune*

128 Christina Paolucci
John L. Cross, *The Free Press*, Mankato
Christina Paolucci
Dean Riggott, www.riggottphoto.com
Renée Jones, *Owatonna People's Press*
Derek J. Dickinson
Joe Rossi

129 Dean Riggott, www.riggottphoto.com
Raoul Benavides
Dean Riggott, www.riggottphoto.com
Jessica 'laine Walters Rogers
Laila Rojas
Raoul Benavides
Dean Riggott, www.riggottphoto.com

131 Rowan Gillson
Judy Griesedieck
Renée Jones, *Owatonna People's Press*
John Keenan, johnkeenan.com
Judy Griesedieck
John Keenan, johnkeenan.com
Christina Paolucci

134 Darlene Pfister Prois
Brian Peterson, *The Minneapolis Star-Tribune*
Richard Hamilton Smith

Brian Peterson, *The Minneapolis Star-Tribune*
Dianne Towalski
Brian Peterson, *The Minneapolis Star-Tribune*
Brian Peterson, *The Minneapolis Star-Tribune*

135 Brian Peterson, *The Minneapolis Star-Tribune*
Brian Peterson, *The Minneapolis Star-Tribune*
Brian Peterson, *The Minneapolis Star-Tribune*
Brian Peterson, *The Minneapolis Star-Tribune*
Derek J. Dickinson
Brian Peterson, *The Minneapolis Star-Tribune*
Jayme Clifton Halbritter

138 Bill Alkofer
Renée Jones, *Owatonna People's Press*
Todd Asher
Bill Alkofer
Raoul Benavides
Christina Paolucci
Kimm Anderson

139 John L. Cross, *The Free Press*, Mankato
Kimm Anderson
Christina Paolucci
Bill Alkofer
Joe Rossi
Raoul Benavides
Bill Alkofer

141 Scott Cohen
Eric Hylden, *Grand Forks Herald*
Scott Cohen
Renée Jones, *Owatonna People's Press*
Renée Jones, *Owatonna People's Press*
Scott Cohen
Bill Alkofer

142 Bill Alkofer
Jayme Clifton Halbritter
Bill Alkofer
Jayme Clifton Halbritter
Joe Rossi
Jayme Clifton Halbritter
Bill Alkofer

143 Joe Rossi
Bill Alkofer
Joe Rossi
Joe Rossi
Joe Rossi
Joe Rossi
Jayme Clifton Halbritter

144 Brian Peterson, *The Minneapolis Star-Tribune*
Darlene Pfister Prois
Christina Paolucci
Darlene Pfister Prois
Jayme Clifton Halbritter
Darlene Pfister Prois
Richard Marshall

146 Joe Rossi
Joe Rossi
Richard Hamilton Smith
Ann Arbor Miller
Brian Peterson, *The Minneapolis Star-Tribune*
Joe Rossi
Joe Rossi

147 Joe Rossi
Dean Riggott, www.riggottphoto.com
Kimm Anderson
Mike Krieter
John L. Cross, *The Free Press*, Mankato
Richard Hamilton Smith
Richard Hamilton Smith

148 Andy King
Mike Krieter
Richard Hamilton Smith
Richard Hamilton Smith
Richard Hamilton Smith
Richard Hamilton Smith
Richard Hamilton Smith

149 Richard Hamilton Smith
Richard Hamilton Smith
Richard Hamilton Smith
Richard Hamilton Smith
Mike Krieter
Richard Hamilton Smith
Richard Hamilton Smith

150 Richard Hamilton Smith
Bill Alkofer
Mike Krieter
Joe Rossi
Richard Hamilton Smith
Richard Hamilton Smith
Richard Hamilton Smith

151 Richard Hamilton Smith
Richard Hamilton Smith
Joe Rossi
Richard Hamilton Smith
Bill Alkofer
Kimm Anderson
Richard Hamilton Smith

Staff

The *America 24/7* series was imagined years ago by our friend Oscar Dystel, a publishing legend whose vision and enthusiasm have been a source of great inspiration.

We also wish to express our gratitude to our truly visionary publisher, DK.

Rick Smolan, Project Director
David Elliot Cohen, Project Director

Administrative
Katya Able, Operations Director
Gina Privitere, Communications Director
Chuck Gathard, Technology Director
Kim Shannon, Photographer Relations Director
Erin O'Connor, Photographer Relations Intern
Leslie Hunter, Partnership Director
Annie Polk, Publicity Manager
John McAlester, Website Manager
Alex Notides, Office Manager
C. Thomas Hardin, State Photography Coordinator

Design
Brad Zucroff, Creative Director
Karen Mullarkey, Photography Director
Judy Zimola, Production Manager
David Simoni, Production Designer
Mary Dias, Production Designer
Heidi Madison, Associate Picture Editor
Don McCartney, Production Designer
Diane Dempsey Murray, Production Designer
Jan Rogers, Associate Picture Editor
Bill Shore, Production Designer and Image Artist
Larry Nighswander, Senior Picture Editor
Bill Marr, Sarah Leen, Senior Picture Editors
Peter Truskier, Workflow Consultant
Jim Birkenseer, Workflow Consultant

Editorial
Maggie Canon, Managing Editor
Curt Sanburn, Senior Editor
Teresa L. Trego, Production Editor
Lea Aschkenas, Writer
Olivia Boler, Writer
Korey Capozza, Writer
Beverly Hanly, Writer
Bridgett Novak, Writer
Alison Owings, Writer
Fred Raker, Writer
Joe Wolff, Writer
Elise O'Keefe, Copy Chief
Daisy Hernández, Copy Editor
Jennifer Wolfe, Copy Editor

Infographic Design
Nigel Holmes

Literary Agent
Carol Mann, The Carol Mann Agency

Legal Counsel
Barry Reder, Coblentz, Patch, Duffy & Bass, LLP
Phil Feldman, Coblentz, Patch, Duffy & Bass, LLP
Gabe Perle, Ohlandt, Greeley, Ruggiero & Perle, LLP
Jon Hart, Dow, Lohnes & Albertson, PLLC
Mike Hays, Dow, Lohnes & Albertson, PLLC
Stephen Pollen, Warshaw Burstein, Cohen, Schlesinger & Kuh, LLP
Rick Pappas

Accounting and Finance
Rita Dulebohn, Accountant
Robert Powers, Calegari, Morris & Co. Accountants
Eugene Blumberg, Blumberg & Associates
Arthur Langhaus, KLS Professional Advisors Group, Inc.

Picture Editors
J. David Ake, Associated Press
Caren Alpert, formerly *Health* magazine
Simon Barnett, *Newsweek*
Caroline Couig, *San Jose Mercury News*
Mike Davis, formerly *National Geographic*
Michel duCille, *Washington Post*
Deborah Dragon, *Rolling Stone*
Victor Fisher, formerly Associated Press
Frank Folwell, *USA Today*
MaryAnne Golon, *Time*
Liz Grady, formerly *National Geographic*
Randall Greenwell, *San Francisco Chronicle*
C. Thomas Hardin, formerly *Louisville Courier-Journal*
Kathleen Hennessy, *San Francisco Chronicle*
Scot Jahn, *U.S. News & World Report*
Steve Jessmore, *Flint Journal*
John Kaplan, University of Florida
Kim Komenich, *San Francisco Chronicle*
Eliane Laffont, *Hachette Filipacchi Media*
Jean-Pierre Laffont, *Hachette Filipacchi Media*
Andrew Locke, MSNBC
Jose Lopez, *The New York Times*
Maria Mann, formerly AFP
Bill Marr, formerly *National Geographic*
Michele McNally, *Fortune*
James Merithew, *San Francisco Chronicle*
Eric Meskauskas, *New York Daily News*
Maddy Miller, *People* magazine
Michelle Molloy, *Newsweek*
Dolores Morrison, *New York Daily News*
Karen Mullarkey, formerly *Newsweek, Rolling Stone, Sports Illustrated*
Larry Nighswander, Ohio University School of Visual Communication
Jim Preston, *Baltimore Sun*
Sarah Rozen, formerly *Entertainment Weekly*
Mike Smith, *The New York Times*
Neal Ulevich, formerly Associated Press

Website and Digital Systems
Jeff Burchell, Applications Engineer

Television Documentary
Sandy Smolan, Producer/Director
Rick King, Producer/Director
Bill Medsker, Producer

Video News Release
Mike Cerre, Producer/Director

Digital Pond
Peter Hogg
Kris Knight
Roger Graham
Philip Bond
Frank De Pace
Lisa Li

Senior Advisors
Jennifer Erwitt, Strategic Advisor
Tom Walker, Creative Advisor
Megan Smith, Technology Advisor
Jon Kamen, Media and Partnership Advisor
Mark Greenberg, Partnership Advisor
Patti Richards, Publicity Advisor
Cotton Coulson, Mission Control Advisor

Executive Advisors
Sonia Land
George Craig
Carole Bidnick

Advisors
Chris Anderson
Samir Arora
Russell Brown
Craig Cline
Gayle Cline
Harlan Felt
George Fisher
Phillip Moffitt
Clement Mok
Laureen Seeger
Richard Saul Wurman

DK Publishing
Bill Barry
Joanna Bull
Therese Burke
Sarah Coltman
Christopher Davis
Todd Fries
Dick Heffernan
Jay Henry
Stuart Jackman
Stephanie Jackson
Chuck Lang
Sharon Lucas
Cathy Melnicki
Nicola Munro
Eunice Paterson
Andrew Welham

Colourscan
Jimmy Tsao
Eddie Chia
Richard Law
Josephine Yam
Paul Koh
Chee Cheng Yeong
Dan Kang

Chief Morale Officer
Goose, the dog